Being a Woman~Naturally

Dr. Jan McBarron's
Guide to
NATURAL SUPPLEMENTS
BEYOND 25

Conchita,
I hope you
enjoy this as much
as I did.
Love,
Angelia

Disclaimer: This information is presented by
an independent medical expert whose
sources of information include studies from
the world's medical and scientific literature,
patient records, and other clinical and anec-
dotal reports. The material in this book is for
informational purposes only and is not
intended for the diagnosis or treatment of
disease. Please visit a medical health profes-
sional for specific diagnosis of any ailments
mentioned or discussed in this material.

ISBN 1-893910-16-4
Third Printing June 2002
Printed in the United States
Published by Freedom Press
1801 Chart Trail
Topanga, CA 90290
Bulk Orders Available: (800) 959-9797
E-mail: info@freedompressonline.com

My Dedication

This book is dedicated to every female over the age of 25. There is no cure for death. We all hope to push that date as far back as we can, provided we can maintain a healthy, vibrant day-to-day living up until the day death calls. This book is dedicated to helping every woman over the age of 25 achieve that goal.

In addition, this book is dedicated to my husband, Duke. When we were single, I felt he was "blue" and I was "pink." Together after many years of courtship and 15 years of marriage, I feel "lavender." He is truly my soul mate, my inspiration, my reason.

This book is further dedicated to my mother, Ellen "Lorraine" Packer--McBarron. Over the years, our relationship has changed and grown. The depth of my love, respect and admiration can never be expressed in words. From the time I was 18, when I felt I knew it all to present when I now feel she knows it all, she truly is my heroine. As the mother of four children, she taught me the meaning of truly accepting people as they are with their greatness and their shortcomings, as well as her greatest gift: the lesson of unconditional love.

Table of Contents

Acknowledgments

Every author acknowledges everyone from his or her kindergarten teacher to his or her current role model in life. Since this is impossible, let me simply say, thank you to my husband, family, many friends, fans, loyal listeners of the *Duke and The Doctor* nationally syndicated radio program and passing acquaintances over the years. I wish to thank all of you, both male and female, young and old, for the way you have touched my life and helped me to arrive at, and define, who I am and where I am at this point in my life. An incredible thanks to Terry Lemerond for introducing me to David Steinman, publisher of this book. My sincerest appreciation to Susan Peterson, Deborah Lumen, Tammy Teel, Donna Sides, Dee McConnell, Judy Daniels, Linda Smith, Ruth Rahn, and the entire staff of Georgia Bariatrics, Peachtree Natural Foods, The Institute for Healthy Living and Duke & The Doctor Enterprises. I also wish to thank Rachael Baseley and Cassandra Glickman for their caring editing of this book. Although this may sound like an acceptance speech at the Oscars, simply stated, "Thank You" to everyone who has allowed me to be here now.

Introduction

First, We Take Baby Steps

Cindy was distraught. She was going through daily mood swings and snapping at her husband so viciously that she hated herself, yet she wanted to hold him in her arms and tell him she was sorry at the same time. While trying on a skirt one day and looking at her legs in the mirror, Cindy told herself she would have to let the hem down. A championship volleyball player who had always enjoyed firm, well-toned legs, she now feared her once shapely legs and firm butt were a thing of the past. She was almost embarrassed to wear her bathing suit. The fifteen pounds she had gained didn't help her self-esteem. Sex with her husband had become physically painful, and she was desperately afraid that he would start taking an interest in some of the younger women at his office.

"I don't know what to do," she told me one day when she came to my office. "I eat right. I exercise. But things are changing so rapidly. What's happening to me, Dr. McBarron?"

Cindy was 47. A detailed history revealed very common signs of her entry into her second life, what some doctors call perimenopause, a time of fluctuating hormonal levels in women, certainly not the menopause and perhaps two to three years from that point in a woman's life—but, nevertheless, with potentially devastating symptoms that were causing difficult-to-understand-or-cope-with problems.

Because Cindy had seemingly lost interest in sexual relations with her husband, her gynecologist wanted to put her on a hormone "cocktail" consisting of estrogen, progestins (synthetic progesterone), and testosterone. Deep inside, she felt there was a better way. That's why she came to me.

Cindy knew virtually nothing about health. She thought that vitamins, minerals, and herbs were quackery. As a doctor, I realize that many patients,

Cindy included, must take baby steps before they can run with this program. Even though I have a long list of women's natural youth formulas that have been clinically and scientifically validated and that I know work from my thousands of patients' clinical experience—I also realize many of my patients are adverse to taking a lot of different pills all at once, especially when they start off on their natural make-over. They have to modify their diets, lifestyles, and even shopping habits. They have to take baby steps. And, sometimes, that's all we can do at first.

Cindy was no exception. So I started her on a very basic formula—a simple multiple vitamin and mineral formula—together with some soy-based foods and an herbal supplement containing black cohosh.

That was it. Too much too soon would be a mistake.

Within four weeks, Cindy felt back in control of her life. Her vaginal tissues had begun to rejuvenate, thanks to the combination of soy and black cohosh. Her moods and hot flashes had stabilized, and relations with her husband were much better. Next, we worked on that 15 pounds she needed to lose by using a combination of fat-burning herbs and a walking program, then added a few supplements known to help with cellulite.

I'll tell you more about what worked for Cindy and thousands of others of my patients. However, the message I want to leave you with is that we can work together to help design a program that will work for you too. Of all of the natural healing formulas and pathways detailed in this book, you will use only what is necessary for your own natural makeover.

I want to make it easy for you to enjoy better health and nutrition as a way of life. I'm a big believer in *baby steps*, of not making anything too difficult. I'll show you how, just by taking a few easy baby steps each month, you're going to step up to a whole new level of health, energy, stronger immunity, and reversal of disease. Brick by brick, you and I can work together to rebuild your health into a mighty fortress of beauty, energy, and strength!

I've heard other doctors call it "the miracle of compound health," and that it's the first cousin of compound interest—you invest your money and begin earning interest. Then you start earning interest *on your interest*, and your wealth starts to snowball. It's the same with your health. Each baby step I'll help you to take brings you to a slightly higher level of health, and you go onward and upward from there. The regular progress you make is exhilarating, as you feel better with every passing week.

In time, you'll wonder, "Hey, where did my cellulite go?" or "What happened to my hot flashes and mood swings?" You'll remark to yourself, "I feel so much

more energy than I have in years." You may even find your blood sugar, cholesterol, and triglycerides begin to normalize. There will be a new spring in your step and a twinkle in your eye, and you'll be thrilled to be alive again. It all happens *baby step by baby step*.

Hormone Hell

We women know what we want, and—as Cybill Shepherd recently warbled before an audience on *Oprah* when she was playing the chanteuse on national television—we don't want to be singing those non-ovulatory, mood-swinging, hot flash blues!

We're part of the boomer generation—those 40 million women between the ages of 35 and 55—who want it all but who may feel that as they are getting older they are losing their magic and youthful glow.

Some of my women patients who are on their second marriage or who are divorced have experienced infidelity by men seeking younger women. They feel they are no longer as attractive to men. They do not feel pretty inside or out. They worry about being a few pounds overweight, sagging skin and wrinkles, or how their mood swings may be affecting their relationships with men. Unfortunately, many women base their self-esteem on how men perceive them.

The problem isn't just from the chin up A little make-up won't solve the problem. The problem is also from the neck down, inside and out.

My women patients may be experiencing perimenopause (which often occurs in a woman's mid-forties) or frank menopause. They are experiencing many changes that actually start from within: loss of vaginal lubrication, leathering of skin, loss of their beautiful shapely legs, cellulite, and weight gain.

Many of my patients have mothers who are in their seventies and eighties. When they look at their mothers, they are scared of becoming just like them. "Oh please, I don't want to end up like my mother," is an exclamation I often hear. They mean no harm by what they say. I understand. They are afraid.

Perhaps their mothers have dowager's hump or suffer other forms of bone loss, are severely wrinkled, or require a walker—and they don't want to end up the same way. I don't blame them. Do you have those "I'm-becoming-my-mother" nightmares, too?

Well, I can help you. As a medical doctor and member of the boomer generation, I'm here to say that together we're revolutionizing concepts of aging and beauty. Wouldn't you love to look at your reflection in the mirror and, no matter what your chronological age—whether 35, 40, 50, 70 or beyond—still see your youthful self, a warm glow, and skin with minimal wrinkles, firm and tight with a supple feel?

Wouldn't you love to know that your body is protected, to the fullest extent possible, from cancer, heart disease, bone loss, arthritis, and simply the wear of time? That varicose veins, cellulite, excess wrinkling, and flabby thighs are other women's problems—*not* yours? That when it is time for romance your vaginal tissues are as youthful, moist, and sensitive as possible? That you have energy to spare and a glow of health and happiness no one can deny is alluring?

It is possible to give yourself a completely natural make-over inside and out, and it's possible without hormone replacement therapy. Of course, a great diet and exercise are always important. But diet and exercise alone are not the answer.

THE FOREVER YOUNG GENERATION

You, the modern woman of the new millennium, are a member of the first generation in history to be forever young. The tremendous breakthroughs in medical and longevity sciences that have been developed at breakneck speed in the last few years are now at your disposal. You can no longer turn your back on the possible. It is possible to stay as youthful and beautiful today as when you were thirty-something without facelifts, collagen or Botox injections. At the very least, keep in mind that cosmetic camouflage isn't the answer, either. Nothing can replace proper nutrition that supports what I call "hormonal harmony," together with proper daily detoxification.

Fortunately for all of us, many women doctors and scientists today are also members of the boomer generation, and they are passionately interested in improving their own lives (perhaps for selfish reasons). Thanks to them, great scientific advances that can contribute to your quest for health and beauty are now being reported and published regularly in medical journals around the

world. What I have done is taken my extensive clinical experience as a medical doctor who is a board-certified weight loss specialist and combined my clinical work, which emphasizes natural solutions, with the published research from thousands of medical journals. In my daily work, I see results firsthand. Nothing that I'm talking about in this book is based only on theory. These natural solutions have worked safely and effectively for thousands of patients, many of them my own or of doctors who've also stressed natural solutions to life's nagging age-related health issues.

The breakthrough findings in this book are my attempt to alert you to what has been proven to be both safe and effective at reversing the aging clock—without the need for medical hormone replacement therapy or other medical drugs. These natural anti-aging helpers have been brought together in this easy-to-use, comprehensive, definitive guide.

NEW CHALLENGES

Today, women are living longer than ever before and far longer than their mothers or grandmothers. In the past, when fewer women lived beyond their child-bearing years, osteoporosis and heart disease were less prevalent. Of course, wrinkling, cellulite and varicose veins can be problems at any age—but especially in midlife and beyond. At the turn of the century, a woman's average life expectancy was 50. Today it is almost 80.[1] Many diseases that were uncommon in shorter-lived past generations are common today and afflict larger numbers of women.

Plus, there are other factors at work. We live in a world of fantasy with computer-enhanced photography, facelifts, collagen implants in our lips and silicone implanted in our breasts, tummy tucks, and liposuction. These unreal images of beauty, whether surgically or digitally created, leave many ordinary women feeling guilty, depressed, and even ashamed. Well, maybe we can't all be supermodels—but we can all fulfill our own inherent potential for beauty.

These changing evolutionary and social patterns emphasize that women desperately require a new class of natural anti-aging helpers that have never before been part of our health or medical lexicon. And we boomers are creating this new language of age-defying beauty. These newly discovered and rediscovered anti-aging agents abound in nature—yet, it wasn't until scientists perfected techniques of molecular research that they could be identified and isolated, their powers unlocked and captured in modern youth formulas.

Today, every smart, beautiful woman should have a few anti-aging strategies on her side. Fortunately, nature's own pharmacy can supply safe, natural allies. Your doctor may have told you that the only anti-aging strategy available to women is to use hormone drugs. This just isn't true.

Each of the safe, natural, and effective anti-aging formulas reported on in this book can play an important complementary or alternative role to hormone replacement therapy and other medical drugs.

There is no longer the need to risk cancer for youth. And that's exciting.

No More Hormone Hell

Not Medicine as Usual~ Beyond HRT

So what can we do to not make the same mistakes our own mothers have made? What can women do to protect their bone health? How about their joints? What about drying or atrophy of their vaginal and uterine tissues? How can they improve their moods without Valium or other prescription drugs? What about wrinkling, cellulite, and varicose veins? How can women look and feel their best—how can they remain in the glory of their youth—no matter what their chronological age may be?

For years, we doctors have been trying to figure out how our women patients can stay younger longer. Is there magic in hormone replacement therapy? Are there certain potions, creams, or lotions, foods or dietary supplements that hold the key to youth and longevity? What about exercise, or the mind-body connection? Can these influence a woman's youth quest?

There seem to be so many pieces to the puzzle that doctors often don't know what steps to advise their patients to take or when to take them. And often the drugs that doctors prescribe are themselves fraught with complications. It's not surprising, then, that our patients often wonder whose advice to trust.

Doctors frequently like to prescribe estrogen replacement therapy, often together with progestins (i.e., synthetic progesterone), for women who are entering their second lives or who have symptoms of perimenopause. Are these powerful hormones really the answer? Are they safe for long-term use? Do their benefits outweigh their risks?

"Menopause used to shout 'middle age," writes Gail Sheehy in *Silent Passage*.[2] "But boomers simply aren't having middle age. Youth is intrinsic to their identity. And, in fact, boomers are the beneficiaries of a revolution in

their life cycle... in the space of one short generation the whole shape of the adult life cycle has been fundamentally altered. The territory of the fifties, sixties, and beyond is changing so radically, it now opens up whole new passages leading to stages of life that are nothing like what our parents or grandparents experienced."

But women must be knowledgeable about their options. "When I work with women patients or lecture to women at my workshops and seminars, I strongly emphasize the importance of women assessing their menopausal symptoms as well as their risk factors for conditions which become more prevalent after midlife, such as osteoporosis, heart disease, and breast cancer," says Susan Lark, M.D., a member of the clinical faculty of Stanford University Medical School who maintains a private practice in Los Altos, California. "Interestingly enough, while there are multiple treatment options for menopause and menopause-related conditions, such as prescription hormones, natural hormone therapies and nutritional therapies, only a minority of women chooses not to take prescription hormones. If a woman's symptoms are mild to moderate and her risk factors for conditions like osteoporosis are minimal, often lifestyle-based therapies such as dietary and nutritional supplement programs, stress reduction techniques, acupressure, and exercise are sufficient. I always recommend that even women utilizing prescription hormones practice healthy lifestyle habits for best results. I feel strongly that each woman should be knowledgeable about these treatment options and initiate her own self care program for best results."

I agree with Dr. Lark. My patients' clinical results dramatically prove that many natural remedies can easily outclass medical estrogen when it comes to great results and safety. Indeed, practicing healthy habits can be as powerful a "medicine" as using estrogen drugs.

ESTROGEN: WOMEN'S HORMONE OF YOUTH AND VITALITY

Let's call this section Estrogen 101. It's a quick course to get you centered on the theme of much of this book: the many amazing beneficial attributes of estrogen—as well as its risks when given in supplemental form. I want to deal with estrogen first, because the estrogen question is one every woman eventually must deal with—and today we have some 3,500 women entering menopause daily. So you can see how important it is. We need to get the estrogen issue out on the table for some frank talk.

Estrogens are the primary feminizing group of sex hormones. Ovaries and, to a lesser extent, adrenals and abdominal fatty tissues, using compounds derived from cholesterol, produce estrogen. Estrogens are secreted from these sites and circulate in the bloodstream throughout the body. The breasts and other organs and tissues, brain, bones, liver, and skin, have multitudes of receptors on their cells' outer membranes to which circulating estrogen can attach. These receptors directly link to the cell's inner genetic (DNA) materials.

Only about a decade ago, scientists learned that these receptors are themselves attached to the spiraling strands of DNA where our genes lie like beads on a string. When attached to estrogen, the receptor triggers a change in gene expression.[3]

Estrogen's influence on women is critical and all encompassing. There is almost no aspect of health on which estrogen doesn't touch. We now know that postmenopausal women with high natural levels of estrogen and those who use supplemental estrogen suffer less bone loss, that their skin is more supple, their vaginal tissues stay youthful, moist and lubricated, and that their uterus won't shrink to its prepubescent size. These are but a few of the reasons why medical estrogen supplements are so widely—and routinely—prescribed. It is even thought that estrogen replacement therapy can reduce heart disease risk and might even prevent Alzheimer's disease.

Medical Doctors Discover HRT

The history of hormone replacement therapy (HRT) can be traced back to the 1960s when a woman simply known as Mrs. P.G. visited Robert Wilson, a New York City obstetrician-gynecologist.[4] As Wilson later described, she must have been a knock-out. In her fifties, she had the smooth, fair skin of a far younger woman. She stunned Dr. Wilson when she disclosed that, at age 52, she was still using birth control pills.

"Dr. Wilson, I have never yet missed a period. I'm so regular, astronomers could use me for timing the moon," she told him.

It was truly as if she would be youthful forever. This experience led Wilson to author *Feminine Forever*. The book was a huge publishing success. In its first seven months, it sold more than 100,000 copies.

It opened up the flood gates for hormone replacement therapy to become standard medical practice. Robert Greenblatt was then chairman of the Department of Endocrinology at the Medical College of Georgia, the state where I practice medicine. Dr. Greenblatt wrote Wilson "sounds the clarion call, awakening a slumbering profession to a woman's needs."

The book was colorful, enthusiastic and, yet, paradoxically, sexist and demeaning. Wilson promised women eternal youth and sexual equality by taking estrogen. He wrote:

"The unpalatable truth must be faced that all post-menopausal women are castrates.... Our streets abound with them—walking stiffly in twos and threes, seeing little and observing less. It is not unusual to see an erect man of 75 vigorously striding along on a golf course, but seldom a woman of this age.... Now, for the first time in history, women may share the promise of tomorrow as biological equals of men. Thanks to hormone therapy, they can be feminine forever."

Eventually Dr. Wilson went just a bit over the top. Well, maybe way over the top. He began to advocate estrogen therapy for teenagers with poor complexions, acne, flaccid breasts, and dull hair. Post-menopausal women who took estrogen, Dr. Wilson promised, could be "sexually restored."

Dispensed as pills, patches, and creams, estrogen is now the number one prescription drug in the United States with a market of one in every four menopausal women.[5, 6] The usual HRT dosage is 0.625 milligrams of conjugated estrogens, such as Premarin (from American Home Products, a mixture of about 10 different estrogenic hormones derived from pregnant mares' urine) and, if deemed medically necessary, 5 to 10 milligrams of Provera (medroxy progestin from Ortho Pharmaceuticals) for 10 to 16 days monthly.

Prescriptions for estrogen drugs more than doubled between 1982 and 1992.[7] A 1994 survey "found almost all gynecologists routinely prescribed [HRT] for recently menopausal women." However, about 20 percent of women never fill their doctor's prescription. Of those who do, some 30 percent quit after nine months or so; more than one-half quit within one year, while others continue for five or more years.[8] In my own experience, I find that many women simply feel out of sorts when taking estrogen. They just don't feel right taking a drug to treat a normal phase in life. After all, menopause is not a disease. Why treat it with drugs? Many of my women patients come to me because they desperately want to get off the medical estrogen supplements prescribed by their previous doctors.

Another increasing trend is the use of HRT for breast cancer survivors. Until recently, its use with survivors seemed out of the question "because of the fear that the hormone could trigger new tumor growth."[9]

Nevertheless, an American Medical Association committee has recommended trials to study HRT's effects in breast cancer survivors. Many doctors feel the use of estrogen among breast cancer patients or women with a history of breast cancer is outrageous! That's because estrogen isn't some benign

miracle drug. No, it's a double-edged sword that can trigger cancerous processes in women's bodies.

You see, estrogen definitely has a dark side: increased risk for uterine, ovarian, breast and liver cancer are only some of its serious complications. Other complications include blood clots, fibroids, gallstones, and PMS.

For now, my message is that there are medically proven safe and healthy natural alternatives to HRT that women seeking drug-free passage through menopause need to know about.

Estrogen Replacement Therapy Balancing Risks vs. Benefits	
Benefits	*Risks*
Relief of menopausal symptoms, mood swings, hot flashes, and night sweats	Breast cancer
	Uterine cancer
	Ovarian cancer
Reduction in heart disease (tentative)	Liver cancer
Reduction in stroke (tentative)	Blood clots
Reduction in osteoporosis	Stimulation of growth of fibroids
Reduction in colon cancer	Gallstones
Reduction of vaginal atrophy	Weight gain
Reduction in urinary incontinence	Premenstrual syndrome
Preservation of libido	False mammograms
Preservation of elasticity of skin	Possible aggravation of asthma
Possible prevention of	Bleeding
Alzheimer's disease (tentative)	Possibly heart attack (when used by women with a history of high blood pressure or heart disease)

WHAT IS MENOPAUSE, ANYWAY?

Menopause is the phase during which the ovaries slowly decrease estrogen production. This may start several years before the last menses, typically around the age of 50. Some 20 percent of United States women pass through menopause without any significant problems. Others experience hot flashes, vaginal dryness, and mood swings. They also become more susceptible to osteoporosis and heart disease.

Menopause Facts
- Some 3,500 new women enter menopause every day in the United States.
- Some 50 million women became menopausal or were beyond menopause by the year 2000.
- One of the fastest growing demographic groups in America today is that of women between the ages of 40 and 60. This trend is even more pronounced in Europe.

Four Stages of Mid-life
- *Premenopause* is marked by hormonal fluctuations associated with early menopause-related changes while regular menstrual cycles are maintained. Some women experience premenopause in their late thirties to early forties.
- *Perimenopause* is the transition between the premenopausal phase and menopause and is characterized by changes in estrogen levels, irregular menstrual cycles, and increased menopausal symptoms.
- *Menopause* is the lack of spontaneous menstruation for twelve consecutive months with no other identifiable biological cause.
- *Postmenopause* is the period of life that follows the last menstrual period when a woman's natural levels of estrogen are at their lowest.

BEAUTIFUL INNER YOU

Whether you are 20, 40, or 80, beauty should have no limit. Every woman has a right to be beautiful, but she needs to nurture both her inner self and outer self to foster and maintain her beauty. As Ann Louise Gittleman, M.S., C.N.S., notes in *The Living Beauty Detox Program* (HarperCollins 2000), "When you are feeling your best, you look your best. In fact, unless you are nutritionally supported from within, it is virtually impossible to look really good because real beauty isn't just skin deep. Beauty isn't about how thin you are, about smearing some cover-up on your face, or even about wearing the right kind of lipstick. Achieving true beauty—even in our media-swayed, visual society—begins by turning things inside out."[10]

Natural beauty is the total expression of a vibrant, physically healthy body and healthy mental attitude. For a woman to look great, she needs to *feel* great. You've got to pay attention to your diet, your lifestyle, and your mind-body connection. They work together to make you the best woman possible.

Proper nutrition, activity levels including exercise, spiritual harmony, a positive mental attitude, and emotional balance all contribute to your most beauti-

ful self. Natural beauty begins with a balanced, healthy lifestyle. A balanced, healthy lifestyle consists of nourishing foods and nutritional supplements, exercise and stretching, managing stress, emotional balance, serenity in the midst of tempestuous life events, and adequate rest. The good news is you don't need to rely on medical drugs that could increase your risk of breast or uterine cancer to accomplish all of this. The even better news is that I'll show you how.

Nature's Answer to Estrogen: The European Alternative

Many times, patients who come into my office have tried everything. Their doctors have given them hormone replacement therapy, anti-anxiety drugs, and anti-depressants. You name it, they've been on it. The drugs, whether they are estrogen, Valium or Prozac, just aren't what they want to be on the rest of their lives. Their husbands sometimes complain that the drugs themselves have changed their wives to the point where they don't know who they married anymore.

Then one day they wake up, and they know they need a change. They wake up to the insanity of it all. I mean, first of all, calling menopause—something that occurs in every woman's life—a disease? And then medicating women with tranquilizers, hormones, anti-depressants, and sleep medications? And what about the new trend for women with severe premenstrual syndrome (PMS) wherein doctors put them on Prozac or other anti-depressants for a condition that occurs only two weeks out of the month? Who needs that kind of help? The patient? Or doctors who believe menopause is a disease requiring medication?

Probably the biggest issue my women patients face is whether or not to fill their doctor's prescription for hormone replacement therapy. It is a critical decision in women's lives. There are many benefits, and there are many risks. Generally, most medical doctors believe that, for most women, the benefits tremendously outweigh the risks. I'm different that way. Let me tell you right off the bat, except in rare instances, I don't believe in trading risks for benefits. I don't think we need to.

That's the old paradigm of medicine.

In the new medicine, at least with the issues my patients most commonly face, women can receive all of the benefits of hormones without any risks. The key is to look beyond the neighborhood, to seek out answers beyond our usual sources. That's what I have done as a medical doctor so that I can bring my patients the best that medicine today has to offer. One important aspect of the natural make-overs my women patients experience is that they are liberated from the need for estrogen drugs.

Let me explain. The public and even many medical doctors may think of estrogen replacement therapy as a relatively new medical development, but history books tell us natural healers have prescribed estrogenic and other types of healing plants for thousands of years—and that they work. The fact is that chemists did not synthesize estrogens until the 1930s; yet, women's experience with natural estrogenic agents dates back thousands of years. Once, women collected certain "special" herbs that could draw down their milk, smooth their menses, and rebalance their overall reproductive health. They treasured these herbs, often secreting them from men. Indeed, I believe that the real fountain of youth (if there were such a thing) would be located in a pastoral mountain or forest setting with fields of fennel, clover, licorice, and black cohosh.

THE MYSTERY OF BLACK COHOSH

There is one particular phytomedicine (a plant extract used as medicine) that even modern medical science must acknowledge holds a special place in supporting women's health. That plant is called black cohosh.

Black cohosh is one of the natural medicines I recommend that will enable you to participate in your natural make-over without estrogen drugs. You will receive many of the benefits of HRT without any risks. Black cohosh is easily the most popular estrogen alternative in the world today for both menopause and PMS; yet, in spite of widespread use throughout Europe, most women in North America have never even heard of black cohosh.

Known also as squaw root, black snake root, or rattle weed, black cohosh is a North American forest plant that can grow up to eight feet tall. In Eastern woodlands, black cohosh arises from a gnarled, dark root. The entangled foliage rises up into a tall plant bearing feathery, white flowers in graceful spikes. The flowers have a puffy appearance, like clouds. Interestingly enough, black cohosh gets its Latin name (*Cimicifuga racemosa*) from its properties as a bug repellant. *Cimicifuga* comes from *cimex* (a bug) and *fugo* (to drive away). Its

rank smell was used to drive insects away, which gave it the common names of bugwort and bugbane.

In both America and China, black cohosh was considered a remedy for snakebites. It appears to be able to counteract venom in general. Years ago, the medical doctors of the western frontier often used black cohosh for treating rattlesnake bites (but, please, immediately visit a qualified health professional or emergency room in the event of any venomous poisoning incident).

The portion used in healing medicine is the rhizome or root. Native Americans boiled the root and women drank the resulting beverage to relieve menstrual problems and aid childbirth. (Hence the name squaw root.) In 1743, it was recommended for use to induce uterine contractions. Its first official botanical description occurred at the end of the 17th Century It was accepted as a medicinal herb in the 18th Century in Linné's *Materia Medica*, where it was recommended for use in cases of joint, muscle, and nerve pain during the menopausal years and in cases of rheumatism.

Probably the strongest characteristic of black cohosh is its antispasmodic action, which has been recognized for centuries. Black cohosh has long been known to help relax all kinds of muscle spasms and cramps throughout the body and muscular and crampy pains in every part of the body. This ability to relieve muscle spasms led to its traditional use for asthma and whooping cough. In both conditions there is a constriction and cramping in the respiratory tract.

The herb was an official "drug" in the U.S. *Pharmacopoeia* from 1820 to 1926. Some have called black cohosh nature's "repeller of darkness."

Energetics of Black Cohosh—A Traditional Perspective

Before modern medical science, we would have examined black cohosh from an energetic or homeopathic perspective. Indeed, the traditional energetic understanding sheds new light on the physical indications for black cohosh.

One interesting property of black cohosh is its anodyne (pain-relieving) action. It contains a chemical called anemonin that safely and mildly depresses the central nervous system, thereby reducing sensations of pain. Native Americans used black cohosh for neuralgia. It has also been traditionally used for ovarian and uterine pain, contractions during childbirth, and breast pain. It was also used for uniquely female complaints. The herb's antispasmodic action is wonderful for relieving menstrual cramps and even helps prepare the uterus for childbirth. In fact, women who are pregnant and who wish to minimize their need for an epidural or other drugs during childbirth may want to talk about the use of this herb with their medical doctor—as much of the pain in

childbirth is due to the inability of the muscles to relax and allow the pelvic floor to open up. Both men and women might be interested in knowing that, since black cohosh dilates the muscles in the blood vessels, the plant helps reduce high blood pressure.

The herb reduces nerve and muscle pain and is useful for pain in both rheumatoid and osteoarthritis. This pain-relieving action is assisted by an anti-inflammatory effect, as the plant also contains salicylate (a natural form of aspirin found in plants like white willow, meadowsweet, and wintergreen). Although not clinically validated, some herbalists find the plant effective for people with tinnitus (ringing in the ears).

Another reason my patients like black cohosh so much is that the plant is an effective anti-depressant. Specifically, it works for the kind of depression that feels almost as if a "black cloud" hangs over the person. This depression is often brought on by disappointment in love or failure in business, says an expert. In women, it is often related to a fear of death during pregnancy or after childbirth. There is a feeling that the head and the heart are weighted down. It has also been used to treat hysteria, fears of impending evil or death, and dreams of impending evil.

Black cohosh has the wonderful and valuable power to give a person confidence to go through "black" states of mind and rise above them (as signified by the root and flowers), says author Steven Horne of the Tree of Light Institute. People who need black cohosh often feel entangled and entrapped in their lives, giving them a feeling of gloom or dark despair, he adds. "In women, this sometimes arises from a pattern of abusive relationships."

These plant "signatures" help us relate to the personality and hence, the medicinal power of this plant, continues Horne. "The gnarled, black root suggests the dark state of mind from which black cohosh helps to lift a person. This plant's personality is clearly useful for people who are plagued by dark, brooding thoughts and depression."

How Black Cohosh Is Thought to Work—A Modern Perspective

Modern research on black cohosh goes back to 1932, when an experimental study revealed its strong effect on circulation and respiration.[11] In 1944, further experimental studies demonstrated that black cohosh stimulated ovarian function and normalized irregularities of the menstrual cycle. The weight of the ovaries and quantity of the corpus lutea (yellowish structures that develop in the ovary on the site where an ovum or egg is released and that secrete progesterone if fertilization occurs) clearly increased. This showed that black cohosh's traditional folk usage definitely had a basis in science.

The LH Connection

For some time, it was thought that black cohosh exerted its effect via pituitary gland regulation.[12] The pituitary is a tiny pea-sized gland in the center of the brain that secretes several hormones, including luteinizing hormone (LH), which regulates women's estrogen and progesterone production.

As women enter their menopausal years and the ovaries' estrogen production naturally decreases, the pituitary gland continues to produce very high levels of LH in an effort to jump-start the ovaries back into estrogen production. The whole thing becomes an endocrinological mess. High levels of LH in the blood are associated with menopausal symptoms, including hot flashes, night sweats, headaches, heart palpitations, and drying and thinning of the vagina.[13] Fortunately, the chemicals in black cohosh seem to beneficially moderate the body's secretion of LH, normalizing the pituitary-gonadal axis—in other words, helping to create hormonal harmony.

We now know that plants, like many other biological creations, contain sex hormones. (I'll talk more about plant-based sex hormones in the diet chapter.) Plant-based hormones are fascinating to scientists because many of them seem to have very beneficial effects on women's health without the detrimental damaging toxicity of medical estrogen. Research shows black cohosh also contains plant-based hormones called isoflavones that bind to estrogen receptor sites on estrogen-sensitive tissues in the body (such as breast and vaginal tissues) because they have a similar molecular shape to estrogen. This is another way black cohosh seems to work.

However, to call this plant a "natural estrogen" and leave it at that is to do a great disservice to both the plant and to the most proven and unique form of the plant found in the standardized black cohosh formulas that I generally recommend. That's because the estrogenic effect of the black cohosh in standardized extracts is very weak compared to other sources of plant estrogens (such as soy). It certainly does not have the same pure overall estrogenic (or toxic powers) as medical estrogen, so it is misleading to call it that.

Black cohosh's phytoestrogen constituents, if they are to be compared with estrogens at all, have effects like those of estriol, which is thought to be the least carcinogenic and safest kind of estrogen and "not associated with increased risk of breast, ovarian or endometrial cancers," according to herbal expert Varro Tyler, dean emeritus of the Purdue University School of Pharmacy and Pharmacal Sciences.[14]

In any event, black cohosh's "medicine power" goes way beyond a simple estrogenic effect. We're still not entirely sure how it works, but we know it does. We know from scientific studies and our patients that for all of the challenges women face, black cohosh works great for relieving painful periods (premen-

strual syndrome as well as irregular or absent menstrual periods) and for women in midlife who desire to extend their younger years.

The Science Behind Black Cohosh

If you're seeking a youth pill with true hope and scientific validation that can substitute safely and effectively for HRT, you'll want to try black cohosh. Investigations of black cohosh have been carried out on thousands of women patients in clinical settings. It is from the sheer number of published studies, and from the women who have successfully used black cohosh, that we know it's reliable. It is important to remember that not all black cohosh supplements are the same. I recommend a standardized extract of black cohosh from your health food store.

Therapy with a standardized extract of black cohosh has proven successful for alleviating all acute menopausal complaints. Hot flashes, mood swings, and depression can all be lessened. I also like the effect it has on vaginal tissues. Vaginal dryness and atrophy can be countered using black cohosh and, if needed, natural progesterone or other lotions, without complications associated with estrogen drugs or synthetic progestins.

How the Black Cohosh Clinical Studies Were Done

When studies on natural or synthetic agents for acute menopausal relief are undertaken, results must be measured both psychologically and physically. What's more, measurements are best done from a variety of perspectives. That's why scientists use questionnaires that involve not only doctors' attitudes about the healing agent but also those of patients. The studies on the standardized extract of black cohosh are no different. Let's look at some of the standardized questionnaires that were used.

Kupperman's Menopausal Index. In many of the studies, women's profiles of menopausal ailments have been quantitatively recorded through the use of Kupperman's Menopausal Index.[15] This is a weighted index, which means the survey assigns more significance to the more bothersome and acute menopausal complaints, such as hot flashes, than it does to what are generally considered milder symptoms. The Kupperman Index is based subjectively on symptoms including hot flashes, chills, dizziness, insomnia, tinnitus, fatigue, sweating, nausea, diarrhea, and constipation.

Hamilton Anxiety Scale. The Hamilton Anxiety Scale is recorded by the doctor and helps to assess anxiety states. It takes into consideration both psychological feelings and those that are manifested physically.[16]

Self-Assessment Depression Scale. The Self-Assessment Depression Scale (SDS) is filled out by patients. This scale evaluates 20 criteria related to depression, which are weighted according to the frequency of their occurrence. It is helpful to researchers to detect and then analyze depressive moods. Because the scale is designed to come up with trends or quantity results, it is very useful to researchers who desire to compare one treatment to another.

Profile of Mood States. The Profile of Mood States (POMS) is a self-evaluation scale for patients. It provides a "mood profile" that measures one's strength of motivation as well as weariness, depression, and ill-humor.

Now let's look at the studies.

Study #1

The first study on a standardized extract of black cohosh that we will examine was conducted in 1982 and was carried out by 131 general practitioners among 629 female patients. Some of the women had been receiving other therapies, including HRT and mood-altering drugs; some were receiving no medical treatment.[17] All were seeking help for their menopausal symptoms.

Fortunately, there was good news almost immediately. Only four weeks into the study, the women who received the black cohosh extract showed clear improvement in their menopausal ailments. Indeed, 80 percent of the women improved within the first four weeks. After six to eight weeks, some patients experienced a complete disappearance of symptoms.

There was no discontinuation of therapy with black cohosh extract—unlike as often happens with HRT. The following table from the 1982 study illustrates how well the formula worked.

Therapeutic Success with Standardized Extract of Black Cohosh			
	Symptoms Gone	*Improved*	*Overall Benefit*
Hot flashes	43.3%	43.3%	86.6%
Profuse Perspiration	49.0%	38.6%	88.5%
Headache	45.7%	36.2%	81.9%
Vertigo	51.6%	35.2%	86.8%
Heart Palpitation	54.6%	35.8%	90.4%
Ringing in Ears	54.8%	36.1%	92.9%
Nervousness/Irritability	42.4%	43.2%	85.6%
Sleep Disturbance	46.1%	30.7%	76.8%
Depressed Moods	46.0%	36.5%	82.5%
Source: Stolze, H: *Gyne*, 1982; 1: 14-16			

Studies #2 and #3

Another type of patient is one for whom HRT is simply contraindicated or who refuses it. She might have a history of breast cancer, have active breast cancer, or be at higher than normal risk. Or it may be that the breast cancer issue is not so troubling, but that the patient simply feels "out of sorts" while using HRT.

The next two studies, carried out in gynecological practices, followed women who had either refused hormone therapy or were suffering from health conditions that contraindicated hormone therapy, such as active breast or other reproductive cancers or a history of such cancers.[18, 19]

Again, results came quickly. The doctors noted clear improvement in their patients' menopausal ailments within four weeks with black cohosh therapy. The women experienced an overall decrease in complaints such as hot flashes, as well as marked improvement in psychological symptoms including decreases in weariness, despondency, and ill-humor and increases in motivation and mood. In other words, they were being not only physically but also emotionally rejuvenated with this simple, natural pill.

Study #4: Sex, Black Cohosh, and Vaginal Rejuvenation

Each year, more than one million women in America enter their menopausal years. As menopause approaches, ovarian production of sex hormones—estrogen, progesterone, and androgens—decreases. The declining estrogen levels associated with menopause may cause vaginal dryness. When estrogen levels drop, vaginal tissues produce less lubrication. Without adequate lubrication, sexual intercourse can become uncomfortable, even painful. In addition, the walls of the vagina may lose their elasticity as fibrous connective tissue replaces muscle cells. The biochemical environment of the vagina becomes less acidic, leading to a shift in flora. Because of the diminished blood flow, vaginal lubrication is slower and less copious.

Fifty-two percent of the women who experience sexual difficulties after menopause say they address their symptoms with treatments such as HRT, over-the-counter lubricants, and prescription vaginal creams. While HRT and over-the-counter lubricants help raise estrogen levels or relieve symptoms, a standardized extract of black cohosh also can address the underlying cause of vaginal dryness at menopause—without the risks of uterine, breast, or ovarian cancer, bleeding, or clotting associated with long-term use of HRT. Natural healing pathways can also help restore vaginal pH to normal levels and increase resistance to vaginal infections. Black cohosh extract safely stimulates vaginal rejuvenation without risk of cancer. It's especially

beneficial if you begin using it just prior to menopause and continue throughout menopause.

In 1985, results were published from a 12-week comparative study on 60 female patients in a gynecological practice.[20] The women were treated either with a standardized extract of black cohosh, hormones, or diazepams (mood-altering drugs such as Valium). Providing clear evidence that black cohosh can counter vaginal atrophy, physical improvements with black cohosh or hormone therapy included a positive estrogen-like effect on the vaginal tissues, especially the mucosa, creating greater lubrication. All three forms of therapy had comparatively beneficial influences on menopausal symptoms.

Study #5: Black Cohosh vs. Estrogen

How would black cohosh extract do in head-to-head competition against estrogen drugs? In 1987, results were published from a randomized, double-blind study carried out on 80 female patients in a gynecological practice. The women were given either black cohosh, conjugated estrogens, or a placebo.[21] With black cohosh, there was a notable increase in the degree of proliferation of the vaginal tissues; after 12 weeks of therapy there was significant improvement of other acute symptoms in comparison to estrogen and the placebo. Conjugated estrogens only slightly influenced the vaginal epithelium. After 12 weeks of black cohosh therapy, menopausal ailments required no further treatment.

Study #6: Black Cohosh vs. Testosterone

In *The Hormone of Desire: The Truth About Sexuality, Menopause, and Testosterone*, psychiatrist Susan Rako writes that women lose much of their testosterone, as well as estrogen, at menopause. She argues that very low testosterone levels interfere with women's sex drive. Julian Whitaker, M.D., maintains that women given small amounts of testosterone exude a glowing sexuality.

Many experts say prescribing testosterone for women is untested. Although there is currently "a big sell going on for testosterone," there are no long-term studies to back up its use, cautions Dr. Wulf Utian of the University Hospitals of Cleveland.

In spite of the enthusiasm among both doctors and patients, there are few long-term clinical safety studies; one study reported a 60 percent increased breast cancer risk.[22] As women—particularly those who are obese—convert testosterone to estrogen, higher circulating testosterone levels will cause greater increases in estrogen. A high testosterone level in women strongly predicts elevated breast cancer risk.[23]

Further evidence comes from the Nelson Institute of Environmental Medicine and Kaplan Comprehensive Cancer Center, New York University School of Medicine; in this study, elevated testosterone levels showed suggestive evidence of increasing women's breast cancer risk by as much as 270 percent.[24] "These results," say the researchers, "are consistent with the hypothesis that testosterone has an indirect effect on breast cancer risk, via its influence on the amount of bioavailable estrogen."

This is a little-studied combination whose long-term effects could produce undesirable carcinogenic activity in a limited number of women. Fortunately, such combinations may not be necessary. In 1987, a study was carried out in a gynecological clinic over the course of six months with 50 female patients with notable menopausal symptoms.[25] The idea of this study was to convert these women from a six-month hormone injection regimen consisting of both estrogen and androgens (such as testosterone) to a treatment using a standardized black cohosh extract. A clear improvement of the menopausal symptoms was observed after 12 weeks with the black cohosh therapy with a significant reduction in the Kupperman Index. Some 56 percent of patients with black cohosh required no additional hormone injections. Some 82 percent of patients reported the success of the therapy as "good" or "very good." Further hormone treatment was necessary in only 18 percent of patients.

Use It or Lose It

One study of women between the ages of 50 and 67 found that those women who had intercourse at least 3 times a month had less vaginal atrophy than did those who had intercourse fewer than 10 times a year. A second study has also reported that weekly intercourse is associated with less vaginal atrophy.

Study #7: Black Cohosh Helps Surgically Induced Menopause

Sometimes, menopause is surgically induced, often as a result of partial or complete hysterectomy. In 1988, a randomized therapeutic study was published that had been carried out on 60 female patients under 40 years of age in a university gynecological clinic over the course of six months.[26] These women had undergone surgical menopause. Group one received a standardized extract of black cohosh; group two, estriol; group three, conjugated estrogens and group four, an estrogen-progestin combination. All forms of therapy helped women to experience improvements of symptoms common in women who undergo surgically induced menopause. There was a significant decline in the

modified Kupperman's Menopausal Index. There was no significant therapeutic difference between the individual medication groups. The black cohosh patients experienced clear improvement of post-operative ovarian functional deficits after hysterectomy in young women and equally good therapeutic success in comparison to treatment with estriol, conjugated estrogens, or an estrogen-progestin combination.

Study #8

In 1991, an open, controlled comparative study was published that had been carried out on 110 patients in a university gynecological clinic over the course of two months.[27] Luteinizing hormone (LH) serum concentrations were measured. High levels of LH cause hot flashes and other menopausal symptoms. There was significant LH suppression with black cohosh extract in comparison to the placebo group.

For Depression

For women with mild depression, look for a formula that contains black cohosh extract *plus* standardized St. John's wort. Black cohosh provides nutritional support for women's healthy reproductive cycles. St. John's wort provides support for emotional well-being. This is especially important for women at midlife because we now recognize that, as estrogen levels decrease, neurotransmitter levels may also be affected. An imbalance of neurotransmitters such as serotonin is associated with depression.

Again, there is preliminary clinical validation. In a study involving 886 women, researchers discovered that black cohosh plus St. John's wort was effective for women who were suffering not only hot flashes and mood swings but also depression.[28]

Complete Safety

The Journal of Women's Health notes that standardized extract of black cohosh is a safe and effective natural agent that may be used by women with active reproductive cancer or a history of breast, uterine, or other reproductive cancers. In fact, the monograph regarding black cohosh prepared by the German Federal Health Office includes no contraindications or limitations of use in tumor patients.[29] Because of its assured complete safety, the Health Office recommends black cohosh for relieving menopausal symptoms in all women, including those women with a history of or active breast, uterine or ovarian cancer.

The *Journal of the Society of Obstetricians and Gynecologists of Canada* compiled a comprehensive report on menopause and osteoporosis in its November and December 1998 issues. In its review of complementary approaches, the organization concluded that black cohosh is a "useful alternative" to estrogen drugs for menopause. This article, along with the medical society's complete collection of articles, was approved for distribution to the Canadian Consensus Conference on Menopause and Osteoporosis, which defines the standard of care for menopausal women in Canada and assists women and their caregivers in making informed choices to promote health and prevent disease.

The estrogen drugs and their derivatives bring about different biological activities in various target organ tissues. If black cohosh is to be compared to estrogen, it should be the weakest form, estriol. The proliferative activity of estriol on the uterine tissues is very weak compared to estrogen drugs derived from estradiol.[30] Due to its weak estrogen potency, estriol possesses only a short dwelling time on the estrogen receptor. Tissues, such as tumors, do not react or react only minimally to estriol, as they require a longer-lasting binding of an estrogen molecule to the receptor for their proliferation.

Experimental studies on standardized black cohosh extract indicate no conspicuous changes in female reproductive tissue even with very high doses for six to eight months. Thus, this herb is considered safe for use by all women.

MORE PHYTOMEDICINE HELP
FOR EASING MENOPAUSAL SYMPTOMS

A phytoestrogen is a hormonal compound found in plants (*phyto* being the Greek root of the word plant). Plant extracts with estrogenic properties have long been used as folk remedies for treating menopausal symptoms.[31, 32, 33, 34]

Dioscorides observed, "Fennel herb itself is of the force to draw down milk, as doth the seed being drunk [and] it expels the menstrua."

More than 40 years ago, researchers from the Massachusetts College of Pharmacy in Boston, writing in the *Journal of the American Pharmaceutical Association*, noted, "Licorice root was found to contain an estrogenic hormone in appreciable quantity."[35]

The *Journal of Ethnopharmacology* in 1980 noted:

"Fennel, *Foeniculum vulgare*, and anise, *Pimpinella anisum*, are plants that have been used as estrogenic agents for millenia. Specifically, they have been reputed to increase milk secretion, promote menstruation, facilitate birth, and increase libido."

Even as late as 1916, *The National Standard Dispensatory* noted that an infusion of fennel can be "given to increase the lacteal secretion, and to establish the menstrual flow."[36]

Phytoestrogens can have a balancing effect on women's hormone levels. Phytoestrogens are capable of exerting estrogenic effects when necessary, yet can also be helpful in reducing overall estrogen levels by inducing production of sex hormone binding globulin (SHBG) and competing with more powerful, toxic forms of estrogen for receptors on estrogen-sensitive tissues.[37]

Phytoestrogens discussed in this section are capable of helping the body adapt to estrogen excesses or deficiencies. If estrogen levels are low, since phytoestrogens have some estrogenic activity, they will cause an increase in estrogen's effect; if estrogen levels are high, since phytoestrogens bind to estrogen receptor binding sites, thereby competing with estrogen, there will be a decrease in estrogen's effects.

Because of the balancing act of phytoestrogens, it is common to find the same plant recommended for conditions of estrogen excess (such as with premenstrual syndrome) as well as conditions of estrogen deficiency (such as menopause). In addition to their mild estrogenic effects, several of these plants—most notably dong quai—exert a natural effect on the vascular system that is extremely useful in reducing both the frequency and intensity of hot flashes and night sweats.

It is also possible that phytoestrogens, present in fiber-rich foods such as grains and beans and like those discussed below, "may be protective with regard to estrogen dependent and perhaps other types of cancer," note researchers in the *Journal of Steroid Biochemistry*.[38]

These phytoestrogen-rich plants have traditionally been used by women:

Angelica sinensis **(dong quai).** Dong quai has a long-standing tradition in Asia as a remedy especially suited to women. Dong quai has been used in conditions such as dysmenorrhea (painful menstruation), amenorrhea (absence of menstruation), and menopausal symptoms (especially hot flashes), as well as to assure a healthy pregnancy and easy delivery. The pharmacology of dong quai is related to its high coumarin content. Some of the pharmacological activities demonstrated include estrogenic activity, analgesic activity, cardiovascular effects, smooth muscle relaxing effects, anti-allergy and immunomodulating activity, and antibacterial activity. Japanese angelica has demonstrated uterine tonic activity, causing an initial increase in uterine contraction followed by relaxation.[39] Administering Japanese *Angelica sinensis* to mice resulted in an increase of uterine weight, an increase of the DNA con-

tent of the uterus and liver, and an increase of glucose utilization by the liver and uterus. Because of these and other effects, angelica has been reported as a uterine tonic.[40, 41]

Gamma-Oryzanol. Gamma-oryzanol is a naturally occurring component of rice bran oil. Japanese researchers have found gamma-oryzanol to be effective in the treatment of menopausal symptoms, amenorrhea, and certain ovarian disorders.[42, 43, 44, 45] Y. Murase and co-investigators studied the effects of gamma-oryzanol on menopausal and postmenopausal women. They found that a daily dose of 20 milligrams per day (mg/day), given orally for 38 days, produced a decrease of 50 percent or more in the Kupperman Menopausal Index in 67 percent of women, with an effective rate of 75 percent for post-menopausal subjects.[46] Even more significant results were reported by researchers using higher dosages. M. Ishihara reported in the *Oceanic Journal of Obstetrics and Gynecology* in 1984 that dosages of 300 mg/day for eight days resulted in an 85 percent improvement in the Kupperman Menopausal Index along with decreased levels of blood lipids (cholesterol, triglycerides) in patients with hyperlipedemia.[47]

Other phytoestrogen-rich herbs to look for in a women's support formula include soy, red clover, fennel and licorice root. A formula with these herbs and the others already mentioned can truly help women who need a gentle, safe estrogen boost.

Quick Tip: Tofu Salad Eases Menopausal Problems

In Japan, where tofu is a dietary staple, only about 16 percent of women experience menopausal problems. An easy way to put more tofu into your diet? Toss some into your next salad.

NUTRIENTS TO HELP ALLEVIATE ACUTE MENOPAUSAL SYMPTOMS

Vitamin E

Vitamin E is another important supplement for women who are going through menopause. Dr. Rita S. Finkler tested vitamin E therapy in 66 selected and controlled patients who complained of the characteristic symptoms of menopause. Good to excellent results were obtained in 31 women, and fair results in 16. In 19 patients the treatment was ineffectual. When the vitamin E preparation was discontinued, symptoms reoccurred. When vitamin E was reinstituted, symptoms ceased. Dr. Finkler wrote of a 48-year-old married

woman complaining of hot flashes, sweats, and headaches that had continued for 4 years, 8 to 10 times daily. The woman was placed on vitamin E therapy, 10 milligrams daily. Dr. Finkler observed:

"Within a week the patient reported improvement in the severity and decrease in the frequency of the symptoms. When the medication was increased to 20 milligrams t.i.d. [three times per day], there was a complete disappearance of her hot flashes and sweats. After five weeks of vitamin E therapy, it was decided to substitute placebo medication in order to evaluate the role which psychogenic influence might have played. There was a prompt recurrence of her original complaints within a week. Re-institution of vitamin E therapy once again caused a subsidence of the complaints."

Dr. Finkler substituted placebo medication for the vitamin E preparation in 17 patients who had obtained good results from vitamin E therapy. "All had a recurrence of symptoms and relief ensued when vitamin E was reinstituted." She concluded that, "Vitamin E is a valuable aid in the treatment of menopausal patients in whom estrogens are contraindicated."

Meanwhile, J. Christy, M.D., gave vitamin E to 25 patients ranging in age from 22 to 55 years. Of these 25 women, 1 suffered from symptoms of natural menopause, 5 from surgical and irradiation menopause, and 19 from radiation-induced menopause. Dr. Christy noted in the *American Journal of Obstetrics and Gynecology*:

"First reports of experimental use of this drug were astonishing. The entire group of cases responded to the treatment and showed either complete relief or very marked improvement with less frequency and less severity of the hot flashes and drenching perspiration and a definite change for the better in their mood and outlook... A great reduction in the number of hot flashes per day was evident promptly upon taking the prescribed medication, and the patient's general condition greatly improved.... The relief of symptoms in patients after administration of vitamin E could not be distinguished from that obtained with the natural or synthetic estrogens. In some cases vitamin E seems more effective in relieving the symptoms of vasomotor instability than estrogens."[48]

In January 1950, Nadina R. Kavinoky, M.D., wrote in the *Annals of Western Medicine and Surgery*:

"Vitamin E is undoubtedly effective in treating climacteric [menopause] and some associated symptoms.... There are several reasons for welcoming a harmless remedy which has no toxic effects and which does not have the tissue growth-stimulating effect of the estrogens."[49]

Boron

Often overlooked by the medical community, boron has shown promise of being a key element for women who are at risk for menopausal symptoms and osteoporosis. In a study of 12 women between the ages of 48 and 82, the effects of magnesium and boron were studied for major mineral metabolism; women who supplemented their diets with 3 milligrams of boron daily had markedly reduced losses of calcium and magnesium, report Forrest H. Nielsen of the U.S. Department of Agriculture's Human Nutrition Research Center in Grand Forks, North Dakota, and co-investigators. Moreover, for women with menopausal symptoms, boron supplementation markedly elevated the serum concentrations of 17β-estradiol and testosterone. Indeed, several of the women in the study who took supplemental boron had the same levels of 17β-estradiol in their serum as the women in the study who were on estrogen therapy.[50] "The elevation seemed more marked when dietary magnesium was low," note Nielsen and co-investigators in the *FASEB Journal*.[51] The investigators further note:

> "The findings suggest that supplementation of a low-boron diet with an amount
> of boron commonly found in diets high in fruits and vegetables induces changes
> in postmenopausal women consistent with the prevention of calcium loss and
> bone demineralization."[52]

It is important to note that while boron may raise blood levels of estradiol, this does not suggest it poses the same risk as supplemental estrogen therapy. The carcinogenic effect of estrogen therapy is dose related. Most orally administered estrogen is converted to estrone rather than the more desirable estradiol; therefore, large amounts of estrogen must be given to achieve clinically useful serum levels of estradiol. Thus, boron appears capable of producing an estrogenic effect without exposing the body to dangerously high amounts of estrogen.

Boron also participates in reactions that may help the body produce estriol, a weak estrogen with documented anti-cancer activity. Increasing estriol levels as a proportion of the total estrogens may reduce the incidence of certain types of cancer, including breast cancer. If boron does indeed increase estriol production, then it might actually help prevent breast cancer.

In addition, boron is needed for vitamin D to convert to its most active form within the kidney.[53] And vitamin D, we now know, is essential for super, natural bone health.

Dr. McBarron's Prescription for
A SMOOTH MIDLIFE TRANSITION

My first choice for my patients is black cohosh. Having been used in Germany since 1956, we now know its safety record is perfect. Because black cohosh tends to become more effective with long-term use, women need take only one 20 mg tablet in the morning and one in the evening. Be sure your black cohosh product is standardized. Physical symptoms indicating a need for black cohosh include hot flashes, night sweats, headaches, heart palpitations, and vaginal atrophy. Psychological indications include depression, anxiety, nervousness, sleep disturbances, and decreased libido.

I'm not alone in my support for black cohosh. Many other medical doctors also prefer the black cohosh extract over estrogen for their patients.

Among leading U.S. health care professionals now recommending black cohosh extract are author and Yale-trained psychiatrist, Harold H. Bloomfield, M.D., and Varro Tyler, Ph.D., Sc.D., Dean Emeritus of the Purdue University School of Pharmacy and Pharmacal Sciences. I can also name a whole contingent of medical doctors who strongly endorse black cohosh for their women patients. "I have found black cohosh to be of great value in the treatment of menopausal symptoms, premenopausal symptoms and in delayed menstruation," says Arnold Fox, M.D., who often prescribes it to women in his own anti-aging practice. Not only does black cohosh help to ameliorate the symptoms of menopause, this remarkable standardized extract has good tolerance, no contraindications, no specific side effects, and is proven to pose no risk for breast or other reproductive cancers, making it extremely safe and beneficial for long-term use."

If you need additional help, try supplements containing a combination of dong quai, fennel, licorice root, gamma oryzanol, vitamin E, boron and soy. I'll discuss soy in more detail in our next chapter.

By the way, natural lubricants are also available for relieving vaginal dryness.[54] These include almond, coconut, or vitamin E oil, as well as some water-soluble products. Visit your local health food store for many natural vaginal lubricants.

Taking Care of the Basics: Nature's Most Powerful Bone-Builders

It is important to take care of the basics, and that includes being sure to pay attention to the prevention of osteoporosis, the technical name for bone loss. Osteoporosis is one of the most serious and common diseases faced by women and, to a much lesser extent, by men (whose skeletons tend to be more dense than women's).

As I've said, you simply can't get around the fact that if you're not healthy inside, there's no way you can look great on the outside. And when we're talking about your bones and tendons and even your teeth—basically, your *skeleton*—well, then, taking care of your inner health is even more imperative. I'm talking about the basic structure of your body—the support that helps keep your facial cheeks high, firm, and well formed, that gives shape to your shoulders, keeps your posture straight and energetic, and that vitally enhances your glow of health.

Without healthy bone structure, there's a lot you lose out on. You won't be able to exercise vigorously enough to keep your muscles in shape. And while many women with osteoporosis are fairly thin, sometimes it may be the kind of thin that is accompanied by loss of bodily skeletal mass and muscle tone. Because osteoporosis kind of sneaks up on women, I really do have to be extra vigilant in my practice to sensitize my women patients and work with them to get them to value their inner health—including their skeletal health.

American women hear a lot about osteoporosis, thanks to all the advertising for calcium supplements and the big push to get women on estrogen replacement therapy. Osteoporosis is a very profitable condition for the drug industry. So it has rapidly become a big deal with tremendous money to be made,

sometimes unscrupulously. You need to be a savvy shopper when it comes to your bone health.

Yet, in other areas of the world, amazingly, not everyone has considered bone loss much of a problem for women, even where it should be. Ten years ago, in the United Kingdom and throughout Europe, osteoporosis was not a word that even existed in the vocabulary of the general public.[55] The majority of doctors dismissed osteoporosis as a normal process of aging, affecting only the very elderly, about which nothing could be done. In other parts of the world, such as Japan and some African civilizations, osteoporosis isn't part of the vocabulary, either—but that's because women there don't seem to get the disease. Scientists have long wondered why, and they've come up with some pretty startling theories that may shake the very foundation of your approach to your health. More about them a little later in this chapter.

Of course, many doctors' answer to bone loss is to prescribe HRT. More than likely, when a woman in her late forties or fifties suffering menopausal symptoms consults her doctor, she'll be routinely put on HRT,[56] told to pop a few Tums and eat more dairy products, and be sent home. It's unlikely that a diet of foods rich in bone-building vitamins and minerals will be mentioned. Neither will the importance of exercise. Prescribing HRT or other bone-building drugs of dubious safety is the convenient, quick, standard medical practice, but it's not the whole story for preventing and reversing osteoporosis.

It is not that prescribing HRT or other such drugs is always bad medicine. Sometimes HRT is the best treatment for some women who are going through menopause and losing bone rapidly or for women whose ovaries have been surgically removed, creating artificially induced menopause. And many perfectly healthy women with very low risk factors for breast cancer may want to take advantage of the benefits, too. Still, you can't get around the fact that a healthy diet, rich in a wide range of bone-building nutrients, intelligent use of the proper dietary supplements, and consistent exercise remain the key to long-term skeletal health.

In my time as a physician, I've read and heard a lot about HRT's bone-building benefits—especially from pharmaceutical sales representatives who visit my clinic and attempt to convince me that HRT is the best—and only—way to go for women suffering bone loss. I remain disappointed by the one-sided arguments they make and because they dismiss HRT's risks as trivial, unimportant, or not coming close to matching up to the benefits.

On the other hand, I've also heard many claims for supplements that can build bones. And even though the risk of negative side effects for herbal

products is minimal, beware—there's a lot of hype in the natural products industry, too.

THE STRAIGHT STORY

First of all, HRT definitely can slow bone loss. Its use, however, must be continued throughout your lifetime. A woman at age 76 who discontinues HRT is at about as much risk for a broken hip or fractured vertebrae as a woman who never used HRT in the first place. So, it works—but are the benefits worth the risks? Should one make a lifetime commitment that increases risk for uterine and breast cancer, blood clotting, liver disease, and other very real side effects?

OSTEOPOROSIS IMPLICATIONS

Also known as "brittle-bone disease," osteoporosis causes loss of bone mass and flexibility. This deterioration in skeletal health, if left unchecked, can result in hip fractures, disfiguration, and restrictions in physical activity—in all senses diminishing women's quality of life.

The humped-back profiles of some aging women demonstrate how osteoporosis erodes both health and quality of life. Bone loss in women can begin as early as 35. The loss accelerates in the 8 to 10 years prior to menopause and is especially high immediately after menopause.

As more women today than ever before are living beyond their eighties, osteoporosis has reached epidemic proportions in the United States, afflicting 15 to 20 million Americans, and causing an estimated 1.3 million fractures each year of the vertebrae, hips, forearms, and other bones in women 45 and older. However, it is women in their mid-seventies and older who are most vulnerable.[57, 58] By age 90, one-third of all women will suffer hip fractures. Of those who do, up to 20 percent will die, and many others will require long-term nursing home care.[59] In the United States, hip fractures cost up to $10 billion annually.[60] Fear of fractures, together with the need to treat menopausal symptoms such as hot flashes and mood swings, has created a burgeoning market for HRT. Indeed, one of the most commonly cited reasons for your doctor to prescribe HRT is to combat bone loss.

But HRT isn't the only answer. Fortunately, we now have a number of safe and natural pathways that women can follow with far less risk than the use of estrogen and also with excellent results.

Actually, bone loss is pretty easy to minimize or even prevent—as long as women don't let it get out of hand. I've worked with women of all ages, including those in their eighties and beyond, and I've helped them immensely with proper dietary supplements and regular weight-bearing exercise. Most women can reclaim their skeletal health if they follow my simple and basic program.

Are You At Risk for Osteoporosis?

Complete the following questionnaire to determine your risk for developing osteoporosis. The more times you answer "yes," the greater your risk for developing osteoporosis.

Question	Yes	No
1 Do you have a small, thin frame, or are you Caucasian or Asian?	☐	☐
2. Do you have a family history of osteoporosis?	☐	☐
3. Are you a postmenopausal woman?	☐	☐
4. Have you had an early or surgically induced menopause?	☐	☐
5. Have you been taking excessive thyroid medication or high doses of cortisone-like drugs for asthma, arthritis, or cancer?	☐	☐
6. Is your diet low in dairy products and other sources of calcium?	☐	☐
7. Are you physically inactive?	☐	☐
8. Do you smoke cigarettes or drink in excess?	☐	☐

Used with permission from the National Osteoporosis Foundation

RETURN TO WHOLE FOODS AND HEALTHY LIVING TO STAVE OFF BONE LOSS

Before discussing calcium supplements, let's first discuss other key areas of health to consider: shopping and cooking, diet, exercise, alcohol, smoking, and avoiding use of specific medications that promote bone loss.

Shopping and Cooking for a Healthy Diet

The food choices you make and your cooking methods are important for your health—particularly your skeletal health. The good news is that all of these suggestions will also go a long way toward addressing many other estrogen-related health concerns such as heart disease, beautiful skin and hair, and weight management.

Follow these guidelines to ensure your bones' optimal nutritional support:

Emphasize shopping choices that make up a largely vegetarian diet. You don't have to go completely vegetarian, but tilting your diet in that direction is a good idea. Keep in mind that dietary changes are very easy to make and don't require as much sacrifice as you might think. A vegetarian-style diet, largely if not entirely free of meat, is associated with a significantly lower risk of osteoporosis. [61, 62, 63, 64, 65]

I know you probably think that you need to get as much protein in your diet as possible—but most people eat too much protein. My concern is that some of our typical protein sources such as red meat and fatty dairy can also be loaded with toxic hormones, antibiotics, and pesticide residues—as well as cause bone loss. These toxic chemicals may increase your risk for various cancers, including of the breast and ovary. So I want you to rethink your approach to meeting your protein requirements.

Also, a diet with excessively high amounts of protein can cause the body to lose more calcium than it gains. [66] In the body, after protein is digested, it is broken down into smaller amino acids that pass through the intestinal wall, entering the bloodstream. After they are used by the body, excess protein is transported to the liver and metabolized into urea, a powerful diuretic. Urea and amino acids enter the kidney and cause not only loss of water but minerals, including calcium.

This is clearly shown in studies of various ethnic groups where a higher average protein intake is correlated with higher rates of osteoporosis. Eskimo women typically consume a diet made up largely of fish and other marine protein sources. They also take in a huge amount of calcium, probably greater than 2,000 mg daily, yet they have very high rates of osteoporosis. The women of the Bantu tribes of the central Africa eat a very low-protein diet and their calcium intake is only about 300 mg a day, but osteoporosis is rare, even in the very old. Japanese women who eat a traditional diet with similarly low protein and calcium intakes rarely suffer osteoporosis. [67]

The benefits of a largely vegetarian diet, with limited servings of dairy and fish, may not appear when women are in their thirties or forties. However, these advantages become quite apparent as women enter their fifties and beyond. As my colleague Carolyn DeMarco, M.D., notes, "This ties in with the statistic that the average measurable bone loss of female meat-eaters at age 65 is 35 percent; versus the average measurable bone loss of female vegetarians at age 65 at 18 percent. In any case, if you cut down on red meat and excessive dairy products and move toward a low fat diet of fresh fruits, vegetables, and whole grains, you

will also be following current recommendations for the prevention of both heart disease and cancer. And if you are eating a low protein vegetable diet you will need a lot less calcium in your diet." [68] So it's important to think of your diet not only for what it will do for you now but how it will help down the road as well.

Make sure your shopping choices include soy foods. Soy foods are rich in estrogen-like compounds (i.e., phytoestrogens). Asian women, whose traditional diets are rich in soy foods, suffer few of the menopausal symptoms that plague Western women; they are also at lower risk for osteoporosis-related fractures. Tofu hot dogs, luncheon meats, cheeses, and even plain tofu are all readily available and easy to prepare. Even hard-core meat eaters often find soy-based foods quite tasty. Soy foods can also be rich in calcium and magnesium, two key bone-building nutrients.

Shop for organically grown produce and grains. A 1993 study by Bob Smith in the *Journal of Applied Nutrition* reports that organically grown fresh produce and grains are significantly higher in bone-building elements such as boron, calcium, magnesium, silicon, and zinc than conventionally grown foods. Organically grown foods are available from health food stores and supermarkets, from farmer's markets, by mail, and at many chain grocery stores.

Buy whole grain products; avoid "enriched" grain products. Enriched, highly processed grain products have lost much of their original minerals, including important major minerals such as magnesium and trace minerals like boron and silica. Be sure to purchase only whole grain products made with organic flour. Read labels to be sure. Such products are widely available at health food stores and supermarkets and by mail.

Limit dairy products. Dairy intake is controversial when it comes to osteoporosis. We know from some studies that a diet rich in dairy products can positively impact bone mass and reduce the incidence of hip fractures, as well as promote increased bone density. Other researchers counter that, despite their high calcium content, the high-protein content of dairy products results in calcium losses that offset the gains.

In the February, 1985 *American Journal of Clinical Nutrition*, researchers divided 22 healthy postmenopausal women into two groups; one group of 13 received 24 ounces of milk per day, and the other group of nine did not. At the end of one year, in spite of the heavy milk consumption, differences in bone mineral content of the forearm and wrist thickness between the two groups were not significant. The researchers concluded, "The protein content of the milk supplement may have had a negative effect on calcium balance, possibly through an increase in kidney losses of calcium..." The researchers suggested

that if women are going to eat dairy products, they should eliminate other rich sources of protein. I recommend that if women are going to eat dairy products, they reduce their consumption of beef, chicken, lamb, and other protein-rich (calcium-poor) foods.

I usually try to take a middle-ground, as I feel that organic dairy products can be an important contributor to overall health for many people. Non-organically produced dairy foods frankly frighten me because of the very high levels of a growth factor called Insulin-like Growth Factor One, which can stimulate latent tumors into full-blown cancers. Non-organic dairy products contain high levels of this growth factor because non-organic dairy farmers inject their cows with bovine growth hormone (or if they do not, their milk is being mixed with supplies from other farmers who do). I don't like turning animals into bio-machines, and I don't like it when my women patients are placed at higher risk for breast cancer due to use of this genetically engineered drug. If you want to learn more about dairy dangers and your health, read *The Breast Cancer Prevention Bible* (Macmillan 1998) or *The Safe Shopper's Bible* (Macmillan 1995). These books really blow the lid off the dairy industry and make a great case for why consumers are better off selecting only dairy products from organically raised animals.

Moreover, women should consume nonfat organic dairy products. Some of the dairy products I do like my patients to consume include organic nonfat yogurt and organic nonfat milk.

Try to keep dairy to no more than three servings a day, and definitely reduce your intake of meat.

Steam or bake your vegetables. Boiling vegetables reduces mineral and vitamin content more than any other method of cooking. Studies have shown that as much as 75 percent of minerals are lost when vegetables are boiled unless you drink the water you boiled them in. As for vitamins, vigorous boiling has been shown to reduce by 84 percent the folic acid content of cauliflower, 69 percent of broccoli, 65 percent of spinach, 57 percent of cabbage, 28 percent of Brussels sprouts, and 22 percent of asparagus.

The ideal way to cook vegetables is to steam them or briefly stir-fry them in a Chinese-style wok. Or, better yet, munch some of your vegetables raw. Storing vegetables at room temperature also reduces the content of some vitamins. Refrigeration helps preserve the vitamin content of vegetables.

Limit sugar. Excess intake of table sugar and sweets causes calcium loss.

Limit soft drinks. Phosphoric acid in soft drinks leaches calcium from the bones. This is very important! I see a lot of patients who are literally addicted

to soft drinks, and I worry about them. Not only am I concerned about their bone loss, I am also concerned about the high levels of chlorine-based chemicals in soft drinks that are known to cause bladder and rectal cancer. I think that women who drink too many soft drinks are placing themselves at an unnecessarily high risk for bladder cancer.

Limit caffeine. Caffeine causes calcium loss as well as general bone mineral deficiencies. A cup or two of coffee a day (at most) is okay, but drinking more coffee than that means a potential bone-loss problem. I also worry that my patients who are heavy coffee-drinkers will lose their B-complex vitamins, vitamin C, and many other vital nutrients.

VERY IMPORTANT TIP:
USE BONE-BUILDING SUPPLEMENTS

I mentioned that my patients usually have to crawl before they can walk and then take baby steps before they can run when it comes to use of dietary supplements. I don't like rushing them. I want them to move at their own pace—as long as they keep moving in the right direction. But, eventually, I also want my patients to add to their basic multiple vitamin and mineral formulas a calcium supplement that is oriented toward bone-building.

Taking supplements requires a little more commitment, since it means swallowing four to eight capsules or tablets daily. In the long run, though, it's really worth it. It just takes some getting used to.

There are several brands that are good and many that are not. Osteoprotect by Vitologic is the one I take and recommend most often. It is available at your health food store or from the Institute for Healthy Living (see Resources). What makes a calcium supplement good is not simply how many milligrams of calcium it has but how the calcium is supported with additional nutrients. Please read on.

Calcium supplements

Bones require a constant course of calcium in order to prevent loss of mass and for ongoing rebuilding.[69] Eighty percent of women consume less than the recommended dietary allowance (RDA) for calcium.[70] Starting early in life and getting enough calcium at all ages is essential.[71] Physically active college students who have a high calcium intake have significantly higher bone density than less active peers with lower intake. Many health professionals recommend that postmenopausal women supplement with up to 1,500 milligrams of calcium daily.

Research shows not all calcium sources are recognized and equally utilized by the body. Calcium citrate and calcium hydroxyapetitate appear to fortify bones better than oyster shell or other calcium sources. Tums is not a good source of calcium. Stomach acid must be present in order for calcium to be absorbed. Antacids such as Tums may actually block calcium absorption and do not prevent osteoporosis.

CALCIUM ALONE NOT ENOUGH

Healthy bone metabolism is dependent on an intricate interplay of many nutritional and hormonal factors. When women think of osteoporosis and dietary supplements, the common perception is that calcium supplementation is all that is required to prevent the progression of osteoporosis. Unfortunately, this belief can give women who only take calcium supplements a false sense of security, so they overlook other important dietary and lifestyle modifications that are equally important. There is no question that calcium deficiency can cause osteoporosis, yet skeletal calcium depletion is present in only about 25 percent of osteoporotic women. It is important for women to recognize that although calcium supplementation in doses of 1,000 mg to 1,500 mg per day plays an important role in preventing and treating bone loss, calcium supplementation alone is not enough. Be sure to get these additional nutrients:

Vitamin D

Vitamin D stimulates the proper absorption of calcium. Vitamin D can be produced in our bodies by the action of sunlight on 7-dehydrocholesterol in the skin if the liver and kidneys are functioning properly. Women with disorders of the liver or kidneys may suffer from low levels of the body's most potent form of vitamin D.[72, 73] If sufficient amounts of calcium are consumed but vitamin D is inadequate, the calcium cannot be effectively utilized for bone formation.

Vitamin D has been shown in several human studies to help to prevent fractures in the elderly, often in combination with calcium.[74, 75] Supplementation is recommended, particularly among people in northern latitudes where there is less sunlight. Most recently, we have seen that women can markedly enhance the benefits of calcium by taking vitamin D, too. In a study published in the *New England Journal of Medicine*, Dr. Bess Dawson-Hughes gave volunteers either 500 mg of calcium plus 700 IU of vitamin D3 (cholecarciferol) per day or a placebo of sugar pills.[76] Of the 37 volunteers who had experienced non-vertebral fractures (fractures of bones other than those in the spine), 26 were in the placebo group and 11 were in the calcium-vitamin D group. The conclu-

sion was that "dietary supplementation with calcium and vitamin D moderately reduced bone loss... and reduced the incidence of nonvertebral fractures."

Levels of vitamin D in American women decrease by about 50 percent in the course of a lifetime. One would expect to see little change in the blood content of vitamin D in older people in the United States because our foods are so heavily fortified with vitamin D. However, a study of a group of Americans demonstrated a 45 percent reduction in vitamin D levels in healthy elderly subjects as compared with younger people. The reduction was significant enough to contribute to the decline in calcium absorption with age.[77]

Vitamin D is required for intestinal absorption of calcium. Reduced plasma levels of vitamin D are common in elderly individuals, especially women. Factors that lower vitamin D levels in the elderly include reduced exposure to sunlight, decreased dietary intake, and malabsorption. Fortunately, now that we know this, women at risk for osteoporosis can be sure their calcium supplement also contains vitamin D.

Magnesium

Only 25 percent of women meet the RDA for magnesium. An Israeli study found that supplemental magnesium can lead to bone density increases of up to eight percent; women in the study who did not take supplemental magnesium lost bone.[78] Magnesium deficiency is widespread in the United States. "According to the U.S. Department of Agriculture's food-consumption survey, only 25 percent of all Americans meet the recommended dietary allowance (RDA) for magnesium. An alarming 39 percent consume less than 70 percent of the RDA, indicating that magnesium is a 'problem nutrient.'"[79] In fact, because of the low-calorie, low-complex-carbohydrate diets presently consumed by people, "the amount of magnesium in the typical American diet has dropped drastically—from an average of 475 mg per person in 1900 to 245 mg today."[80] As for women, at least 78 percent of them are getting less than 100 percent of the RDA.[81]

This mineral is key in reducing menopausal and PSM symptoms, as well as risk for osteoporosis and heart disease. Magnesium participates in many biochemical reactions that take place in the bone, and is almost as important as calcium supplementation. Individuals with osteoporosis have lower magnesium content than people without osteoporosis, as well as other indicators of magnesium deficiency.[82] Magnesium also plays a role in converting vitamin D to its active forms.[83]

Some of our most popular foods that are richest in magnesium include wheat germ, tofu, dried beans, bulgur wheat, pumpkin, watermelon, sunflower and squash seeds, whole wheat flour, fish, nuts, peanut butter, cereals, green veg-

etables (e.g., spinach), and dried apricots.[84] See the box below for the overall top magnesium-rich foods.

Top Dietary Sources of Magnesium Per Common Measure[85]		
Food	*Common Measure*	*Mg Magnesium*
Pumpkin and squash seeds	1 oz	152
Watermelon seeds	1 oz	146
Bean curd (tofu)	1/2 c	94
Wheat germ	1 oz	91
Bran, unprocessed	1/4 c	87
Snails (escargots), cooked	1 oz	85
Spinach, fresh, cooked	1/2 c	79
Chard, Swiss, fresh, cooked	1/2 c	76
Clams, canned	1/2 c	65
Clams, raw	3 oz	55
Navy bean sprouts, raw	1/2 c	53
Beet greens, fresh, cooked	1/2 c	49
Artichoke, cooked	1 med	47
Broccoli, fresh, cooked	1/2 c	47
Okra, fresh, cooked	1/2 c	46
Amaranth, cooked	1/2 c	36

Vitamin C

Vitamin C deficiency is associated with osteoporosis.[86] The elderly are particularly likely to be deficient. Researchers from the Center for Health Studies, Group Health Cooperative of Puget Sound, Seattle, Washington, examined the relationship between dietary and supplemental vitamin C and hip bone mineral density (BMD) in postmenopausal women in the Seattle area.[87] Some 1,892 women ages 55 to 80 years were screened for hip bone thickness and other osteoporosis risk factor information. For women 55 to 64 years old, long-term use of vitamin C was associated with higher BMD in women who had not used estrogen replacement therapy. What's more, when these women used vitamin C supplements for 10 years or longer, they also had a higher BMD than non-users.

Boron

Women taking boron in one study lost 40 percent less calcium, 33 percent less magnesium and less phosphorous. Boron also helps boost women's estrogen levels (see Chapter 2).

Manganese

Manganese is required for bone mineralization and for the synthesis of connective tissue in cartilage and bone. The optimal intake of manganese is not known, but at least half of the manganese in a typical diet is lost when whole grains are replaced by refined flours. Rodents fed a manganese-deficient diet had smaller, less dense bones with less resistance to fractures than those fed adequate amounts of manganese. Many humans may also be sensitive to a marginal or severe deficiency of manganese.

Silicon

In recent years, silicon's recognition as an essential trace element for connective tissue in bone and cartilage has been noted. Silicon is found in high concentration at calcification sites in growing bone. This mineral appears to strengthen the connective tissue matrix by cross-linking collagen strands. Animals fed a silicon-deficient diet developed gross skull abnormalities and had thin leg bones with evidence of impaired calcification. Silicon also has shown suggestive evidence of counteracting the deleterious effects of aluminum, which has been implicated as a factor in both osteoporosis and possibly Alzheimer's disease.[88, 89]

It is not known whether the typical American diet provides adequate amounts of silicon. As with other nutrients, a deficiency could result from over-consumption of refined foods. In patients with osteoporosis, where accelerated bone regeneration is desirable, silicon requirements may be increased and supplementation needed.

Inulin

Derived from Jerusalem artichoke fiber, inulin has extensive documented historical human use through the consumption of edible plants and fruits. The Aztecs consumed inulin via the dahlia plant. South American Indian cultures consumed artichokes, which are rich sources of inulin; in fact, for millennia, native peoples of Central and South Americans consumed 50 to 100 grams per day. The Japanese have historically consumed inulin-rich foods such as the yacon plant. Australian aborigines of the nineteenth century consumed a whopping 200 to 300 grams of inulin per day with the murnong plant. In sixteenth century Western Europe, people consumed 35 grams per day through Jerusalem artichokes, Belgian endive (chicory greens), roasted chicory roots, and as a coffee substitute. Today, however, the average daily intake of inulin the American diet is only about 2.6 grams, which is too bad, since we are missing out on a truly health-promoting miracle of nature.[90]

One of the major benefits of adding inulin to one's diet is enhanced mineral absorption. We often think of fiber and the compounds associated with fiber (e.g., phytates) as reducing the absorption of minerals such as calcium, magnesium, zinc, and manganese. But inulin is a *soluble* fiber and the effect of soluble fiber on mineral absorption is extremely beneficial. The addition of soluble forms of fiber such as inulin, pectins and gum, has been found to add viscosity to the gut contents, and promote fermentation and production of volatile fatty acids in the cecum (where the large intestine begins). "Thus," notes J.L. Greger of the Nutritional Sciences Department, University of Wisconsin-Madison, "it is not surprising that the addition of soluble forms of fibers to diets often has been found to improve absorption of minerals."[91]

In an experimental study from Showa University, Tokyo, calcium absorption was significantly greater with inulin added to the diet.[92] And, researchers have reported at the World Congress of Pediatric Gastroenterology and Nutrition that teenaged girls will absorb more calcium in their diet if they supplement with inulin.[93] The two-month crossover study of 28 girls, aged 11 to 14 years, found that those drinking calcium-fortified orange juice and supplementing with inulin absorbed 18 percent more calcium. This could greatly increase bone mass later in life, the researchers said. The inulin product I recommend is called Inuflora™ from Naturally Vitamins. Studies show that this proprietary extract is the most biologically active form of inulin. (See Resources.)

Flax & Borage Oil

There is growing evidence that the essential fatty acids contained in flax and borage oil are super bone protectors. Indeed, what seems to happen, at least in some cases of osteoporosis, is that the body's stores of calcium become deposited in other tissues and organs besides the bones, especially the kidneys and arteries, causing kidney disease and, most commonly, arteriosclerosis (or coronary artery disease). Essential fatty acids in flax and borage oil seem to be able to correct this tendency of the aging body to store calcium in all the wrong places.

Thus, the interaction between essential fatty acids and calcium metabolism deserves further investigation since it may offer novel approaches to not only the prevention of osteoporosis but also helping to prevent calcification of other vital organs, which is associated with osteoporosis, and which seems to be responsible for so many related deaths such as those from kidney disease and coronary artery blockages.

Interest in essential fatty acids and osteoporosis stems from recent research showing essential fatty acid-deficient animals develop severe osteoporosis cou-

pled with increased deposits of calcium in the kidneys and arteries, thereby indicating that the body's metabolism of this vital mineral is impaired.

"This picture is similar to that seen in osteoporosis in the elderly, where the loss of bone calcium is associated with ectopic calcification of other tissues, particularly the arteries and the kidneys," note Drs. M.C. Kruger and D.F. Horrobin, of the Department of Physiology, University of Pretoria, South Africa.[94]

Indeed, such undesirable calcium deposits may portend another way that essential fatty acids aid women's health. Recent mortality studies indicate that undesired calcification of bodily tissues may be considerably more dangerous than the osteoporosis itself, since the great majority of excess deaths in women with osteoporosis are vascular (i.e., blood clots) and unrelated to fractures or other bone abnormalities.

Drs. Kruger and Horrobin note that essential fatty acids "have now been shown to increase calcium absorption from the gut, in part by enhancing the effects of vitamin D, to reduce urinary excretion of calcium, to increase calcium deposition in bone and improve bone strength and to enhance the synthesis of bone collagen."

> *Be sure to sprinkle some flaxseed and inulin on your yogurt.*
> *Flaxseed can also be used for baking.*

IPRIFLAVONE—AN IMPORTANT BONE-BUILDING SUPPLEMENT

Medical science has shown a supplement called ipriflavone is both highly effective at helping build and maintain bone mass and very safe. Ipriflavone is a synthesized isoflavone that appears to occur naturally in bee propolis.[95]

Ipriflavone has been used in Europe and Japan and is proven to enhance the benefits women derive from calcium. With ipriflavone, results appear to exceed those of HRT for preventing osteoporosis. I recommend ipriflavone for women who are at higher than normal risk for bone loss. For example, I have several patients whose doctors detected rapid bone loss. The doctors recommended HRT, but my patients opted for ipriflavone and are doing very well.

Ipriflavone resembles estrogen and, according to clinical trials with post-menopausal women, causes women's bodies to rebuild significant amounts of bone (like estrogen)—but without detrimental classical "estrogenic" effects such as stimulating breast or uterine tissue growth.

Ipriflavone stimulates bone-building or what is technically known as osteoblast activity.[96] Ipriflavone's ability to reduce bone loss without a cancer-causing effect is what researchers find most intriguing, as drug estrogens also inhibit bone-degrading (osteoclast activity) but have cancer-related complications.[97] Ipriflavone is even more important when we consider that while low doses of estrogens (0.3 mg/day of conjugated estrogens) can counteract acute menopausal symptoms, higher doses, which carry greater cancer risks (0.625 mg/day), are required to prevent bone loss in postmenopausal women. What's more, estrogen drugs must be taken for a lifetime, or the protective effect is almost completely lost. This also increases estrogen-related cancer risks.

Studies show ipriflavone works effectively in combination with calcium and as an adjunct to estrogen therapies (for women who wish to continue with estrogen but want to reduce their dosage).

One study involved 198 postmenopausal women (aged 50 to 65 years) with vertebral (back bone) bone density below normal who were enrolled in six Italian centers. About 134 of the women completed 2 years of treatment with ipriflavone.[98]

Each woman received either ipriflavone (200 mg, 3 times daily) or a matching placebo. All of the women received an oral daily supplement of 1,000 mg of calcium carbonate. (It's not the type of calcium I recommend, as it is *the* most difficult for the body to absorb.) Vertebral bone density and markers of bone loss were measured at the beginning of the study and every six months. A complete routine analysis of liver and kidney functions, along with blood tests, were also performed before and at the end of the study.

Women using ipriflavone experienced a significant increase in vertebral bone density of 1.4 percent on average after one year, and another 1 percent at the end of the treatment period. The placebo group suffered a significant *decrease* after two years of treatment. Adverse reactions, mainly gastrointestinal, occurred to a similar extent in the two groups. "This study demonstrates that ipriflavone can prevent bone loss in postmenopausal women with low bone mass," concluded the researchers.

Two additional multi-center, double-blind, placebo-controlled, two-year studies were carried out to evaluate the ability of ipriflavone to slow bone loss or rebuild bone in postmenopausal women with low bone mass.[99] Some 453 women (aged 50 to 65 years) with a vertebral or radial (wrist) mineral density value that was significantly lower than normal were randomly selected to receive oral ipriflavone (200 mg, three times daily) or a matching placebo, plus 1,000 mg of calcium daily.

In both studies, women using ipriflavone experienced stable bone mass. In the placebo group, bone mineral density was significantly decreased. The final outcome was a bone-sparing effect of 1.6 percent in one study and 3.5 percent in the other after two years among women using ipriflavone. "The results of these studies show that ipriflavone is able to prevent... bone loss in post-menopausal women with low bone mass, and is well tolerated," concluded the researchers.

In another study, researchers studied whether oral administration of ipriflavone could prevent bone loss occurring shortly after menopause. This is important, as the time around menopause is the most critical period for intensive bone loss, and failing to address bone loss within five years of menopause may cause significant damage to women's skeletal health.

Fifty-six women with low vertebral bone density and with postmenopausal age less than 5 years were randomly allocated to receive either ipriflavone (200 mg, three times per day), or a placebo.[100] Again, all of the women received 1,000 mg elemental calcium daily.

Vertebral bone density declined after two years in women taking only calcium but did not change in those receiving ipriflavone. "Ipriflavone prevents the rapid bone loss following early menopause," concluded the researchers. "This effect is associated with a reduction of bone turnover rate."

Many more studies show ipriflavone is a premiere bone-builder that works as well as estrogen therapy.[101, 102, 103, 104] What these studies show us is that ipriflavone works extremely well in building bone and reducing risk of fracture. Ipriflavone can replace a potentially toxic drug like estrogen to reduce osteoporosis. Its bone-building capabilities are equivalent to, if not greater than, those of estrogen. What's more, if you choose to use estrogen, ipriflavone can enhance the benefits of estrogen and reduce your estrogen dosage, making the drug safer.

To date, 2,769 patients have been treated with ipriflavone (the trade name is Ostivone™) for a total of 3,132 patient/years in 60 clinical studies performed in Italy, Japan, and Hungary and reviewed for long-term safety assessment. The incidence of adverse reactions in ipriflavone-treated patients (14.5 percent) was similar to that observed in subjects receiving the placebo (16.1 percent). Side effects were mainly gastrointestinal.

Ipriflavone, however, may temporarily inhibit certain liver detoxification pathways, resulting in abnormally high blood concentrations of some drugs, including theophylline (an asthma drug).[105, 106] Be sure to work with a qualified health professional when using ipriflavone if you are taking any other over-the-counter or prescription medications.

EXERCISE

Exercise is critically important for bone health. Women who vigorously engage in weight-bearing exercises such as running, walking, and weightlifting have more bone mass in their hips and spine, increased muscle mass, and better strength and balance. Water calisthenics, especially for women with osteoporosis or arthritis, is a good way to ease into exercise. Even wading provides resistance that helps offset bone loss. An overall improvement in muscular and skeletal health helps prevent fractures.

Parents and young adults should know that very active female college freshmen who exercised at least 4 hours a week had 17 percent more bone density than their less active peers.[107] Exercising at all ages helps to provide lifelong protection against breast cancer too. One of the overall best activities for women is weight-bearing exercise. In the December 1994, issue of *Journal of the American Medical Association*, Tufts University and Pennsylvania State University researchers reported on the impact of high-intensity strength training on 40 postmenopausal women from 50 to 70 years of age; none of these women were using estrogen, exercising regularly, or suffering from osteoporosis. The women were divided into 2 groups. One group used exercise machines for 45 minutes for 2 days a week for a year to strengthen their hips, knees, backs, and abdomens. The other group did not exercise. One year later, the women who engaged in the high-intensity exercises exhibited an increase in bone density in the area of their hips and spine. This is an important finding, as these areas of women's bodies are most vulnerable to osteoporosis-related fractures. The women who did not exercise lost bone density. The women who exercised also demonstrated increases in muscle mass, muscle strength, and balance, improvements that help prevent falls. In this sense, the study demonstrated that exercise may be even more effective than estrogen. While estrogen will certainly help women retain bone density, exercise not only builds bone density but increases muscle mass, strength and balance; estrogen does not affect any of these other areas of health and lasting beauty. What's more, exercise helps to reduce risk for both heart disease and cancer.

By the way, I'd rather have you exercise ten minutes every day than sixty minutes once a week. In other words, small periods of exercise done consistently are better than simply pouring it *all* into one exercise period and then basically laying dormant from muscle soreness and aches and pains for the rest of the week. Ten minutes a day to start is great—even if it is only walking. I'll talk a lot more about the best exercise programs later.

SMOKING

Not smoking is as important a factor in the prevention of bone loss as diet and exercise.[108] Smoking inhibits bone repair, depletes valuable nutrients, and causes bone loss.[109]

In the February 9, 1994 *New England Journal of Medicine*, researchers studied 41 pairs of female twins and discovered that smoking plays a huge role in bone loss. In fact, smoking two or more packs daily resulted in nine percent greater bone loss in the spine of the twin who smoked than in the twin who did not. That loss of bone mass translates into a nearly 44 percent greater risk for fracture. The number of pack-a-day smokers in the United States has doubled in the past two decades. We can expect even more smoking-related fractures in the years to come. Smoking is highly hazardous at all ages. Don't smoke. Smoking causes hollow bones.

ALCOHOL

Alcohol consumption in excess of two drinks a day results in the destruction of bone cells and increases the risks of falling and fractures.[110, 111, 112, 113] Women who drink two to three beers or more than four drinks of hard liquor daily experience a risk of hip fractures two to seven times greater than non-drinkers. Autopsies of alcoholics have revealed that their bones are extremely demineralized and they appear far older than their chronological age at time of death.

DRUGS TO AVOID

Avoid aluminum-containing antacids. Excess amounts may interfere with the body's ability to use other bone-building nutrients.[114] Avoid or restrict your intake of prescription and over-the-counter (OTC) medicines that increase bone loss, including indomethacin, ibuprofen, and other non-steroidal anti-inflammatory drugs (NSAIDs).[115, 116] Other drugs known to deplete calcium include anticonvulsant medications (eg. Dilantin), cholesterol lowering agents (eg. Cholestyramine), corticosteroids (e.g., Prednisone), furosemide (water pill), high dose thyroid medication (e.g., Synthroid), and certain antibiotics, including tetracycline.[117]

Dr. McBarron's Prescription for
HEALTHY BONES

❖ Be sure to watch your diet. Consume plentiful amounts of bone-building foods. Your diet should include soy-based foods, seafood such as salmon, green leafy vegetables, nonfat organic yogurt, and smaller servings of naturally raised meats. (See my list of great foods *below*.)

❖ Avoid taking just a calcium supplement. Take a complete bone-building formula daily. In severe cases, these formulas can be complemented with ipriflavone.

❖ Exercise. Just get out and move. At least 10 to 20 minutes a day is important.

❖ Clean living is very important. Avoid smoking. Limit your intake of alcohol.

❖ If you must take medications that can dissolve your bones, then be sure to take additional calcium.

Foods for Prevention and Treatment of Osteoporosis

Nutrient	Benefit	Source
Minerals		
Calcium	Vital in formation of strong, dense bones. Proven to slow bone loss in postmenopausal women.	Almonds, Bok choi, Broccoli, Canned mackerel, salmon and sardines (with bones), Cheese (low-fat, nonfat), Collards, Filberts, Kale, Milk (low-fat, nonfat), Okra, Tofu, Turnip Greens, Yogurt (low-fat, nonfat)[118]
Magnesium	More than half of all magnesium in the body is found in the bones.[119] Many bone-building processes in the body involving calcium also depend on adequate intake of magnesium.	Amaranth, Artichokes, Beet Greens, Black Beans, Broccoli, Bulgur Wheat, Cereals, Dried Apricots, Dried Beans, Filberts, Green Vegetables, Okra, Peanut Butter, Seeds (pumpkin, squash, sunflower, watermelon), Snails (escargot), Spinach, Swiss Chard, Tofu, Wheat Bran, Wheat Germ, White Beans, Whole Wheat Flour[120]
Boron	Improves calcium absorption and helps postmenopausal women maintain optimal levels of estrogen. Activates formation of vitamin D.	Kelp, Leafy Vegetables, Fruits, Nuts, Whole Grains

Nutrient	Benefit	Source
Copper	Adequate amounts help prevent spontaneous bone fractures.[121] Helps in the formation of collagen for bone and connective tissue. Nearly 20 percent of the body's copper is found in the skeleton, and a deficiency can result in bone demineralization.[122]	Crabmeat, Dark Green Leafy Vegetables, Dried Beans and Peas, Lobster, Nuts, Oysters, Vegetables (fresh), Whole Grain Cereals and Breads, Yeast (dried)[123, 124]
Silica	Necessary for bone and connective tissue formation and calcium absorption. Contained in connective tissue. Strengthens collagen. Necessary for maximum activity of several enzymes involved in bone and collagen synthesis.[125, 126]	Alfalfa, Beets, Bell Peppers, Brown Rice, Leafy Green Vegetables, Rice Bran, Soybeans, Unrefined Whole Grains[127]
Zinc	Necessary for collagen formation and for the body to use calcium.	Bran (unprocessed), Brazil Nuts, Crabmeat, Dry Beans, Lentils, Mussels, Nonfat Dry Milk, Oysters, Pecans, Peanut Butter, Pine nuts, Seeds (pumpkin, sunflower, squash, and watermelon), Spinach, Squid, Turkey (dark meat), Wheat Germ, Whole Grain Cereals[128]

Nutrient	Benefit	Source
Vitamins		
D	Essential for the body to process calcium and phosphorous and is especially important for normal bone and tooth formation in children.[129]	Fortified Cereals (e.g.,Product 19 40% Bran Flakes), Eggs, Milk (vitamin D-fortified; low-fat, nonfat), Sunshine (stimulates body to produce vitamin D)
B_6, B_{12}, Folic Acid	Together, these 3 vitamins are able to reduce homocysteine concentrations in the blood; elevated levels of homocysteine are thought to play a role in osteoporosis by interfering with collagen cross-linking, leading to a defective bone matrix.[130]	*Vitamin B_6:* Bamboo, Bananas, Carrots, Potato Skin (boiled/baked), Salmon (smoked), Sauerkraut (canned), Spinach, Tuna,Turkey, Watermelon *Vitamin B_{12}:* Abalone, Anchovy (canned), Clams (including canned clam chowder), Crabmeat, Rabbit, Salmon (canned), Sardines (canned), Squid (calamari) *Folic acid:* Artichoke, Asparagus, Beets, Broccoli, Bulgur, Collards, Mustard Greens, Okra, Red Kidney Beans, Spinach, Turnip Greens, White Beans
C	Essential for healthy collagen and connective tissue. Helps the body utilize calcium.[131]	Apple Juice, Blackberries, Broccoli, Brussels Sprouts, Cantaloupe, Cauliflower, Cabbage, Cherries, Grapefruit Juice, Green and Red Peppers, Guavas, Kale, Kiwi Fruit, Oranges, Orange Juice, Papayas, Peas, Potatoes, Strawberries, Tangerines, Tomatoes
Plant Chemicals		
Flavonoids	Helpful in stabilizing collagen, the major protein structure in bone.	Blackberries, Blueberries, Cherries, Hawthorn Berries, Raspberries
Phyto-estrogens	High consumption correlated with low risk for osteoporosis and fewer menopausal symptoms.	Beans, Miso, Textured Vegetable Protein, Tofu

Women and Heart Disease

I recently attended a medical conference sponsored by a well-known pharmaceutical company hyping its latest innovation in estrogen replacement therapy. A group of doctors discussing women's health all agreed that breast cancer is a devastating women's disease. They also said that, as health professionals, it was important to remember that hundreds of thousands of women die each year from heart disease and stroke; among some age groups, this is ten times the number of those who die from breast cancer. So the upshot of their discussion was that they must keep pumping estrogen drugs in the name of saving lives. That was how they justified the use of HRT. Needless to say, I think that this is a terrible justification and flawed rationale for the use of HRT.

One thing we all agreed on at that conference was that it's a myth women need not be concerned about heart disease. The only major difference in heart disease risk between men and women is that premenopausal women have a lower risk because they are protected by estrogen. However, by age 65, women's risks are the same as men's. And, unfortunately, it's a fact that women sometimes get far less medical help for their heart disease than men.

One in two women die of heart disease.[132] It is this fact that often leads doctors to prescribe estrogen. Because estrogen is somewhat protective against heart disease, it is a very useful drug with very real benefits. For every woman who might lose her life to HRT-related breast cancer, some 10 may be spared death from heart attack or stroke.[133] Deaths from breast, ovarian, and uterine cancers do not come close to matching those from heart disease. From age 50 to 94, the cumulative risk of death from heart disease is about 31 percent, versus only about 3 percent for breast cancer.[134] This is a persuasive argument for estrogen.

A recent study provides further strong evidence that long-term use of estrogen protects against the major cardiovascular killers and thus significantly increases life expectancy. "Postmenopausal women on HRT have a reduction of about 40 to 50 percent in the risk of...heart disease as compared with women who do not receive such therapy."[135] Over 14 studies have confirmed the decreased risk of coronary disease among estrogen users.[136] Indeed, estrogen has been called the "key player" in women's reduced risk of heart disease. "The overall benefit of long-term estrogen use is large and positive."[137, 138]

Okay, that's the good news. The not-so-good news is that "a slightly higher rate of breast cancer deaths" was admitted among estrogen users.[139]

What's more, many experts are now no longer convinced HRT's well-documented benefits for reducing heart disease justify its risks for breast and other cancers. In 1995, the authors of the Harvard Nurses' Health Study concluded:

> "The substantial increase in the risk of breast cancer among older women who take hormones suggests that the trade-offs between risks and benefits should be carefully assessed.... These findings suggest that women over 55 years of age should carefully consider the risks and benefits of estrogen therapy, especially if they have used estrogen for 5 or more years."[140]

And most recently, researchers reporting in 2001 in the *Journal of the American Medical Association* note that findings from the Heart and Estrogen/Progestin Replacement Study suggest that, among women with clinically recognized heart disease (including high blood pressure), hormone replacement therapy may be associated with early harm and late benefit in terms of coronary events.

A further word of caution: This argument does not justify use of estrogen-progestin combinations. There is convincing evidence that estrogen-progestin combinations are less protective of the heart than estrogen administered alone.[141] They provide less, if any, heart disease risk reduction benefit, and may even be more harmful than beneficial.[142, 143]

Researchers state in *The New England Journal of Medicine*:

> If the addition of progestin reverses even 5 to 10 percent of the relative benefit of estrogen-replacement therapy with regard to. . . heart disease, its net effect as compared with unopposed estrogen therapy [without progestin] would probably be detrimental..."[144]

So I truly believe that my women patients will benefit greatly from looking at their heart and circulatory health in a whole new way, and that's what I want to show you in the rest of this chapter.

What is Heart Disease?

Heart disease is a term used to identify several disorders that result in inadequate circulation of blood to the heart. Heart disease most often results from narrowing of the coronary arteries, a process called atherosclerosis. This causes a buildup of debris on the lining of the vessels, increasing risk for angina, heart attack, and stroke. While one of the leading causes of death in postmenopausal women, heart disease is also one of the most preventable—one that lends itself very nicely to intervention with a healthy diet and intelligent use of quality natural medicines.

THE HEART SMART ACTION PLAN

I am convinced that when it comes to heart disease, the news is very good. Heart disease can be reversed with a combination of diet, attention to lifestyle and mind-body interaction, and smart use of select dietary supplements. To reduce your risk for a heart attack or the need for surgery or medical drugs:

Eat a healthy diet. Your first line of defense must always be a healthy diet. Researchers note in the January 5, 1991 *Lancet*, "Many populations consume very low amounts of fresh fruits and green vegetables, and therefore have very low levels of antioxidants, suggesting that they should supplement their diets with more cereals, oil rich in vitamin E, vegetables, and fruit."[145] Just about every public health expert agrees that one's first line of defense must be whole foods, especially plenty of fruits, vegetables, and grains.[146]

Consider the Mediterranean Diet, based on the traditional diets of people who live in the Mediterranean region. Imagine an inverted pyramid. At the top (the widest part) are fresh fruits and vegetables. Then there are whole grains, rich in many heart-protective nutrients. Next is seafood, then occasional servings of meat and dairy at the bottom.[147] Limit beef, lamb, and poultry to three to four ounces a day, and choose lean cuts. Use low-fat cooking techniques such as grilling, broiling, baking, steaming, and poaching. Sauté with olive or canola oil sprays, broth, or fruit juice. Limit your intake of butter, full-fat cheeses, and egg yolks. For salad dressings, prefer flax recipes.

Eat cholesterol-lowering foods. Beans are an often-overlooked food when it comes to improving cholesterol. From black beans, chickpeas, and lentils to navy beans and pinto beans, eating beans can markedly help reduce cholesterol levels. Beans can reduce LDL (low-density lipoproteins, called "bad" cholesterol) within about three weeks (experts recommend one cup of beans a day). They also will increase HDL (high-density lipoproteins, called "good" cholesterol).

Raw onion is excellent for boosting HDL. Cardiologist Victor Gurewich of the Harvard Medical School notes that eating about half a raw onion a day has been shown to boost HDL by as much as 30 percent. Onions lose their HDL-boosting punch the more they are cooked, so eat them raw whenever possible (e.g., in sandwiches or salads).

Foods rich in soluble fiber, such as apples, bananas, citrus, carrots, barley, oats, and rice bran, are also effective for lowering cholesterol. Soluble fibers lower cholesterol by binding the cholesterol and bile acids in the intestine and promoting their excretion.

Avoid trans fatty acids found in typical margarines and other processed foods. Read labels. If the label says the product contains partially hydrogenated oils, this product contains trans fatty acids, which have been linked with increased risk of heart attack.[148] Supermarket bakery products are likely to contain these fats.

Avoid polyunsaturated oils. Avoid corn, sunflower, and safflower oils, which contain polyunsaturated fats that can increase oxidation of the body's bad cholesterol. Again, prefer flax, olive or canola oil whenever possible. Walnut oil is a better choice, too. By the way, vegetable oils can also be very bad for your skin, especially when they are used for frying, since they raise the body's overall levels of inflammation.

Exercise. Exercise is highly protective against heart disease, particularly because it reduces your risk for obesity.

Lose weight. Obesity, even being 10 percent over your ideal body weight, is a significant risk factor for heart disease. Lose weight through exercise and proper diet.

Stop smoking. Just quit. Use the natural supplements or go through a behavioral modification or detox program, but quit.

Limit sodium. Choose sodium-free or low-sodium products; some people are sensitive to sodium, which can raise blood pressure.

BASIC HEART HEALTHY NUTRIENTS

Vitamin E

I recommend that every one of my patients over age 25 take 400 to 800 International Units (IU) of natural vitamin E daily. This single vitamin plays a vital role in reducing risk of a heart attack or stroke.

Your doctor may or may not tell you about how important vitamin E is to your health. Observes one health writer, "Last November, a speaker stood up

before an audience of scientists and physicians at a conference on antioxidant vitamins. 'How many of you take vitamin E?' he asked. Half the audience raised their hands. 'And how many of you tell your patients to take it?' The hands came down."

Much of the medical community's current interest is focused on vitamin E's role in the prevention of coronary heart disease (CHD). It is no wonder. Almost one-half of all deaths in the United States are heart disease-related and more than 1.25 million heart attacks occur annually, two-thirds among men.[149] There are also some one-half million strokes annually.[150] It is clear that a relatively nontoxic, inexpensive substance, proven to reduce heart disease risk, can play an important role in helping people to stay healthy.

While most people now recognize that high blood levels of cholesterol are associated with an increased risk of heart attack, the culpable cholesterol substance in the blood appears to be an elevated concentration of low-density lipoproteins (LDLs, the "bad" cholesterol). The body's LDLs are especially vulnerable to becoming damaged in a process called oxidation, caused by highly reactive and ubiquitous molecules called free radicals. Free radicals are produced naturally every time we breathe and metabolize oxygen. Other sources of free radicals include exposure to bacteria, cigarette smoke, viruses, chemical pollutants such as pesticides and industrial chemicals, solar radiation, and even daily stress.

The body's cells are constantly under siege by free radicals. The problem, insofar as heart disease is concerned, occurs when people have too much LDL-type cholesterol, which causes cellular debris to accumulate on the walls of the arteries.[151] There, this debris attracts other substances in the blood, such as white blood cells and circulating immune complexes, causing even greater buildup of cellular debris and additional narrowing. When some of this debris dislodges from an artery, it causes a blood clot, blocking blood flow to the heart. This can cause a heart attack. If the clot is in the carotid arteries, which lead to the brain, a person will suffer a stroke.

Vitamin E appears to reduce CHD risk by acting as an antioxidant, protecting LDL cholesterol from oxidative damage and keeping it from adhering to vessel walls. Vitamin E is also thought to raise levels of HDLs, which are less vulnerable to oxidation, and to help keep the blood "slippery" by inhibiting blood platelets from adhering to arterial walls, thus reducing the chances of arterial blockage and clots.

Several recent large-scale human studies that have examined the role of vitamin E in cardiovascular health offer evidence of a beneficial effect. The

Nurses' Health Study used data from 87,245 women, aged 34 to 59, who were free of heart disease in 1980. After adjusting for age, smoking, obesity, exercise, and other risk factors, nurses who took vitamin E supplements had only two-thirds the risk of heart disease compared to those not taking the supplement. Women taking vitamin E for more than two years had only about half the risk.[152, 153] The vitamin E supplements taken by the subjects provided a greater amount than one could get normally from dietary sources alone. The protective effect was not seen in persons whose only source of vitamin E was from food.

Study co-investigator Meir Stampfer, M.D., of the Harvard School of Public Health told the American Heart Association, "I'm skeptical by nature but I was even more skeptical going into this study. It just didn't seem plausible that a simple maneuver like taking vitamin E would have such a profound effect. So even though there was really a lot of sound scientific basis for the hypothesis that antioxidant vitamins can reduce heart disease, I expected to show that this was not in fact a true association."

While many studies have focused on the benefits of vitamin E supplements and heart disease, other studies have examined the role of whole foods, rich in vitamin E and other nutrients and plant chemicals, on heart disease risk. In 1994, P. Knekt and co-investigators reported in the *American Journal of Epidemiology* that the risk for heart disease was lowered by 32 percent and 65 percent for men and women, respectively, who had the highest intakes of vitamin E compared with those people with the lowest intakes.[154] In a 16-nation European study, men with the highest vitamin E levels were at lowest risk for heart disease-related mortality.[155]

In a study from the University of Tennessee in Memphis, vitamin E emerged as the strongest nutritional factor in stroke prevention. The study involved more than 10,000 men and women, ages 45 to 65, from four states, including Maryland, North Carolina, Mississippi, and Minnesota. Among people over 55, those with the highest dietary intake of vitamin E also had the least thickening of the carotid arteries.[156]

Why We Must Supplement with Vitamin E

The National Research Council's RDA for vitamin E is 12 to 15 IU per day for women and men, respectively.[157] In the United States, the amount of vitamin E supplied by the normal diet is estimated to be about 10 to 13 IU.[158] Thus, most people are not suffering deficiencies as defined by the RDA. However, the research shows benefits seem to accrue with long-term intake of vitamin E in

amounts of about 100 to 800 IU daily or greater. Ensuring an intake of vitamin E equivalent to that amount, without dietary supplements, is virtually impossible.[159] Because vitamin E is a fat soluble nutrient, its richest natural sources are fats, especially vegetable oils, nuts, and, to a lesser extent, whole grains. But 100 grams (slightly less than four ounces) of wheat germ oil daily provides only about 178 IU.[160] Eating the same amount of sunflower seeds would provide only about 74 IU of vitamin E.[161] To put this in perspective, to get 30 IU of vitamin E from spinach, a relatively rich vegetable source, you would need to eat nearly two-and-a-half pounds. To get the same from whole wheat bread, you would need to eat 124 slices.[162] A small apple provides less than one International Unit. A little less than four ounces of fresh asparagus provides fewer than three.[163]

The most dramatic results come from studies where daily intake was closer to at least 400 IU. This amount is not obtainable from food, even if the diet is optimal. That makes a case for supplementation, particularly since virtually no adverse side effects have been associated with daily intake of vitamin E at dosages of 400 to 800 IU.

Natural vs. Synthetic Products

Natural-source vitamin E is isolated from vegetable oils. Synthetic vitamin E is produced from petrochemicals. Natural-source and synthetic vitamin E are not equivalent. Natural-source vitamin E, according to animal studies, has at least 36 percent greater potency than its synthetic counterpart. Moreover, it has been shown that natural source vitamin E tends to be more readily taken up by tissues and lasts longer in the body. These findings suggest that, overall, naturally derived vitamin E is superior.

Natural-source vitamin E is more costly and, in order to lower prices, many manufacturers use the cheaper synthetic vitamin E. To identify the kind of vitamin E in a supplement, it is necessary to read the chemical names in the contents description on the product label. Natural source vitamin E always begins with "d" even though it may have complex-sounding chemical names.[164] The names of synthetically derived vitamin E begin with "dl" and also may be attached to complicated-sounding chemical names. As long as the first 2 letters are "dl," it is synthetically derived. Most health food stores and natural product supermarkets sell quality naturally sourced vitamin E supplements.

Vitamin C

Later on in this book, you'll learn about the wondrous benefits topical vitamin C has for your skin. But, interestingly, the same benefits that accrue to your outer skin also accrue to your inner skin—the lining of your veins and arteries.

Before he died in his mid-nineties, Dr. Linus Pauling discovered a key process in the formation of atherosclerosis. He learned through animal studies that vitamin C (also called ascorbic acid) is essential for helping the body to rebuild collagen, the main component of both the arteries and skin. Experimental animals deprived of vitamin C suffer arterial lesions in high numbers. Dr. Pauling concluded the body needs a constant supply of vitamin C to rebuild itself and prevent damage. By keeping vitamin C levels high all day, Dr. Pauling believed that damage caused to the arteries by oxidation could be both prevented and reversed. Today, medical science has validated Pauling's theories on heart disease. We now know that vitamin C significantly prevents damaged cholesterol from building up in the arteries.

Vitamin C does many things for your blood. It lowers cholesterol and raises the fibrinolytic activity of the blood, which basically means that it helps to keep your blood from clumping and causing blockages and clots. Like aspirin, vitamin C reduces the tendency of platelets to clump or form clotting materials such as fibrin. If you've had a heart attack, high dose vitamin C may be as important as aspirin. But to gain these benefits, you'll need to take more vitamin C than is provided in any multiple vitamin formula.

Medical scientist Judith Hallfrisch evaluated blood cholesterol in relation to vitamin C levels in 316 women and 511 men ranging up to 95 years of age. She reported in 1994 in *The American Journal of Clinical Nutrition* that people with the highest blood levels of vitamin C also had the highest levels of good cholesterol.[165] The results suggest that high blood levels of vitamin C help to reduce risk of clogged arteries and heart disease.

The lesson here is simple: Be sure to take supplemental vitamin C (500 mg to several grams a day). If the acidity of vitamin C is a problem, then be sure to take a neutralized form of vitamin C. Known as Ester-C®, this product is great. Ask your health food store retailer or pharmacist for a product containing Ester-C. No tummy upset at all!

Be sure your vitamin C supplement also contains bioflavanoids, as these are the activators of vitamin C found in nature. Plain vitamin C without the bioflavanoids is much less effective. I recommend and personally take BioC by Vitalogic, available at health food stores and natural product supermarkets.

Another great way to get adequate vitamin C is to drink a few glasses of orange juice daily (unless you are diabetic).[166] Some recent research I have

reviewed shows that orange juice is great for your heart. Drinking several glasses of orange juice daily can significantly increase high–density lipoproteins. Imbibing three cups of orange juice a day can raise HDL levels by up to 21 percent. However, tangerine juice may be even more potent. Its peel is the richest source of HDL-boosting flavonoids. If blood concentrations of sugar are a concern, taking dietary supplements with bioflavonoids can also help.

Folic Acid

In the last few years, scientists have discovered a new and important risk factor for heart disease, osteoporosis, and memory loss, as well as neural tube birth defects and cervical cancer. It is called folic acid deficiency. In some instances, this deficiency causes the body to be unable to properly metabolize the amino acid methionine to cysteine. Instead, an amino acid called homocysteine is formed. When levels of homocysteine become elevated, risk for these maladies is significantly increased. The irony is that homocysteine can be easily controlled without drug therapy through the use of dietary supplements that supply folic acid, together with vitamins B_3 and B_{12}. Many formulas are designed to counter homocysteine levels, but if you take a good quality multiple vitamin and mineral formula that should be enough insurance.

Soy Protein

I mentioned that soy foods can help relieve menopausal hot flashes and aid your body in maintaining strong bones. Well, soy-based foods and supplements are also great for your heart and circulatory health. If you don't believe me, ask the Food and Drug Administration, which recently approved label claims that soy protein can reduce risk of heart disease.

Researchers recently presented the results of a study showing that regular intake of soy protein may help the cardiovascular health of post-menopausal women. The findings of the study, which were presented by Dr. Robert DuBroff and Dr. P. Decker at the 1999 annual meeting of the North American Menopause Society, add to the mounting data supporting the cardiovascular benefits of soy protein with naturally occurring isoflavones.

Drs. DuBroff and Decker, both of Southwest Cardiology Associates, Albuquerque, New Mexico, outlined results of the study of 44 post-menopausal women, which revealed significant improvement in vascular function in women who consumed 40 grams of soy protein daily during the 30 days of the study. "Our research shows that daily consumption of soy protein with naturally occurring isoflavones can result in significant improvement in endothelial

function, an important marker of vascular function," noted Dr. DuBroff. This study is relevant in light of the dramatic increase in the incidence of cardiovascular disease in women following the onset of menopause. The study indicates that soy protein may present a viable, healthy alternative to HRT.

There are lots of good sources of soy protein today. I like some of the soy milks that you can pick up in the dairy section of your local supermarket. Soy cheeses are pretty good for sandwiches, and baked tofu and tofu-based products like hot dogs are also great. You'd be very smart to include a couple of servings of tofu in your daily meal plan.

EUROPEAN DOCTORS' FAVORITE PHYTOMEDICINES FOR HEART HEALTH

If you are have high blood cholesterol, high blood pressure, angina, or other cardiovascular and circulatory problems, you may want to try dietary supplements known as phytomedicines (i.e., plant medicines) proven to help heart and circulatory health, such as garlic and hawthorn, which contain important phytochemicals. Phytochemicals are powerful compounds found in plants. They are neither vitamins nor minerals, yet they are just as powerful. The National Institutes of Health is spending millions of dollars studying phytochemicals because it's believed phytochemicals could aid the search for cures to cancer, heart and circulatory disorders, diabetes, and other major killing diseases. Phytochemicals help the internal workings of your body as well as keep your outer appearance youthful. They can even help you to say *no* to estrogen and other medical drugs!

Fortunately, research has identified select phytochemicals proven to help protect against heart disease by reducing overall cholesterol levels, optimizing the body's balance between good and bad cholesterol, and functioning as antioxidants that reduce oxidation of LDL. Here are some of my favorites:

Garlic
If you suffer from mildly elevated cholesterol levels or high blood pressure, you should know that *Allium sativum* (garlic) has proven to be an effective natural cholesterol and blood pressure-lowering agent. Its active phytonutrients include allicin, diallyl disulfide, and dipropyl disulfide. It lowers cholesterol by inhibiting a liver enzyme involved in cholesterol synthesis. Solid scientific evidence demonstrates that both fresh garlic and fresh garlic supplements are fantastic for heart and circulatory health. Some 20 published human studies have

validated the use of garlic for lowering cholesterol and improving the body's HDL-LDL balance, as well as for reducing blood pressure.

In 1993, scientists at L.T.M. Medical College in Bombay found people taking garlic on a daily basis for two months reduced their cholesterol levels by 15 percent—from an average of 213 milligrams per deciliter (mg/dl) to 180 mg/dl. In 1993, scientists at Bastyr College in Seattle found daily use of garlic reduced cholesterol levels 7 percent in one month and raised beneficial HDL by 23 percent.

A 1994 evaluation by C. Silagy and A. Neil, published in the *Journal of the Royal College of Physicians of London*, analyzed results from 16 earlier trials of garlic involving 952 subjects. This study found the overall cholesterol reduction for all of these trials was 12 percent. The reductions usually became evident within one month of starting use.

A 1998 study of fresh garlic, which looked at 60 patients with coronary artery disease (half of whom were given garlic extract or a placebo), found that garlic supplements significantly lowered total serum cholesterol and triglycerides, while significantly increasing HDL (the "good cholesterol") and fibrinolytic (anti-clotting) activity.[167]

Hawthorn

Hawthorn extract is standard medicine in Europe for persons with heart problems. Both subjective and objective measurements indicate that hawthorn can improve the health of persons with congestive heart failure, including improved pumping action (left ventricular ejection fraction).

Grape Seed

Bioflavonoids are extremely important phytochemicals for people with heart problems because of their outstanding potential for protecting bad (LDL) cholesterol from oxidation damage. Bioflavonoids first aroused scientific interest when it was shown they enhance the body's ability to utilize vitamin C.

Among the most powerful bioflavonoids are those found in grape seed (*Vitis vinifera*). The protective action of bioflavonoids in grape seed was called "remarkable" by R. Maffei Facino and co-investigators in a 1994 report in *Drug Research*. Other reports have found grape seed to be a more potent free radical scavenger than vitamin E. Grape seed also helps to repair the arteries by inhibiting enzymes that attack collagen and elastin, the main structural materials of the arteries. This unique ability to help reverse arterial damage is not found in conventional cholesterol-lowering drugs.

Systemic Oral Enzymes

Systemic oral enzymes are critical to take for heart disease prevention because they do such a good job of reducing the body's overall inflammation levels. When you go to see your doctor next time, have her perform a high-sensitivity C-reactive protein test. It only costs about $50 and it measures the level of inflammation in your body. High-normal or greater levels of inflammation can markedly increase your risk for a heart attack or stroke. I know you probably haven't heard about this heart disease risk factor, but it's very real. "Convincing evidence" has been uncovered that inflammation is strongly linked to heart attacks and stroke, according to Attilio Maseri, M.D., of the Catholic University of the Sacred Heart, Rome, writing in the prestigious medical journal *Circulation*. By curbing excess inflammation, we can literally once again support healthy blood flow in our patients.

Systemic oral enzymes (e.g., Wobenzym® N) can reduce overall inflammation just about as effectively as aspirin, without the stomach irritation.[168, 169] Wobenzym N is a real treasure for women's health, so I'll talk more about its amazing powers later on.

Dr. McBarron's Prescription for
A HEALTHY HEART

No matter what her current state of health, every woman should be taking supplemental amounts of vitamins C and E. Take 400 to 800 IU of vitamin E daily. Take 1 to 2 grams (1,000 to 2,000 mg) of Bio-C three times daily. Consume two to three ounces of organic soy foods daily. It'll do wonders for your bones, your health, your hot flashes, and even your skin and weight! Use the other nutrients detailed in this report, either alone or in combination.

Natural Beauty

Now that we've addressed your inner health,
let's do something about some of those troubling outer problems
we all face at one time or another. There are wonderful
natural pathways for taking care of cellulite, varicose veins, wrinkles,
and even gray hair. Each of these natural, healthy beauty
strategies will contribute to your overall vibrant health.
They're just waiting to be discovered by *you*.

Goodbye, Cellulite

All women who have them hate them—those ripples, dips, and dimples on their thighs, hips, and buttocks. Cellulite can settle in regardless of body weight or fitness level. And you've probably heard the not-so-flattering descriptions—orange-peel skin and cottage-cheese thighs are only two of the self esteem-deflating expressions we women have to live with. Some 85 percent of women have cellulite on their thighs or buttocks. When I was studying in medical school to become a doctor, my professor said, "Cellulite is a layman's term—cellulite doesn't exist." I promptly said, "You've never been to the beach."

On some women, it's barely visible; on others it's very evident. If nothing is done to remedy cellulite, the cells harden, skin begins to lose its elasticity, and the lumps and bumps become more visible. You probably won't concentrate on your cellulite problems until you put on a swimsuit at the beginning of summer or you go into a dressing room, undress, and see the light hit your legs at a different angle.

"A few years ago I overheard some college boys discussing a woman's thighs—the back of her thighs in particular," recalls writer Abbie Jones. "Being somewhat sensitive to the issue, my ears perked up, curious to hear what wisdom they could impart on the subject. 'Hail damage, yep, she's got hail damage,' one of them declared. Hail damage. Of all the euphemisms used to describe cellulite, that was a new one. Leave it to a few… undergraduates to create one more derogatory word to torture us with."

Cellulite is not a disease. In fact, it's perfectly normal. It won't kill you or shorten your life or cause another disease. Yet, every year, women spend millions of dollars hoping to get rid of it.

But now there is true hope. In reviewing more than two decades of medical reports on cellulite from around the world, I have discovered several safe, natural, medically validated remedies that can help to eliminate cellulite.

There are many theories on why women develop cellulite.[170] These range from imbalances of the female hormone estrogen, to the body's impaired collagen production, excess stored water (edema), or prostaglandin imbalances (inflammation). Because cellulite appears to be a condition with multiple causes, a truly comprehensive cellulite program should address each of these influences.

What we do know is that, as unfair as it may seem, there is in fact what the experts call "sexual dimorphism" in the structural characteristics of the connective tissue of women that predisposes them to develop the irregular extrusion of adipose tissue (fat) into their outer skin that characterizes cellulite. In plain words, the layer of connective tissue beneath the skin is different in men and women; therefore, each sex stores fat cells in a different way, which gives way to different shapes and leads to different problems. Everywhere on the male and throughout much of the female body the fat cells are configured within the collagen strands in a flat, crisscross formation—except on the buttocks, hips, and thighs of women. In these areas, as part of women's physiological response to pregnancy, the fat cells are stored in a honeycomb formation so the fat cells layer on top of each other and fill up the honeycombs. Over time, fat deposits accumulate in these compartments, causing them to expand and bulge. As they do, the collagen strands stretch thinner, resulting in the dimpled appearance of the skin.

The situation has been difficult to treat because, in the honeycomb configuration, it becomes virtually impossible for the fat receptors to be triggered for release. In flat, crisscross fatty areas, it is very easy for the body to call upon stored fat for energy, and that fat is easier to impact with diet and exercise. As the smallest vessels in the skin's fat layer suffer structural damage with age, inflammation, impaired circulation, and accumulation of lymph and fluid can occur. The fat cells swell and further protrude into the outer layers of the skin, causing the granular or "buckshot" feel of cellulite. Fatty deposits in the area of women's buttocks, hips and thighs tend to be metabolically impaired—once the fat receptors in the fat cells of these areas are activated and fatty deposits are stored, they are often difficult to eliminate. A deep-acting cellulite program "unlocks" these fatty deposits by enhancing the metabolic pathways.

Some doctors mistakenly believe that cellulite is simply ordinary fat that can be remedied through diet and exercise; yet, scientific investigation tells us a different story. A smooth layer of fat in everyone's body is necessary to insulate and

cushion organs, muscles, and nerves. Cellulite, however, is extraordinarily lumpy. It provides no cushioning and is found only in certain areas of the body.

Maintaining a rich and plentiful blood supply to the fatty tissues is crucial in the prevention of cellulite. When circulation is sluggish and elimination poor, toxins in the bloodstream become lodged in fat cells; collagen is malnourished and weakened, enabling the fat cells to enlarge and become abnormally shaped. The condition is exacerbated by further weakening of the corium or dermis layer of skin and thinning of the collagen tissues that make up the chambers holding in the fat cells.

RIDDING THE BODY OF CELLULITE

Since cellulite occurs in the deeper layers of the skin, the scientific approach is to stimulate the proper healing pathway from within. This is accomplished by restoring the proper integrity to the collagen and other connective tissues responsible for giving shape to the body's fat cells while stimulating better blood circulation. The problem with external applications (e.g., creams and lotions) is that, although they may help smooth the skin's surface, they don't penetrate deeply enough to have a substantial effect.

A beneficial cellulite program must work in three ways:

❖ Enhancing the metabolism of cellulite fat cells by enhancing blood flow—both increasing the flow of nutrients into the cell and transporting toxins out.
❖ Triggering receptors on fat cells to release stored fat for energy, facilitating its elimination.
❖ Using herbs with diuretic properties to help drain metabolically sluggish areas. Fat cells are composed of 90 percent water and 10 percent fatty deposits. Temporary measures against cellulite, such as body wraps, cause the water to drain from the cell. The problem with these quick fixes is that the water returns to restore the balance of the cell. However, if you can truly eliminate the fat the from the cell, then the water can drain away permanently, causing cells to shrink in size.

Plant Extracts that Fight Cellulite

The plant extracts I'll tell you about are known for their threefold natural action against cellulite and fatty deposits. They can increase the body's metabolic rate so that fat can be used faster, eliminating waste and toxins; they trigger fat receptors, and improve blood circulation in cellulite areas, helping your body use the trapped fat as a source of energy; and they exert a diuretic action. Here are some of the best ones to use for getting rid of cellulite:

Bladderwrack (*Fucus vesiculosus*) is a rich source of natural iodine and has long been used to assist in weight loss. Preparations of bladderwrack have long been used with great success for diseases of the thyroid and obesity; in fact, bladderwrack has been used to treat obesity since the 17th century. By stimulating the thyroid gland, the body's metabolic rate is increased. This is critical. Thyroid hormones are made from iodine; hence, the importance of bladderwrack for revving up the body's ability to burn excess fat trapped in the pockets of cellulite. If you have a sluggish thyroid as well as cellulite, bladderwrack will be extremely helpful.

Grape seed extract's procyanodolic oligomers (PCOs) promote stronger capillaries and more elastic collagen, the material from which connective tissue is made. An elastic collagen helps to smooth the skin and fight wrinkling, but more importantly, the renewed resilience of the body's collagen tissues makes them stronger and imparts more firmness, squeezing fat cells to their more youthful shape. By restoring healthy blood flow, grape seed has the potential to revive areas that have been fat-choked. Dimpling of the skin of the thighs and buttocks is a condition of collagen pathology. That is why we recognize the value of herbs known to work to promote collagen and venous integrity. And thanks to grape seed extract, the body's skin gets thicker and stronger, the dehydration that occurs with age is reversed, wrinkling is reversed to some degree, and the appearance more characteristic of young skin returns in the areas of the thighs, buttocks, hips, face, and the rest of the body as well.

Ginkgo biloba has long been known to enhance blood flow through the smallest capillaries, thus freeing trapped cellular debris in affected tissues and enhancing metabolic pathways.

Gotu Kola (*Centella asiatica*) is rich in triterpenic acids (asiatic acid and asiaticosides) that boost circulation in the legs. This herb has demonstrated impressive clinical results when given orally in the treatment of cellulite.[171, 172, 173, 174, 175, 176]

In one study of cellulite in 65 patients who had undergone other therapies without success over a period of three months, very good results were produced in 58 percent of the patients using gotu kola, and satisfactory results in 20 percent. Other investigations have shown a similar overall success rate of approximately 80 percent.

The effect of gotu kola in the treatment of cellulite appears to be related to its ability to enhance connective tissue formation and actually increase its thickness while reducing formation of hardened, non-elastic connective tissue. Specifically, gotu kola works by stimulating a rebalancing of those important

structural components known as glycosaminoglycans (GAGs), in which collagen fibers (the main protein of connective tissue) are embedded. In other words, gotu kola rejuvenates the outer layers of skin, so that fat cells are less likely to markedly protrude into them.

Horse chestnut extract is rich in escin, which has anti-inflammatory and anti-swelling properties that are useful in the treatment of cellulite, thus helping the fatty tissues to drain.[177] It also strengthens the body's venous system, thereby enhancing the metabolic pathways.

Evening primrose oil is an excellent source of gamma-linolenic acid and linoleic acid, essential fatty acids necessary to cell structure, which also help enhance the elasticity of the skin that surrounds and gives shape to fat cells.

Juniper berry is traditionally used as a diuretic and helps to relieve mild swelling in cellulite pockets.

Sweet yellow clover is rich in flavonoids and has an anti-inflammatory action that helps to maintain healthy circulation.

FYI...

❖ Cellulite is a condition resulting from weakened connective tissue structures just below the surface of the skin that affects the appearance of the skin.

❖ Women are affected by cellulite at least nine times more often than men due to structural differences just below the surface of the skin.

❖ Slim women who exercise daily, drink water, and maintain a healthy diet usually have little or less-noticeable cellulite.

❖ An extract of gotu kola (*Centella asiatica*) has demonstrated impressive clinical results in the treatment of cellulite when given orally.

MYTHS ABOUT CELLULITE

Myth: Only obese women suffer cellulite.
Truth: Even very slim women can have areas of cellulite on their thighs, buttocks, and hips—although it is often less obvious.

Myth: Cellulite is a natural part of aging.
Truth: While cellulite can worsen with age, specific plant-based medicines have been clinically shown to help.

Myth: Cellulite is not serious and it won't get any worse.
Truth: The psychological consequences can be devastating. Without appropriate action, the appearance of cellulite will usually worsen over time.

Myth: Strict dieting will eliminate cellulite.

Truth: Dieting cannot get rid of cellulite. In fact, strict dieting is often no more likely to help than not dieting at all.

Myth: Exercise will eliminate cellulite.

Truth: Exercise alone cannot totally rid the body of cellulite. Cellulite deposits are "locked away" and can't be readily used as fuel for your body.

Dr. McBarron's Prescription for
NATURAL CELLULITE ELIMINATION

Cellulite may seem hopeless, but my own clinical experience with patients and independent confirming medical studies show that herbal remedies, when combined with diet and exercise, work extremely well.

A low-fat diet with gradual weight loss helps to minimize cellulite by maintaining a slim underlayer of fat. I also like women to lift light weights with their legs two or three times a week and engage in brisk physical activity, such as walking, hiking, aerobics, or swimming, for about 30 minutes three to five times a week.

You'll find a number of cellulite formulas incorporating all or most of the plant extracts and nutrients detailed in this chapter at health food stores, natural product supermarkets, and pharmacies. Try one of these formulas and you'll be pleased with the results.

Victory Over Varicose Veins

Our body's veins are responsible for returning blood to the heart from the tissues. Aging, and the strain imposed on the valves in the leg veins by our upright posture, both take their toll. When the walls or valves of the veins become damaged, their ability to return blood to the heart is inhibited, causing blood to back up. These pockets of pooled blood cause the bulging, blue, raised veins known as varicose veins, which usually occur at the back of the calf or up the inside of the leg almost anywhere between the ankle and groin.

Except in rare cases when ulcers, clots (thrombophlebitis), or infections occur, varicose veins are usually more annoying than disabling. Patients' concerns are equally split between the cosmetic marring that these unsightly, bulging veins near the surface cause and actual painful swelling in their legs.

Still, varicose veins can be an unsightly reminder of advancing years. But fortunately, again, natural medicine offers ways to minimize and eliminate varicose veins and the deeper-seated circulatory problems from which they arise.

STANDARD TREATMENT OPTIONS

I advise patients to stay off their feet as much as possible. Whenever they sit, their legs should be raised. In particularly severe cases, people should try to raise their legs so that their knee is higher than their hip.

Surgery is an option—unsightly varicose veins can be removed. The work of these lost veins is taken over by other nearby veins. The drawback to surgery is that you may be left with unsightly, highly noticeable scars. There also may be significant bruising. Typically, patients opt for surgery if they are bothered both

by the unsightly appearance *and* the pain. Surgery should be a last resort.

Diuretics also may be recommended to shrink the swelling. Occasionally, varicose veins may be treated with sclerotherapy, in which a small amount of a corrosive chemical is injected into the swollen veins, destroying them. This procedure, however, has several drawbacks. Some patients suffer burning, scarring, and infection that incites phlebitis. Plus, there is a high chance for failure if the varicose vein is in the thigh.

Another option is laser treatments, which require a special machine and a highly trained technician. Typically, multiple treatments on a weekly basis are required for optimal results. The treatments work, but can be painful and expensive.

THE NATURAL SOLUTION

Whenever possible, I recommend natural alternatives to patients as a first choice to prevent varicose veins and to treat them. The combination of herbs detailed below, together with dietary changes, is medically validated and safe. And if they don't work, well, we can always examine our other options at that point. But most of my patients agree that if they can get rid of their varicose veins by simply relying on some safe plant extracts, that's a whole lot better than having to resort to surgery or laser treatments.

Horse chestnut seed extract reduces the number and size of the small pores in the capillary walls. This makes the veins less permeable and prevents backflow of the blood. The active ingredient of horse chestnut extract is escin, which has highly vasotonic activity and even increases the power of the contractions of the elastic fibers in the vein walls.[178] Escin appears to work better than compression hosiery, which works immediately to improve blood flow in the veins but doesn't have a cumulative effect. In other words, hosiery isn't more effective with time and halting treatment ends its effectiveness. Horse chestnut extract works more slowly, but its effects last after treatment is halted.

In one study, horse chestnut seed extract was compared to leg-compression stockings in 240 patients with varicose veins.[179] Over a three-month period, patients received horse chestnut seed extract, compression stockings, or a placebo. The average volume of fluid in the more severely affected legs decreased by 56.5 ml with compression therapy and by 53.6 ml with horse chestnut seed extract; fluid volume actually increased by 9.8 ml with the placebo.

Researchers from the School of Postgraduate Medicine and Health Sciences, University of Exeter, United Kingdom, reviewed much of the published double-blind, randomized, controlled trials of oral horse chestnut extract for patients with

chronic venous insufficiency.[180] They concluded, "Horse chestnut seed extract represents a treatment option for chronic venous insufficiency that is worth considering."

Additional Help

For some, horse chestnut seed extract is completely effective, but more often it is partially effective. There are additional herbs that are effective and can be used in combination with horse chestnut.

Turmeric should also help to inhibit growth factors that enable the cells of the veins to continue to grow and lose more integrity.

Gotu kola improves blood flow and the structural integrity of the veins. Studies validate its highly impressive ability to lessen varicose veins.[181]

Butcher's broom has a long history of use, both orally and topically, in treating hemorrhoids and varicose veins. Butcher's broom's active ingredients, ruscogenins, have anti-inflammatory and vasoconstricting effects. (Butcher's broom's effects are enhanced by flavonoids and vitamin C, which should be part of your healthy-heart supplement program).[182]

Bromelain helps to break down fibrin, which causes blood clots.

Grape seed and **bilberry extracts** are rich in anthocyanidins and proanthyocyanidins that help to maintain healthy connective tissue and restore the integrity of the veins.

Buckwheat tea (*Fagopyrum esculentum*) is rich in flavonoids, especially rutin, and has been shown to outperform a placebo at decreasing total leg blood volume and improving capillary permeability and symptoms.[183]

*Dr. McBarron's
Baby Steps Program for*

ELIMINATING VARICOSE VEINS NATURALLY

Rather than taking the herbs mentioned above separately, you can get them in combination oral supplements designed to minimize or prevent varicose veins. These can be found at health food stores and natural product supermarkets.

Be sure to consume a high-fiber diet rich in blueberries, raspberries, and other deeply colored berries. Eating lots of blueberries, raspberries, cherries, and other such berries will provide your body with collagen-building chemicals and do so much for the health of your veins and arteries.

Exercise regularly. Avoid prolonged standing, knee-high hose, and crossing your legs at the knees.

Natural Skin Care Secrets

I want to tell you about keeping your skin beautiful and young with nature's most powerful skin rejuvenators. Based on extensive clinical validation, these formulas will be very helpful to you—especially if your skin requires deep rejuvenation due to sun-related wrinkling and leathering or other environmentally-caused damage. I'll detail a number of formulas based on herbs and other natural rejuvenators. You can use these together or separately. Each has different properties, so you may want to try each of them and then decide which ones work best for you. Since some of these ingredients are not easily found in your standard drug store or even high-end cosmetics and personal care products, I'll also tell you where you can get them.

SEA BUCKTHORN

Sea buckthorn (*Hippophae rhamnoides*) is an ancient shrub that grows almost everywhere in the world, including Asia, Europe, and North America. It is found on coastal dunes. This sturdy survivor has weathered ice ages, droughts, and salty soil, evolving over the millennia to become one of our most treasured skin care herbs. Being someone who spends a great deal of time outdoors, I was anxious to try sea buckthorn serum when a friend told me about it. I used it more out of curiosity than anything, but found it worked wonderfully, almost overnight, to rejuvenate my skin and turn around the signs of premature skin aging.

Still, sea buckthorn is anything but a modern miracle. The ancient Greek scholars Dioscorides and Theophrasta wrote about it, and the plant is mentioned in the 8th Century Tibetan medical text *Gyud Bzi*. Even its scientific

name acknowledges its health benefits: *Hippophae*, from the Latin for "shining coat," in honor of the healthy horses who were fed this nourishing plant.

Remarkable Constituents of Sea Buckthorn Oil

The fruit and seeds of sea buckthorn are rich in essential fatty acids and vitamins and minerals, especially ascorbic acid, carotenoids, and vitamin E as well as calcium, phosphorus, copper, zinc, magnesium, iron, manganese, and selenium, all possessing physiologically active properties.[184]

Beautiful Skin Science

The amount of scientific research from China, Sweden and other European scientific centers that supports use of sea buckthorn is impressive. Let's look at some of these results:

Powerful topical antioxidant

Your skin loves antioxidants. These powerful, natural protectors scavenge free radicals. Unstable molecules that are missing an electron, free radicals are formed from sun exposure, toxic chemicals, stress, and other daily activities. On the skin, these molecular sharks cause wrinkling, leathering, blotching, and cancer. Antioxidants prevent formation of free radicals and help to defuse those that are produced. Sea buckthorn is a powerful antioxidant. Different fractions of sea buckthorn fruits were investigated for their antioxidant activity.[185] It was found that sea buckthorn's powerful antioxidant properties are related to its very high vitamin C, carotenoid, and phenolic content.

Pollution protection

Because sea buckthorn is such a powerful antioxidant, its ability to protect against premature aging of the skin and the effects of environmental pollution is impressive. Perhaps its most novel antioxidant benefit is to protect against the negative effects of pollution. For example, sea buckthorn has a blocking effect on the formation of cancer-causing nitrosamines, according to Chinese research.[186] In fact, researchers from the Department of Nutrition and Food Hygiene, Shanxi Medical College, Taiyuan, China, note that their study results "suggest that sea buckthorn juice can block the endogenous formation of N-nitroso [cancer-causing nitrosamine] compounds more effectively than ascorbic acid and thereby prevent tumour production."[187] This is very important, since many cosmetic products contain nitrosamines or nitrosamine-forming chemicals, and these can penetrate the skin to increase the body's cancer burden.

Stimulates Faster Skin Repair

In 1989, Dr. E.V. Kostrikova characterized sea buckthorn oil as a "stimulant" of skin reparative processes with a clear-cut anti-inflammatory effect.[188] The effect exerted by sea buckthorn on the healing of experimental wounds showed that the growth of new skin tissue (epithelization) was more intensive and occurred earlier. This marked stimulating effect on the healing process of the skin can be explained by the rich content of vitamins and microelements (sulfur, selenium, zinc, copper) in sea buckthorn, say researchers.[189]

HOSPITAL STUDIES OF SEA BUCKTHORN SKIN CARE PRODUCTS

The Guangdong Provincial Institute of Materia Medica, Guangzhou, China, developed several kinds of sea buckthorn cosmetics that have been clinically studied. According to these studies:

❖ The products were tested on 350 people at Guangdong Provincial Institute of Materia Medica. The results showed that sea buckthorn beauty cream had a therapeutic efficacy on skin discoloration, freckles, prematurely aging skin, skin sclerosis (hardening), scaling or rough skin, facial acne, recurrent dermatitis, and chemically damaged skin. The hospital was gratified to find that applications of cream containing sea buckthorn oil made the tested person's skin fair, clear and delicate. Many cases of acne improved or disappeared after using the sea buckthorn cream; excess pigment disappeared as well. Several postpartum women with large patches of pigmentation found that the patches completely vanished after one to two months of treatment, the skin returning to normal.[190]

❖ Cancer treatment specialists affiliated with Xian Medical University, in cooperation with Northwestern College of Forestry, successfully used sea buckthorn preparations with patients who had undergone radiation therapy which can cause inflammation and burns.

❖ Clinical trials involving some 60 patients suffering from acute (second degree) burns caused by radiation show that, compared with commonly-used drugs, 85 percent of persons given topical sea buckthorn oil healed faster and more completely.

❖ In a preliminary trial with burn patients, the Fourth Military Medical University used sea buckthorn oil to effectively treat extensive, petrol-induced burns on the upper part of the body, as well as skin tears on the lower part of body. It has also been shown that this oil can greatly speed up recovery after a

skin-transplant operation. In addition, Northwestern Institute of Plateau Biology carried out clinical tests among 150 burn patients treated with sea buckthorn oil with better therapeutic results than from a placebo.

Availability

Although sea buckthorn is extremely popular in China and Europe—its use in cosmetics available in the United States and Canada, to the best of my knowledge, is limited to a line of quality products from Aubrey Organics, a Tampa, Florida-based natural skin care company. (By the way, the Aubrey Organics products are highly rated in *The Safe Shopper's Bible* [Macmillan 1995], which is the consumer bible of safe and healthy cosmetics.) If you're dissatisfied with certain signs of aging or if you are concerned with the damaging effects of too much sun exposure, then I would urge you to make sea buckthorn part of your daily regimen. (See Resources for information on contacting Aubrey Organics.)

VITAMIN C

Vitamin C is probably the most potent agent available today for insuring healthy, wrinkle-free skin, says Sheldon Pinnel of the Department of Medicine, Duke University Medical Center, Durham, North Carolina.[191] In a study at Duke University, 10 people were pretreated for five days with a solution comprised of 10 percent L-ascorbic acid (a form of vitamin C), or a placebo. Upon treatment, the volunteers' arms were irradiated with UV rays. After 24 hours, their arms were examined for erythema (redness). Sites treated with topical vitamin C showed 22 percent less redness.

"A vitamin C cream may soon give Retin-A a run for its money," comments Emanuel Cheraskin, M.D., D.M.D.[192] "A new C-based wrinkle-reducer already has been tested on several hundred people, including 50 at the University of Wisconsin-Madison… What is most intriguing is that approximately 95 percent reported a reduction in wrinkling within six weeks to two months. And even more comforting is the fact that the C-treatment appears to be without side effects…"

How Vitamin C Helps

All of the cells of your body require vitamin C to make connective tissue and carry out other essential life processes. In addition, the skin—the first line of defense against many environmental assaults—uses vitamin C to help protect

its layers from damage by sun, smoke, and environmental toxins. Older skin, in particular, may not get enough vitamin C from the body's internal blood supply, so it makes sense to apply it topically to those areas where it can fortify needed antioxidant protection. Vitamin C serves as an antioxidant by scavenging the free radicals generated in cells and tissues by sunlight, tobacco smoke, and the many pollution sources encountered in daily living.

There are a lot of skin lotions now with vitamin C. The best contain Ester-C, which is very stable and won't break down in cosmetic products. Look for Ester-C on the labels of your favorite cosmetics. It's becoming very popular and you should be able to find a plethora of such products at natural health outlets.

EVENING PRIMROSE OIL

Do you look in the mirror and wish your skin wasn't so dry, red, and inflamed? Many of us live with inflammation daily. In fact, inflammation is a key health issue affecting not only our skin, but our vital health as well, including heart, circulation, and joints. Evening primrose oil can be used topically and orally for reducing inflammation and healing eczema and psoriasis.

Used for centuries for its medicinal and nutritional benefits, evening primrose oil is included in many natural cosmetics. Although there is a tendency to consider evening primrose oil a trendy product, the scientific evidence that supports its use in cosmetics and personal care products (as well as when taken internally) is solid.

Evening primrose (*Oenothera biennis*) is a biennial plant that grows to a little over three feet in height with flowers that open in the evening. Although originally found in North America, today evening primrose is naturalized throughout most of Europe and parts of Asia. Not only does its oil contain approximately 78 percent essential fatty acids (EFAs), without which the body cannot function properly, the balance of specific fatty acids it contains also makes it extremely beneficial for the skin.

One key benefit of evening primrose oil is its ability to provide relief for skin inflammatory conditions. Please be patient with this little bit of science. By doing so, you'll understand why evening primrose oil could be the critical missing link in your skin care program, especially for reducing inflammation and resulting redness, roughness, and irritation.

In the body there are chemical messengers called *prostaglandins* (PGs), so named because of their initial discovery in the tissues of the male prostate. We now know that prostaglandins can be found throughout the body, and these

chemical messengers are responsible for control of inflammation, body temperature, contraction of smooth muscle, dilation or constriction of blood vessels, passage of substances in and out of cells, and many other physiological functions. Proper balance of prostaglandins is also a key to the health of your skin.

Prostaglandins are manufactured in the body from dietary EFAs. However, the various types of EFAs in your diet can dramatically affect the body's balance of prostaglandins. These compounds are further divided into what researchers have named the one, two, and three series; each performs different functions. For example, prostaglandins of the PG1 and PG3 series are generally considered beneficial to the skin and helpful for reducing overall inflammation. Those of the PG2 series appear to promote inflammation and inhibit some aspects of immune function. Most of us have very high levels of the PG2 series because of the types of fats we eat—saturated fat, hydrogenated vegetable oils, foods fried in highly processed vegetable oils, and other highly processed foods with chemically altered oils. "The adulteration of polyunsaturated oils contributes to an overt deficiency of these life-sustaining nutrients," notes health expert Michael Murray, N.D. "The essential fatty acids take on the role of Dr. Jekyll and Mr. Hyde, becoming transformed from life-sustaining and health-promoting in their natural state to life-taking and deadly when processed."[193] Due to their intake of highly processed oils, most people suffer chronic high levels of inflammation, including inflammation of the skin.

The skin is unique in that it lacks certain enzymes required to convert the most prevalent EFAs to beneficial prostaglandins. This is where evening primrose oil is valuable. Evening primrose oil is an extremely rich source of a rare fatty acid, gamma-linolenic acid. The skin does not require enzymes to convert gamma-linolenic acid into favorable inflammation-reducing prostaglandins.

The body's prostaglandins cannot be stored and must be constantly manufactured. By supplying the skin with a constant source of easily utilized gamma-linolenic acid, regular use of cosmetic formulas containing evening primrose oil can help to maintain an optimal balance of prostaglandins in the skin. By supplying the skin topically with gamma-linolenic acid, you can favorably moderate swelling and overall inflammation.

Indeed, EFAs promote healthy skin by nurturing the cells' membranes and supporting their fluidity. The EFAs in evening primrose oil are absolutely essential for maintaining the proper condition of the water barrier, which is critical to maintaining a healthy, plush feel to your skin.

A deficiency in EFAs can lead to many skin and hair problems, including scaling, decreased activity of the sebaceous glands, weakened capillaries near the

surface of the skin, loss of water in the outer layers of the skin, thin discolored hair, and increased prevalence of eczema, acne, and psoriasis.[194, 195]

Evening primrose oil is uniquely rich in linoleic and gamma-linolenic acids. In a study published in the *Journal of Investigative Dermatology*, it was shown that topical application of oils rich in linoleic acid is highly beneficial to the skin. Using volunteers suffering EFA deficiencies, researchers found that topical application of sunflower seed oil (also rich in EFAs) markedly increased the skin's linoleic acid levels, that loss of water was highly decreased, and scaly lesions disappeared. In contrast, persons receiving olive oil (which contains virtually no linoleic acid) showed no such improvements.

More studies support the topical use of EFA-rich oils such as evening primrose. For example, it was shown in a 1985 report that topical application of EFAs improves the skin's hydration capacity and protects aged skin against environmental insults.[196] And unlike typical skin creams, topical formulas with evening primrose oil work to correct dry skin not by acting as a barrier (occlusivity), but by actually initiating fundamental structural change within the skin. "This implies the necessity of a well balanced mix of [EFAs] in the diet and in topical application," said the researchers.[197]

Superb Oil for Cosmetics and Personal Care Products

Evening primrose oil is a superb healing agent and moisturizing treatment for dry, flaking skin and skin prone to eczema, itching, and irritation. This nourishing oil also encourages skin cell regeneration and may be helpful to use after cancer-related radiation treatment—as shown in experimental studies performed by researchers associated with the Research Institute, University of Oxford, Churchill Hospital, UK.[198] It also soothes dryness and irritation on contact. Evening primrose oil can be used as a hot oil treatment for scalp problems and split ends. It is a valuable ally for daily use.

Internal Benefits of Evening Primrose Oil (EPO)

EPO is not only a valuable ally topically, but is important to take internally as well. Remember, the skin is a mirror that it reflects what is inside. The skin has seven layers; layers five, six, and seven are where skin is developed and nourished from within the body. Think of skin as a moving escalator. In 28 days, layer seven has moved up to layer one, where it is sloughed off. Humans replace their skin, on average, every four weeks. For skin to appear healthy, soft, and smooth, applying creams is not enough. Internal nourishment is important, so taking EPO capsules is valuable.

ROSA MOSQUETA ROSE HIP SEED OIL

I've been looking at amazing before-and-after photographs of participants in a clinical trial who used a special oil taken from a rose that grows in the southern Andes of South America. Although officially known as *Rosa aff. Rubiginosa*, its most well-known American name is Rosa Mosqueta. Prematurely aging skin, difficult-to heal wounds, and acne scarring are all common concerns among my patients. I believe that, with Rosa Mosqueta, we now have an exceedingly powerful, clinically validated topical healing agent that I will be sure to tell all of my patients about—especially those concerned with scarring from acne or trauma and other cases of severely damaged skin, including premature aging.

Clinical Validation

The history of the scientific and clinical validation of this important skin rejuvenator begins in 1978 when Fabiola Carvajal, M.D., of the microbiology department at Concepción University in Santiago, Chile, was brought a reddish-amber colored oil rich in essential fatty acids and told it was taken from a mountain rose long used by the native peoples of the region for their skin. Dr. Carvajal was familiar with the plant and decided to clinically study the oil for its impact on patients with skin wounds from radiation, ulcers, brown spots, dry skin, and other conditions of poor skin health.

"The results were superb using Rosa Mosqueta oil and cream in all our clinical studies, even with scars over 20 years old and with patients who had not improved using other therapies," she says. "Burns (including UV damaged skin and radiation burns), chronic ulcerations of the skin (such as that with paraplegics and bedridden invalids), skin grafts, brown spots, prematurely aging skin, and dry skin all benefited with Rosa Mosqueta."

Radiologist and oncologist Hans Harbst, M.D., has also worked with Rosa Mosqueta oil and found it to be excellent for treating skin problems following radiation therapy. "As a radiotherapist, I work with many patients who have undergone surgery and therefore have scars," says Dr. Harbst. "In addition, subsequent radiation causes secondary reactions to the skin such as inflammation, darkening, and dermatitis. These effects are inevitable following radiation treatments. This presents an aesthetic problem for patients, but the application of Rosa Mosqueta oil has produced faster healing of these lesions. Also, treatment of scars that cause tightening of the skin and difficulty in moving the arms and legs has been greatly improved with Rosa Mosqueta oil. We have achieved a loosening of the tension in the skin with

Rosa Mosqueta oil. Results have been very good with some patients and spectacular with others."

In one case, says Harbst, "a man who had his whole head radiated due to a brain tumor had no signs of radiation damage after four weeks of treatment with Rosa Mosqueta oil." Another patient who showed an acute dermatitis after radiation had an excellent recovery 24 hours after treatment with the oil. "The skin had actually regenerated."

The results of Drs. Carvajal and Harbst were most recently confirmed in a 1990 study in which the oil of Rosa Mosqueta was applied to ten patients affected by leg ulcers and post-surgical wounds "with very notable improvement on... healing compared with the control group." The researchers concluded, "Due to the lack of side effects, we believe rosa mosqueta oil is very useful to these conditions."[199]

Tell Me More...

Most experts agree the best use of Rosa Mosqueta seed oil is as a preventive therapy to prevent premature skin aging—but as clinical results demonstrate, its skin rejuvenating properties are impressive, and it should also be used for damaged skin.

Although it was initially thought that Rosa Mosqueta's extreme skin rejuvenating properties were due to its high content of omega-3 fatty acids (second perhaps only to flaxseed) and other essential fatty acids, it is now thought that the component responsible for its remarkable rejuvenation properties is retinoic acid. A derivative of retinol or vitamin A, many readers will recognize its synthetic counterpart, Tretinoin, a topical pharmaceutical drug used against premature wrinkling. As with Tretinoin, which has been thoroughly researched for over 30 years, Rosa Mosqueta has impressive skin rejuvenation properties, but without the complications associated with this medical drug's use.

How to Find Rosa Mosqueta

Based on the work of Dr. Carvajal, Aubrey Hampton, of Aubrey Organics, introduced Rosa Mosqueta oil in the United States in 1986. "The examples of skin improvements using Rosa Mosqueta oil and cream seem almost miraculous, but when combined with other anti-aging herbs that I've discovered in three decades of formulating natural cosmetics, the results are even better," says Hampton. Aubrey Organics' Rosa Mosqueta products make up one of the best-selling lines of cosmetics today in the natural products industry. Softly massage in the oil. Effects should be apparent after three to four weeks, with improved elasticity and coloration.

Dr. McBarron's Prescription for
BEAUTIFUL SKIN

Each of these skin care herbs or nutrients has extraordinary healing and skin-nourishing properties. Combined with other toning and moisturizing herbs and vitamins, they work together to help heal and smooth the skin, protect against free radical damage, and keep the complexion softer, healthier and younger looking. Due to individual variability in skin types, you may want to try each of the formulas singly to see which works best for you. You may combine them into a comprehensive skin care regimen. Based on the experiences of my own patients, I'm confident that by using the proper sun-protective clothing, a quality sunscreen, and these products, your complexion can be more youthful looking.

Beautiful Hair and Nails

Is your hair lifeless and lacking luster? Do you want to get rid of old lady's hair, with its coarse shafts and frizzy appearance? Do you have splitting, peeling nails? Do they suffer from fungus problems? Is the growth of your hair or nails painfully slow?

Sometimes, we learn a lot not by reading studies, but by seeing results with our own patients. Such is the case with helping my patients to achieve healthier hair and nails.

Amino acids are the building blocks of protein. Protein makes up all of the tissues, especially the nails and hair, of the human body. Yet, as people age they are often afflicted with diminished responsiveness of the pancreas to produce digestive enzymes necessary to properly digest nutrients. If you cannot extract the nutrients in your foods, symptoms of nutrient malabsorption may become apparent in a number of ways.

Physicians use both physical symptoms and laboratory tests to assess pancreatic function, which is key to proper digestion.

For example, if you're eating an apparently healthy diet but are still protein-deficient and suffering malabsorption, your fingernails may be prone to fungal attacks, become brittle and gray or yellowed. Also, hair that lacks protein often fails to grow or splits and frizzes.

DIGESTIVE ENZYMES

There is little in the medical literature to indicate digestive enzymes to be of value in the growth of hair or nails. But if I were to name one often-overlooked dietary supplement that women seeking beautiful nails and hair should use, it

would be a digestive enzyme formula—one that helps them to better utilize the nutrients they receive from food.

Thick, healthy hair and strong, well-formed nails are not only good indicators of women's outer health, but also of their overall digestive health—particularly their ability to utilize nutrients from their diet.

How to Tell If You Need Digestive Enzymes

Physicians use both physical symptoms and laboratory tests to assess pancreatic function, which is key to proper digestion.

❖ *Symptoms of pancreatic insufficiency include abdominal bloating and discomfort, gas, indigestion, and passing of undigested food in the stool.*

❖ *Dry scaly skin, irritable bowel with bloating, and possible diarrhea with hypersensitivity to specific food groups, especially dairy products, are additional symptoms.*

❖ *Nutrition-oriented physicians use the comprehensive stool and digestive analysis. This comprehensive analysis can indicate the level of pancreatic enzymes by determining the level of excess fat and nitrogen in the stool, and the presence of any other partially or completely undigested food elements. In addition, the complete stool and digestive analysis will also reveal the health of the bacterial flora, another indicator of pancreatic function.*

Hydrochloric Acid Also Key to Digestion

A gradual reduction in hydrochloric acid occurs as people age, beginning in their late thirties. People further exacerbate this problem by taking antacids when, in fact, they suffer not from an excess but a *deficiency* of hydrochloric acid. The result is further difficulty digesting foods, particularly protein-rich foods. It is very important to correct this problem if you want healthier hair and nails.

Be sure when purchasing a digestive enzyme formula that it supplies not only pancreatic digestive enzymes, but about 325 mg of betaine hydrochloride. This nutrient alone may make all the difference in the world in your ability to better utilize nutrients in your diet. An additional benefit is that pancreatic supplements often diminish appetite, resulting in weight loss. One product I recommend is Protazyme™ from Enzymatic Therapy (also known as Protagest™ from PhytoPharmica).

BIOTIN BENEFITS HAIR AND NAILS

Biotin is a B-complex vitamin that works by helping to heal the intestinal lining. Most recently, human studies show that biotin supplements as high as 2,500 micrograms per day can produce significant increases in nail thickness, with 90 percent of patients demonstrating improved nails.[200]

P.S. Another great product for healthy hair and nails is **Formula 50** from Marlyn Neutraceuticals. This formula has been around for something like 50-years. It provides complete all natural, enriched proteins from vegetables and collagen, more than 1.1 grams per capsule, as well as vitamin B_6. Formula 50 is in the *Physicians' Desk Reference* where it is recommended for hair loss and splitting, and thinning nails, especially when accompanied by nail fungus.

Many OB-Gyn's recommend Formula 50 to women after childbirth for help in controlling excessive hair fall-out. Take six capsules daily.

Dr. McBarron's Prescription for
BEAUTIFUL HAIR & NAILS

Improving your body's utilization of protein and other nutrients vital to hair and nail growth is essential. Use a quality digestive enzyme formulation, combined with extra biotin and, if necessary, Formula 50.

Covering Gray Hair~ Naturally

One important cause of loss of self-esteem for many of my patients (both male and female) is gray hair. I know very few women (or men, for that matter) who adjust easily to graying. And, frankly, I don't think that women or men necessarily need to accept graying hair. On the other hand, I do worry about my patients who resort to the chemical hair coloring brews sold in many hair salons, drug stores, and supermarkets. Fortunately, safe alternative brands of hair coloring are available at health food stores, natural product supermarkets, and natural pharmacies. This is, ultimately, good news because these safe brands also work extremely well—even for covering gray.

PROVEN CANCER HAZARD

Specifically, use of permanent and semi-permanent hair dyes is associated with increased risk of non-Hodgkin's lymphoma (the often-fatal disease that killed Jacqueline Kennedy Onassis), multiple myeloma, and Hodgkin's disease.[201, 202, 203, 204, 205, 206, 207, 208, 209] Researchers from the National Cancer Institute estimate that 20 percent of all cases among women of non-Hodgkin's lymphoma are due to their use of commercial hair dye products.[210] The risk seems to be greatest among users of dark shades. Jackie was a brunette.

The evidence is suggestive of an association with breast cancer and especially the older hair dyes (used by women in the 1970s, whose breast cancers may have a latency period of 20 years or more), as David Steinman and Samuel S. Epstein, M.D., report in *The Breast Cancer Prevention Bible* (Macmillan 1998).[211, 212, 213, 214, 215] They note that the dye para-phenylenediamine, used in virtually

every commercial permanent and semi-permanent product, was shown in 1986 to be carcinogenic to the breast following oxidation with hydrogen peroxide, much as these products are used by women.[216] Other preliminary studies have also linked this particular ingredient with cancer. This evidence isn't conclusive, but I can tell you, as a medical doctor who cares about her patients, it is certainly disturbing. Further evidence of the cancer risk from hair dye use comes from studies of hairdressers, which have provided clear evidence that both men and women are at increased risk for bladder and other cancers.[217, 218, 219, 220, 221] Hair dyes may also pose a risk to children whose mothers use them shortly prior to conception or during pregnancy. In fact, the risk of childhood cancer could be increased by as much as tenfold.[222, 223, 224]

How to Avoid Potentially Toxic Hair Dye Products

Follow these guidelines when shopping to avoid potentially toxic hair coloring products:

❖ *Read labels. Avoid choosing any product whatsoever listing the phenylenediamine chemical family.*

❖ *Look for the following disclaimer on the package:*

CAUTION: This product contains ingredients which may cause skin irritation on certain individuals and a preliminary test according to accompanying directions should first be made. This product must not be used for dyeing the eyelashes or eyebrows; to do so may cause blindness.

In both the U.S. and Canada, such warnings on the label mean that the product contains ingredients which are exempt from provisions of the Food, Drug, and Cosmetic Act, including phenylenediamine-based dyes.

❖ *There is some evidence that most of the cancer risk of hair dyes is attributable to the darker shades.*

❖ *Some mainstream manufacturers have begun offering hair coloring products to which they've added herbal extracts, and then call these products natural. Forget it. Every line I've investigated contains potentially toxic phenylenediamine-based dyes.*

SAFE AND HEALTHY HAIR COLORING PRODUCTS

Paul Penders Color Me Naturally

For several years, I've been following the products of Paul Penders, a Petaluma, California-based cosmetic company. I have been impressed with their purity, quality and the way they deliver great beauty results. Most recently, the Penders company has made one of the truly great and important contributions to consumer health in the cosmetic field.

The Penders company has brought out its totally natural temporary hair colors and conditioners to the public. The line is called Paul Penders Color Me Naturally. It is herbally based, totally safe, and works extremely effectively—without ammonia, peroxide, lead or sulfur.

After trying them, many women prefer these products to the commercial permanent and semi-permanent hair coloring products sold in drug stores and beauty shops.

Their brown, red, blue and yellow-derived colors are from safe mineral salts and, whereas commercial products in drug stores and beauty shops often contain other undisclosed impurities, allergens and irritants, the Penders line doesn't. The company has added important conditioning herbs to the products including arnica, calendula, chamomile, ginseng root, hops, horsetail, lavender, nettle, and rosemary.

Light Mountain® Natural Hair Color and Conditioner and Color the Gray

Henna, a plant native to the Middle East, has been used for thousands of years as Mother Nature's hair colorant. A semi-permanent hair color, henna is completely non-toxic. Modern hennas create a wide range of very natural and beautiful hair colors.

One of the excellent qualities of henna, which neither permanent or semi-permanent typical hair coloring products possess, is that it washes out of your hair less slowly. Thus, as new hair is growing in, the problem of noticeable roots is minimized. Henna is also a great conditioner and protects the follicle for thicker, softer, fuller hair.

One company has perfected the henna process and offers a product that can actually cover gray. This is a big advancement in henna-based hair colorants, since most do not cover gray all that well. In fact, Light Mountain Color the Gray is the only henna product available today that can entirely cover gray with a two-step process. Light Mountain® Natural Hair Color and Conditioner and Light Mountain Color the Gray are excellent products, which also come in a wide range of color variations. The Light Mountain line not only adds great color shading to hair, henna is a terrific hair conditioner.

I've seen a number of my patients who have used this formula. They look great! I swear, the color is natural, the gray is covered—and most importantly, there's no cancer risk!

One word of warning: The product won't work for everyone who needs to cover their gray. But if it doesn't work, the company that makes the products provides a complete refund.

See Resources to find out how to obtain these products.

HENNA USE TIPS

Be sure to follow these guidelines when working with henna:[225]

❖ Always wear gloves when using henna as it contains a resinous substance called hannatannic acid with a coating action that can color skin and nails.
❖ Distilled water is best to use when mixing henna.
❖ Always use glass, ceramic, or plastic bowls. Stir with a wooden or plastic spoon. Never use metal utensils or a metal container when mixing henna, as henna can react to metal.
❖ Be careful if you have a perm or chemical tint. Chemical residues left in the hair can react with the henna and cause unusual shades or brassy colors. This can also happen with hair that contains chlorine residues from swimming.
❖ Do a preliminary test on a swatch of hair.
❖ Over a period of several days, the new color will go through subtle and dramatic changes.

THE BEAUTY INDUSTRY'S SECRET

The fact that the hair color industry is legally exposing millions of women to carcinogenic chemicals without label warnings is, in part, due to legislation governing cosmetics dating to the 1938 Federal Food, Drug, and Cosmetic Act. At that time, intensive special-interest lobbying on behalf of the hair dye industry persuaded Congress to exempt the dyes used in these products from government regulation. Under the Act, only an acute health hazard warning is required to be included on product labels that blindness might result from use on eyelashes and that a preliminary test should be conducted to avoid allergic reactions.[226, 227]

This legislation shouldn't be an excuse for the Food and Drug Administration's inaction on this issue. The fact is that the FDA has never gone to Congress asking for regulatory authority over hair dyes. Nor has it aggressively advocated explicit labeling of hair dyes for their carcinogenic hazard. The FDA has always heeded lobbying pressure from the hair dye industry. The dirty secret behind hair dyes' glamorous facade remains concealed in a complicit, unspoken pact between Congress, the FDA, and the beauty industry and its lobbyists.

HOMEMADE HIGHLIGHTING HAIR RINSES

Gray hair can be rejuvenated by bringing out its own natural highlights and shades, using natural and safe ingredients. You can make your own homemade rinses to bring out both highlights and color.

Be patient. When you use natural coloring agents, the changes in your hair become evident gradually. Consistent, long-term use brings the best results, producing dramatic highlights.

Each of these recipes will make one rinse. Increase the proportions and make enough for one or more additional applications. Experiment with different amounts of the listed ingredients in order to perfect a blend that works best for your own hair color.

You will need a small glass bowl that can hold four or more cups of water, as well as a clean shampoo bottle to store the rinse. When using a color high-lighting rinse, be sure to use it after shampooing, rinsing with the coolest water you can stand for at least one full minute.

Store homemade rinses in a cool place and out of direct sunlight. Some people store their rinses in the shower or set aside a special section in their refrigerator.

The following rinses work best for blondes and naturally fair-haired people:

❖ **Chamomile hair rinse.** Purchase from a health food store or gather from your herb garden or nursery 1/4 cup of chamomile flowers. Place in bowl. Pour 2 cups of boiling water over them. Allow to cool; strain and use.

❖ **Rhubarb hair rinse.** Purchase fresh (preferably organic) rhubarb from your local store. Chop into small pieces until you have filled 1/4 cup. Place in bowl. Pour 2 cups of boiling water over them. Allow to cool; strain and use.

For women with naturally dark hair, these rinses have proven effective at adding highlights and color:

❖ **Cinnamon hair rinse.** Break three cinnamon sticks into small sections. Place in bowl. Pour 2 cups of boiling water over them. Allow to cool; strain and use.

❖ **Lavender hair rinse.** Use 1/4 cup of lavender. Place in bowl. Pour 2 cups of boiling water over the lavender. Allow to cool; strain and use.

❖ **Sage hair rinse.** Use 1/4 cup of sage. Place in bowl. Pour 2 cups of boiling water over the sage. Allow to cool; strain and use.

For red highlights:

❖ **Hibiscus flowers.** An especially excellent highlighting rinse for people desir-ing red highlights can be made from either a hibiscus flower-containing tea (purchased from a health food store) or dried hibiscus flowers. Bring two to three cups of water to a boil and pour in bowl; add the flowers or tea. Allow

to steep until the water reaches a desired shade. It is a good idea to use a lighter shade of this rinse the first time, which can be achieved by adding an extra cup or two of water; if desired, you can always make your hair darker with a second application.

THOUGHTS ON GRAYING

It's an individual choice to color your hair. But it is also worthwhile to consider underlying issues. Women are becoming increasingly comfortable and more at ease with graying, which is good. We can use conditioning treatments with natural herbs and other botanicals to eliminate some of the yellowish cast or intensify the gray, and get a stylish haircut. New make-up or clothing colors may be necessary. Remember that graying hair can enhance your authority (and sex appeal!).

For many women, gray hair is located underneath or along the hairline. If you pull back your hair, the gray will show. But if you layer your hair or wear bangs, the gray will remain concealed. If your hair is gray on top, towards the back of the crown, pulling your hair back can help conceal the gray.

It is important not to think less of yourself because you have gray hair. Certainly, Paul Newman and Clint Eastwood don't think less of themselves, so why should you? Do you have gray hair and think of yourself as attractive? Or do think of yourself as undesirable?

If the answer to the second question is yes, take time to reflect on the reasons for your negative self-concept. People are all too often trapped into thinking of themselves as old and less vital—all because they believe gray hair has robbed them of their vitality. Now, isn't that a ludicrous notion? It is not gray hair that robs you of vitality—it's those negative beliefs.

Business is changing its attitudes towards gray hair. It is okay to have gray hair and apply for a job or expect to advance. Quite apart from the fact that it is illegal to discriminate on the basis of age, many companies seek more mature people precisely because of their experience, reliability, and ability to adjust to changing needs.

In today's society, gray hair is neither always an advantage nor always a disadvantage. It simply is part of life. It does not restrict one's vitality, intelligence, or youthfulness. It's time to start making experience in life, and having lived, count as a positive. What really counts is one's vitality, one's health. But if you do want to get rid of the gray, use products that are natural and safe.

Health Rejuvenators

Exercise

Invariably when I speak before audiences or on the radio on my nationally syndicated show *Duke and the Doctor*, and talk with women who want to be really healthy, look great, and enjoy great health, I have to talk about the least expensive, most productive, and valuable health strategy now available. It's been around for a long time, it's inexpensive, and you don't need special equipment or a partner, either. If you do it enough, and if you do it intensively for long enough, you will look fantastic and you will feel good—as great as any feel-good drug could make you feel. I'm talking about *exercise*. Old-fashioned, perspiration-inducing, body-twisting exercise. Exercise is so important to your health that I cannot say enough good things about it. And I cannot stop talking about it or urging patients to do it. Exercise is one of the most pure forms of body expression. Exercise is health.

The funny thing is, most people, especially in the United States, really don't exert any more physical effort than it takes to reach over and pick up the remote control or make it to the bathroom during the commercial break of a television game show. That is really too bad in so many ways. Exercise helps reduce the risk of heart disease, diabetes, cancer, and many other modern killer diseases. Women can markedly reduce their risk of breast cancer with exercise. Exercise, if begun early enough, can stave off the ravages of osteoporosis. Of course, exercise and diet combined are the best-proven antidote to obesity. When you look good, you feel good. And when you exercise, your body produces natural morphine-like substances called endorphins that help you to feel great.

Although regular physical activity is associated with important physical and mental health benefits, an estimated 53 million U.S. adults are inactive during

their leisure time—the period most amenable to efforts to increase physical activity. What's more, while Americans on the whole simply do not exercise enough, people with arthritis and other rheumatic conditions exercise even less, though the very activities they are avoiding could actually help them to feel better.[228]

Exercise can be better understood when we examine what we expect as the end result: Some exercises, such as weight lifting, are designed to primarily improve muscle size and strength. Other exercises, such as stretches and yoga, are adept at improving flexibility and keeping the body limber. Still other exercises, such as hiking and running, increase endurance. Of course, one particular exercise may fulfill each of these needs to different degrees. Any exercise (including brisk, uninterrupted, *not*-walking-the-dog walking) is fantastic for weight loss. Exercise increases your metabolism, enhancing the rate at which you burn calories, an effect that continues for hours after exercising. By exercising daily, you can literally turn your body into a calorie-burning inferno.

There's more. Exercise improves circulation, increases energy, helps regulate hormones, and ends up detoxifying your entire body. When you exercise and perspire, your body releases toxins through the skin. By releasing the body's store of toxins, the blood and tissues are cleansed. This will result in a clearer complexion.

The quality of your complexion is enhanced in another way. When you perspire, your sebaceous glands produce an oil called sebum that acts as the body's natural moisturizer. If you have normal to dry skin, the extra moisture will benefit your skin. If your skin is oily, sweating may produce clogged pores and skin breakouts. One solution is to cool off after you exercise by pressing a cold, wet towel gently against your skin.

Golf. Biking. Yoga. Walking. Gardening. The point is to get moving. Exercise is a powerful healing tool. It's free, and the only thing holding you back is you. No matter what your age, the scientific evidence is in: Some form of exercise is *always* beneficial to your health.

HOW EXERCISE HELPS

❖ Maintains strong muscles, bones, tendons, and ligaments.
❖ Limbers, tones, and stretches the entire body.
❖ Aids detoxification.
❖ Protects against age-related diseases such as cancer, heart disease, and diabetes.
❖ Aids weight loss.

❖ Promotes balance and agility.

❖ Improves mood and mental outlook.

Stretching

It is important to stretch daily. Stretching helps to keep your body limber and flexible and fights premature aging. Stretching improves circulation and mental attitude. Stretching may also be a great way to *prevent* the need for a facelift.

For anyone else who wishes to maximize their health, stretch for 30 minutes at least three times a week, in addition to regularly doing strength, agility, and endurance exercises. Stretching involves two types of movement: range of motion and isometric. Always do range of motion stretches before isometric stretches.

Stretching Tips

❖ *If your joints hurt, try an exercise or movement that is less painful. Do not try to work through joint pain.*

❖ *Work slowly and steadily.*

❖ *Try holding the movement at the point you feel a comfortable stretching sensation. Each movement should be done until you feel your muscles and joints are supple.*

❖ *Even though a stretch is called by the name of a specific body part, it will affect other body parts as well. Try to think of each stretch as a whole body movement that emphasizes one particular area. Shoulder shrugs, for example, may also help the lower back and calves.*

❖ *As with any exercise, if you feel pain or dizziness, stop and talk to your doctor.*

❖ *Avoid bouncing or ballistic movements.*

I recommend the basic stretches below. Work up to about 25 repetitions for each movement.

Neck

Chin-to-chest flex firms and tones muscles of neck, head, and shoulders and stretches the upper back. Neck flexing can help you avoid a facelift by strengthening sagging neck and chin muscles. This movement is especially beneficial for people who work at a computer. *How to do: Touch chin to chest. Bring head up to point chin at ceiling or sky. Repeat. Work up to 25 repetitions.*

Shoulder to shoulder stretch should be done to loosen the muscles on the side of the neck. *How to do: Stretch neck from one shoulder to the other. Repeat. Work up to 25 repetitions.*

Eye to sky stretch supports healthy joints and muscles throughout the head. *How to do: Stand straight. Bend your head as far back as it can comfortably go. Feel muscles throughout neck and head working. Work up to 25 repetitions.*

Hand against side of head (isometric) strengthens and firms up neck muscles. *How to do: Put hand against side of head and push with neck while resisting with hand. Hold six seconds. Work slowly up to 25 repetitions.*

Hand against forehead (isometric) strengthens and firms muscles in back of neck. *How to do: Put hand against forehead. Try to push forehead down while resisting. Hold six seconds. Work slowly up to 25 repetitions.*

Hand against back of head (isometric) strengthens and firms front neck muscles and joints and muscles of chin. *How to do: Put hand or hands against back of head. Try to look up while resisting the motion. Hold six seconds. Work slowly up to 25 repetitions. Repeat with other hand.*

Shoulder

These stretching exercises are especially beneficial for the shoulders and arms. They'll help to tone and firm the skin underneath the arms, too.

Arm and shoulder rotation helps to keep the shoulder flexible. This movement also helps to keep arms and fingers flexible, as the stretching proceeds from the fingertips all the way to the shoulder. *How to do: Rotate arms in circles with gradually widening radiuses. Work up to 25 repetitions.*

Shoulder shrug helps to maintain good, solid posture and can even help the lower back. *How to do: Lift shoulders up and rotate. You'll feel your chest and calf muscles stretch too. Make your whole body part of the stretch. Work up to 25 repetitions.*

Arm raise helps to prevent compressed spine and loosens up the shoulder muscles. *How to do: Hold arm straight out extended fully in front of your chest. Raise to sky and really strrretch! Work up to 25 repetitions.*

Elbow touch helps to stretch the tendons and ligaments and firm the muscles on the back of the arms and across the chest. It also helps the side muscles all the way up to the ears. *How to do: Clasp hands behind back of head. Try to touch elbows in front of body (around face). Work up to 25 repetitions.*

Hips

Knee to chest touch helps to limber up the hips, lower back, knees. Do first thing in the morning before you get out of bed or (preferably) on the floor. *How to do: Lift both knees at once and touch them to your chest, holding for five seconds, using your hands. Rock back and forth and side to side. Work up to 25 repetitions.*

Back thigh lift is important for strengthening lower back muscles. An isometric exercise, it will also help to tighten your buttocks. Some people may feel some gas or cramping the first few times they do this exercise. However, over time, the movement offers excellent protection against lower back problems. *How to do: Lie on your stomach. Try lifting your thigh off the floor, as high as possible, keeping your leg straight. Be sure to keep your hips on the floor. Alternate each thigh. Work up to about 15 repetitions.*

Knees

Knee-calf tensor is an important physical therapy exercise that people with osteoarthritis of the knee can do. It helps to stabilize the knee and stretch out the leg muscles. *How to do: While sitting in a chair, rest your legs (one at a time) on a second chair or table. Extend your leg out as straight as possible. Point your toes toward your chest, really feeling the muscles of the legs being stretched. Work up to 10 to 15 repetitions.*

Legs

Leg raises are the basic strengthening movement for the quadriceps, the major frontal thigh muscle group. They are excellent for slimming your belly and strengthening your abdominal muscles, as well as strengthening your legs. *How to do: While lying on your back, raise one leg, keeping it straight, as high as you can. Be sure to keep your back on the floor and hold your leg in this position for five seconds. After holding the position, bend the leg at the knee and stretch some more, touching your knee and thigh to your abdomen. Work up to 25 repetitions.*

Back

Abdominal raises strengthen the abdominal muscles that support the back. *How to do: Lie on your back and bend your knees. Raise your head with your arms straight out, touching your knees. Hold this position for five seconds. Work up to 15 repetitions.*

Back extender helps loosen the back. *How to do: Face a wall or pole, and place your hands flat against it at shoulder level. Push your back away from the wall or pole, letting all the muscles of your back stretch out. Work up to 25 repetitions.*

Chest

Back flying motion helps both the chest and back. *How to do: While standing, lift your arms to shoulder height and stretch back behind you, like a bird in flight. Work up to 20 repetitions.*

Endurance and Strengthening Exercises

Some exercises increase the pumping power of the heart and strengthen the cardiovascular system. Examples of these include light to heavy weight lifting, tennis, soccer, and hiking. Exercises such as tai chi and yoga are also excellent—they help develop balance, strength, and endurance and aid relaxation.

Aerobics

Aerobic exercises build endurance and tone the cardiovascular system. There are a variety of aerobic "styles"—some types include step training, others involve dance or calisthenics. In low-impact aerobics, one foot always remains on the floor. In high-impact aerobics, both feet may leave the floor at the same time.

Bicycling

Bicycling for endurance and strength is especially helpful for people with arthritis because the joints do not receive the pounding that occurs with running. Bicycling can be beneficial but may not promote full flexibility because the bicyclist's posture remains static over time. For this reason, bicyclists should be sure to stretch before and after their exercise.

Chi Gong Ho

Chi gong ho was popularized by Bill Moyers in the TV series *Healing and the Mind*. Its name is taken from the Chinese *chi* for energy and *gong* for cultivation. Chi gong ho can help reduce joint pain and enhance mobility. The Chinese believe chi is a powerful energy force that nourishes all of the muscles and organs. These exercises and movements help to stimulate chi throughout the body.

Dancing

Don't neglect dancing as a form of exercise. Square dancers can cover several miles a night. Dancing is a great exercise for strength, stretching, and endurance. Ballroom dancing can bring couples together emotionally, spiritually, and romantically.

Golf

Golf enhances upper body movement while placing minimal strain on the knees and joints. People with severe osteoarthritis may want to ride in a cart. Otherwise, use a pull cart or carry your clubs and enjoy the cardiovascular workout with a full 18 holes.

Hiking

An all-around great exercise for strength, endurance, and stretching, hiking is also a magnificent spiritual experience. Being outdoors produces harmony of thought and a more relaxed state. Deepak Chopra. M.D., advises people to spend half an hour to an hour daily in nature, appreciating its harmony and elegance.

Jumping Rope

A great stretching and endurance exercise, jumping rope can be done by people of all ages. A jump rope is an excellent exercise tool for travelers, as it is so light to carry. Jumping rope is also a great calorie burner and promotes nerve connections between all parts of the body and the brain, quickening reflexes. But use caution—this can be a high impact activity.

Karate and Martial Arts

Training in karate or the other martial arts is a great overall way of stretching all of your muscles, as well as improving your self-confidence and self-esteem. Women can especially benefit from karate.

Running

Running is a great endurance builder. The pounding your joints take may require that you run on grass or an indoor track. Be sure to wear high-quality running shoes. Some people may find running exacerbates their arthritis; try shorter strides to minimize the impact on joints. Trail running can stress the ankles. Start gradually and work up to longer durations.

Stair Climbing

The cardiovascular equivalent of running, stair climbers exercise your back, buttocks, and lower legs. It can be painful for people who have osteoarthritis of the knees.

Strength Training and Weight Lifting

Weight lifting and use of resistance machines at a gym are excellent ways of increasing strength and endurance. Harris McIlwain, M.D. notes, "Studies have shown that strength training may actually lengthen the life span of people with chronic inflammatory diseases, including arthritis. With strength training not only will you get increased strength and improved muscle tone but you will also increase your bone, tendon, and ligament strength and help protect your body from injury."[229]

Tai Chi

An ancient Chinese movement exercise, tai chi involves performing a series of movements with grace, concentration, and focus, mimicking many movements of daily life. A great stress reliever, tai chi can be done by almost anyone, young or old, including people with osteoarthritis.

Tennis

Tennis is enjoyed by people of all ages. People with problem joints may find the harsh pounding of singles tennis too painful. Playing doubles, which involves less movement, is less stressful.

Walking

Most people can enjoy the benefits of walking, either outdoors or on a treadmill. As with all exercises, start off gradually and build up to minimize soreness. Try to walk at a brisk pace for at least 30 minutes.

Water Exercise

Water exercise is excellent for people with arthritis because the water supports your body and provides resistance. Wading back and forth in four feet of water has been known to help heal fractures. As your strength increases, you can increase the intensity of exercise.

Almost anyone can enjoy the benefits of water aerobics. By wearing a flotation device and moving against the resistance of the water, it's possible to perform movements that might be too painful or strenuous on dry land.

Weight-bearing Exercise

One of the overall best activities for women is weight-bearing exercise.[230] Women who have osteoporosis should exercise under medical supervision. Even a slight stress on a fragile bone could result in fracture. Start with lower resistance and gradually increase.

In the December 28, 1994 *Journal of the American Medical Association*, Tufts University and Pennsylvania State University researchers reported on the impact of high-intensity strength training on 40 postmenopausal women, ages 50 to 70. None of the women were using estrogen, exercised regularly, or had been diagnosed with osteoporosis. The women were divided into groups. One group, using pneumatic exercise machines for 45 minutes two days a week for a year, exercised to strengthen their hips, knees, backs, and abdomens. The other group did not exercise.

One year later, the women who exercised had increased bone density in the hips and spine. This is an important finding, as these areas of the body are most vulnerable to osteoporosis-related fractures and osteoarthritis. The women who did not exercise lost bone density. The women who exercised also demonstrated increases in muscle mass, muscle strength, and balance—improvements that can help prevent falls. In this sense, the study demonstrated that exercise may be more effective than estrogen for bone health. Strong muscles, tendons, and ligaments can also compensate for some joint damage.

Yoga

Excellent for increasing range of motion, cardiovascular health, strength, and endurance, yoga also is beneficial for reducing stress. It is a great stretching exercise. Yoga can enhance mood, attitude, and self-image.

More Benefits of Exercise

Quite apart from exercise's important weight loss benefits, it reduces the risk of heart disease, cancer, osteoporosis, and diabetes and so can reduce the need for estrogen drugs. In particular, exercise is critical to bone health, a condition for which women are often prescribed HRT.

At all stages of life, exercise is essential for strong bones. University of North Carolina researchers found that very active female college freshmen who also had a high calcium intake had nearly 17 percent more bone density than their less active peers who had lower calcium intakes. Furthermore, freshmen who exercised at least four hours a week had even stronger bones. The amount of calcium they consumed was less important.[231]

HRT is also prescribed to reduce heart disease risk. But Dr. Steven Lindheim of the University of Southern California School of Medicine and co-investigators found that even moderate exercise, e.g., 30 minutes of aerobic activity three times a week, among postmenopausal women confers protection against cardiovascular disease. "The findings underscore the importance of physical fitness and its potential benefits to women who do not wish to take estrogen but still want to protect themselves against cardiovascular disease."[232]

Unlike HRT, exercise protects against breast cancer. *The New York Times* announced in January 1986: "Lower Cancer Risk Found in Athletic Women."[233] In this report, the association between risk of breast cancer and physical activity was examined in some 5,000 college graduates between 1925 and 1981.[234] It was concluded that women who began athletic training in youth and established a vigorous lifestyle significantly lowered their risk of both pre- and post-

menopausal breast cancer and benign breast disease. The less-active women had about twice the rate of breast cancer, plus more cancers of the uterus, ovary, cervix, and vagina, which together are responsible for about 40 percent of all women's cancers. A subsequent report and other studies have confirmed these conclusions.[235, 236, 237, 238, 239, 240]

More recent confirmation came from a study on some 1,000 women under age 40.[241] Consistently exercising about four hours per week reduced breast cancer risk by about 60 percent—even if exercise was begun after adolescence. Striking results were found for those who had children and were physically active as teenagers and in their early twenties. However, even exercising two to three hours a week was protective.[242] Furthermore, some protection was evident in spite of risk factors, such as obesity, early menarche, and childlessness.

> "Our data strongly suggest that continued participation in a physical-exercise regimen can markedly reduce the risk of breast cancer in premenopausal women, and emphasize the importance of beginning an exercise regimen early in life and maintaining it through adulthood."

Unanswered, however, is whether exercise begun after menopause can reduce breast cancer risk. One such study examining women age 55 to 64 is now underway. "I think we will also see an effect among postmenopausal women," said the doctor leading the study.[243]

Other studies report correlations between intense physical activity at work and reduced rates of breast cancer. Active jobs "were associated with a significantly reduced risk for cancer of the breast."[244]

Whether your exercise is low-impact aerobics, tennis, light weight resistance, rapid walking, jogging, hiking, or even pool activity, the point is to exercise consistently four to five times weekly for at least three to four hours total duration. Start easy. Build up your endurance, gradually exercising for longer periods. You will receive an enormous health dividend. Your body will feel better. Your mind will feel better.

Dr. McBarron's Prescription for
EXERCISING

- If you have been diagnosed with severe arthritis, heart disease, osteoporosis, or other health problems, work with your doctor or healthcare professional to develop an exercise program that gradually increases in intensity. It is important to pace yourself and never exceed your sense of physical comfort.
- Start easy. Build up your endurance, gradually exercising for longer periods. You will receive an enormous health dividend. Your body will feel better. Your mind will feel better.
- Don't force your joints into painful positions. With continued exercise, your joints will become more flexible.
- Do some type of aerobic exercise four to five times a week for at least 45 minutes.
- Stretch three to five times a week for at least 30 minutes a day.
- A little physical discomfort is all right, but pain is not! Avoid injury. It's better to go out every day than go out hard once and burn out.
- Above all else, be patient. If you don't exercise one day, remember there is always tomorrow. Don't go too fast and burn yourself out after a few days. We're talking about changing your life! The point is to keep exercising for the rest of your life!

Spiritual and Emotional Health

Health is spiritual and emotional. We can't be healthy without a healthy spirit. Neuropsychologist Kenneth R. Pelletier of the University of California School of Medicine notes that stress-related psychological and physiological disorders have become the number one social and health problem in America over the last decade. He goes on to point out that stress-induced disorders have long since replaced epidemics of infectious disease as the major medical problem of the modern era.[245] Stress also accelerates aging. Look at your friends. The stressed ones who are always rushed and under the gun are the ones who likely experience high blood pressure, insomnia, migraines, asthma, hay fever, arthritis, ulcers, alcoholism, and drug addiction. Prolonged stress, which we may experience when we feel helpless, can turn into depression, anger, and hopelessness.

These signals of desperation often are not taken seriously by patients themselves or their doctors, and they are usually not treated comprehensively with a program for turning on the body's own healing powers. Unfortunately, many patients are treated for stress frequently with tranquilizing and other symptom-masking drugs that don't promote healing or insight. By dealing with stress you will find that you have unlocked your own potential to grow and that you will be more likely to love yourself and eat better and exercise, all of which will benefit the way you look and feel.

To deal effectively with stress, conduct a personal appraisal of your own stress triggers and recognize that stress triggers often overlap, fueling each other (e.g., financial difficulties can create relationship difficulties, illness can become financially devastating and test any relationship). Stress can kill. The belief that stress, depression, and hopelessness contribute to susceptibility to disease dates

to 200 A.D. when Galen, the Greek physician, commented that cancer seemed to afflict melancholy women more frequently than happy ones.[246] For most people, these influences on cancer susceptibility are generally unappreciated.[247]

There is substantial evidence of a relationship between the mind and survival in breast cancer patients.[248] A number of studies have found that passive, emotionally suppressed breast cancer patients have a worse prognosis.[249, 250] In 1995, the *British Medical Journal* reported that the risk of breast cancer was increased by as much as fourfold following severely stressful events in the preceding five years.[251] Others have emphasized the mind's role in relation to the susceptibility to cancer and to survival from cancer. "Mounting evidence suggests that active expression of emotions is related to cancer incidence and prognosis.... Research suggests that people's response to challenge may affect whether and how they develop cancer."[252]

Heart disease, another major killer of men and women, has been shown to have a strong link to stress and depression. Studies such as those of psychologist John Barefoot of the Duke University Medical Center have conclusively proven that depression plays a role in the development of heart disease. In the Barefoot study, which began in 1964, those people with the highest scores for despair, low self-esteem, difficulty concentrating, and low motivation had a 70 percent higher risk of suffering a heart attack and 60 percent higher risk of death overall compared to men and women with low scores. Feeling stressed has real implications for health, causing increased heart rate, constricted blood vessels, and high blood pressure. Ominously, those who took part in the Barefoot study were, for the most part, suffering from what is known as subclinical depression, which is often precipitated by prolonged chronic, low-level stress that at first seems acceptable but, over time, becomes cumulatively devastating to health.

ANXIETY

Very much related to stress is anxiety. Modern society and the angst it engenders in all of us is a killer. Generalized, free-floating anxiety—a feeling of dread, anxiety or anguish, is the *angst* of modern life. Something is *wrong* or about to go wrong. But what? Where? We look around and our demons are often invisible. We cannot touch, smell, taste or feel them. They are *not* saber-toothed tigers that we must run away from or stand up against and fight.

Our modern demons are far more insidious. Our enemies are endless billing cycles; poor and indifferent customer service; reduction of our humanity to nine-digit numbers; late flights; endless miles of asphalt parking lots filled with metal and glass cages carrying angry drivers; inadequate protection against noise

pollution; corporate boorishness; taxes; toxic pollution. A society all too often lacking a human touch. That's the real killer today.

It is constant stress that is the real killer. No matter how strong, no woman can take it forever. Anxiety disorders are among the most common mental disorders in the United States, especially among women, notes Dr. A. Pennington, of the Department of Family and Community Medicine, Bowman Gray School of Medicine of Wake Forest University, Winston-Salem, North Carolina.[253] Most patients with anxiety seek treatment from primary care physicians; therefore, recognition and treatment of anxiety disorders are important functions of the primary care physician.

Generalized anxiety and mixed anxiety-depression have received less attention than the major mood and anxiety disorders with respect to their possible effects in increasing disability and health care utilization, notes Dr. P.P. Roy Byrne, of the Department of Psychiatry and Behavioral Sciences, University of Washington, Harborview Medical Center, Seattle.[254] A review of recent studies, however, indicates that these conditions are prevalent in primary care medical settings and are associated with significant social and occupational disability.

Generalized anxiety disorder is also one of the most common diagnoses seen in patients presenting with medically unexplained somatic complaints such as chest pain, irritable bowel symptoms, and hyperventilation and in patients prone to overutilize health care services in general. Anxiety and depression are predictive of later incidence of hypertension and prescription treatment for hypertension.[255]

Yet, generalized anxiety syndrome is poorly recognized by primary care physicians, possibly due to its chronic nature, which may limit the ability of symptoms to stand out and be easily detected.

Physiologically, constant stress has a profound effect on the body and leads to alterations in adrenocorticotrophic hormone (ACTH), growth hormone (GH) and thyroid stimulating hormone (TSH). Chemical messengers that overtax the system and cause it to breakdown, such as acetylcholine, β-adrenergic catecholamines and plasma cortisol, also increase following continued stress.

Stress & Anxiety Triggers

Experts have found six areas that seem to produce the greatest stress.

Physical

Air, noise, and light pollution create extreme stress, as does overcrowding in living situations. Loss of health triggers many other stresses, especially financial, personal, and workplace.

Job-related

Deadline pressures on the job, the constant sense of competition in work, an individual's poor relationship with a difficult boss, and not working at a job that is meaningful or enjoyable are all major stresses. When we lose a job, major stress occurs. University of Michigan researcher Sidney Cobb studied 100 auto paint factory workers starting from six weeks before their jobs were to be terminated, following them for two years. Incidence of hypertension, peptic ulcers, arthritis, and psychosomatic disorders all increased. Moreover, three of the women were even hospitalized with rare peptic ulcers.

Financial

Money difficulties are a prime cause of divorce, domestic violence, and worry.

Relationships

A difficult time with a lover, mate, child, or friend can create unyielding stress. A death in the family or loss of a relationship can also be stressful. More recently, we now know that women in stressful and unrewarding marriages tend to have a higher risk of heart disease.

Social change

Marriage, pregnancy, job changes, and moving can also be stressful. One of the first modern scientists to document the stress of social change was Adolph Meyer, a professor of psychiatry at Johns Hopkins University. By keeping "life charts," he found that illnesses tended to occur at times when clusters of major events occurred in people's lives within a fairly short period of time.

Avoiding Dangerous Medical Drugs

What I don't want you to do is to medicate yourself if you can avoid doing so. As wholistic psychiatrist Hyla Cass, M.D., notes, "Stress and anxiety exact enormous costs in many areas in our individual lives; our physical and mental health; our relationships, families, and organizations; and in society as a whole. Our consumption-oriented lifestyles create increasing stress and anxiety as we struggle to keep up with an ever elusive goal. Is it more money, more things, more time, or more happiness that we seek? Do we even know what we want, let alone how to get it?"

Dr. Cass's book, co-authored with Terrence McNally, *Kava: Nature's Answer to Stress, Anxiety, and Insomnia* (Prima 1998) noted that the most common pharmaceutical anti-anxiety agents are the benzodiazepines—the best known of

which is Valium. Almost four-million Americans take these medications daily, often for years. Two-thirds of benzodiazepine prescriptions are written by family practitioners and internists; most of the remainder are written by psychiatrists. Dr. Cass notes, "Articles published in the late 1970s and early 1980s showed that when taken at the usually prescribed doses, dependence can occur after only one to two weeks."

Although the benzodiazepines suppress the symptoms of anxiety for a few hours, they do not treat the underlying causes, and the anxiety returns as soon as the drug wears off. Moreover, there is a "rebound effect" occurring as a result of physical dependency, with the individuals experiencing even worse symptoms than they started with. Often, tolerance occurs, meaning that even higher doses are needed for the same anti-anxiety effect. These factors—dependency and tolerance—describe an addiction that can be as difficult as heroin to break. Ignoring the warning that these drugs are meant to be taken for only weeks at a time, doctors may continue to renew a prescription for many months or even years, sometimes simply over the phone.

According to one expert:

"Valium (diazepam) is one of the most frequently prescribed drugs in the world. Some 40 percent of American women and 25 percent of Canadian women have taken diazepam-type tranquilizers." [256]

Elavil and Prozac are drugs that are also widely used as antidepressants, sometimes for related anxiety and stress. Prozac is one of the most over-prescribed drugs in America.[257] It is often recommended for conditions other than depression, including treatment of obsessive-compulsive disorder, panic attacks, and, most recently, premenstrual syndrome.[258] Both drugs promote the growth of breast cancer in rodents following administration of a chemical carcinogen.[259] This is a clear sign that we need to be careful with regard to their use, which should be only when absolutely necessary.

Tips for Reducing Stress & Anxiety

Don't constantly suppress aggression. Trying to avoid constant suppression of aggression is important.[260] Dealing with problems directly, by voicing concerns and taking constructive action, is essential to dealing effectively with stress. Feeling free to ask questions, voice concerns, and question authority are examples of active responses. It is also important to discard the sense of urgency—the feeling that we have to do it all now—that makes life so stressful. Operating with a sense of time urgency can contribute to prolonged stress.

Try to see the big picture. Being able to see the larger picture is calming and relaxing. It's important to find a way to work out problems while alone but not lonely. This can come from walks in nature or a regular program of exercise. By getting your mind off your problems on a conscious level, your mind has a chance to go to work on those problems unconsciously and provide the answers you need, but you must be willing to *let go* to accomplish this.

Exercise. Exercise gives many people a way to positively express socially unacceptable emotions and feelings. For example, you're driving and someone cuts you off. Although angry, you may not retaliate, due to fears of sparking a bout of road rage in someone. But your anger accumulates. Exercise helps you work out your anger. Exercise is the best defense against stress. It seems to tune up all aspects of health function and even makes the body more resistant to environmental carcinogens and other toxins.

Develop a warrior spirit. A warrior or fighting spirit is based on confidence that positive steps can be taken in response to any stressful situation and a sense of hope for the future. It is the opposite of helplessness and hopelessness.

Get involved in self-enhancement. All sorts of self-enhancing activities can help to fight off stress. If you love gardening, set aside time each day to do so. Don't deny yourself. If you love playing guitar, play the guitar every day. Spend time with your spouse, children or grandchildren. Everyone has *something* he or she loves doing. Ask yourself what it is and then do it, and often!

Nutritional Support

Remember to take your vitamins. I personally use **Daily Extra** plus **Stressed Out** by Vitologic during stressful times. When people are stressed their bodies need more water soluble vitamins, especially members of the B complex. What's more, people tend to eat worse when they are stressed, and they might be short of key vitamins and minerals, especially vitamin B_6, which is already a problem nutrient in the American diet, according to surveys by the United States Department of Agriculture. Among the best foods for supplying vitamin B_6 are whole grain cereals, sunflower seeds, prunes, liver, walnuts, potatoes, and bananas.[261] These foods are not routinely eaten by many people.

But there are many other dietary supplements that can help to heal the anxious or stressed-out soul, and I want you to know about these, too. My descriptions may strike a chord with you, and it may be a formula that you want to try.

Anti-anxiety Formula

GeriCare® (known also as **Geriforte®**) is one of the world's most thoroughly validated natural anti-aging formulas. If you are suffering from generalized anxiety, you may well want to pick up a bottle of this all-natural, nontoxic formula. It could be a healing elixir.

We all dream of a trip to Hawaii or another tropical island and laying on the sand in the sun without a care in the world. In a sense, GeriCare is the bioequivalent of such a getaway. We now know that anxiety-related alterations in our physiology may be normalized with GeriCare therapy.

Clinical Evidence of Anti-Anxiety Benefits

In 1984, a trial with GeriCare was conducted among 115 persons with psychosomatic disorders such as anxiety neurosis, early thyroid thyrotoxicosis (i.e., Graves' disease, characterized by an enlarged thyroid, rapid pulse, and increased basal metabolism due to excessive thyroid secretions), hypertension or ulcerative colitis and 40 otherwise healthy persons.[262] Comprehensive clinical, laboratory and psychological investigations were conducted.

Thirty persons among the group of 115 and ten among the otherwise healthy persons were given a placebo, the rest GeriCare.

Among measurements taken were levels of acetylcholine (a brain neurotransmitter); platelet monoamine oxidase (a copper-containing enzyme that catalyzes the breakdown of various brain neurotransmitters); and plasma cortisol (a stress hormone, similar to cortisone, produced by the adrenal cortex); as well as electromyographic readings to observe the effect of GeriCare on the skeletal muscles. Investigations were repeated at monthly intervals.

In the GeriCare group, some 89.5 percent of persons showed a significant improvement in their physical and mental health with marked improvement in palpitations, nervousness, and insomnia. No changes were observed in the placebo group.

Particularly noteworthy was that initially high values of acetylcholine revealed at the beginning of the trial were significantly reduced after three months of GeriCare therapy.

Platelet MAO levels were initially lower in persons with thyrotoxicosis, hypertension, and ulcerative colitis. Although not often discussed by doctors with patients suffering from these conditions (particularly high blood pressure), low MAO activity has been frequently reported by researchers in cases of these conditions; normalization, of MAO activity may be associated with a return to normal blood pressure. But after three months of therapy, there was

a significant normalization of MAO levels in cases of early thyrotoxicosis and essential hypertension.

Plasma cortisol levels demonstrated a decreasing trend in the GeriCare group as compared to initial values; there was no significant change in the placebo group.

Electromyographic readings confirmed considerable muscle relaxation in all the cases of psychosomatic disorders after GeriCare therapy.

An open controlled trial was conducted on thirty male and female patients suffering from anxiety disorders with varying degrees of severity. Many of the patients were utilizing anti-anxiety agents such as imipramine, diazepam, chlordiazepoxide, amitryptiline, or doxepin.[263] GeriCare was administered at a dose of two tablets three times daily for six weeks to the patients who were not responding well to their medically prescribed drugs. The patients' responses were determined by their scores on a standardized anxiety test, the Hamilton Anxiety Rating Scale (HARS). A marked reduction in the HARS scores was observed after administration of the GeriCare formula. The effect was observed after the third week, and there was a marked reduction in the total score at the end of the fifth and sixth weeks. A subjective and objective improvement was reported by the patients who could carry out their daily activities more efficiently and with less dread.

In 1990, a study was carried out among nine men and nine women who suffered generalized anxiety disorders.[264] Each person received one to four GeriCare tablets three times daily for four weeks. During the treatment period, patients did not receive their usual anti-anxiety medications. Evaluations were carried out with HARS measurements. By the end of the third and fourth weeks of treatment, a significant reduction in total HARS scores was recorded, showing that GeriCare helped to relieve mental tension, intellectual impairment, and depression.

GeriCare is a completely safe anti-anxiety and anti-aging preparation, consisting of a contingent of more than 30 Himalayan herbs and mineral extracts, thoroughly tested for purity, potency and safety. The formula has gone through complete toxicity testing and is known to be absolutely safe even for use during pregnancy (although no medication or herbal remedy, prescription or otherwise, should ever be taken by women during pregnancy without first informing their doctor).[265]

The beauty of the formula is that it possesses none of the toxicity of anti-anxiety medications—and it works extremely well, especially when used over a several week-period, as the effect seems to build. The therapeutic dosage is two tablets, three times daily. The maintenance dosage is one tablet two to three times daily. The GeriCare formula is from Himalaya USA. It is available at health food stores and natural product supermarkets, as well as some pharmacies.

5-HTP (5-Hydroxytryptophan)

Sometimes stress can lead to mild depression, and this is where 5-HTP can help. Perhaps the most amazing quality about 5-HTP is how quickly this natural agent benefits persons with mild depression. Known as *dysthmia* (from the Greek *thym* for "mood"), mild depression affects millions of persons in the United States. Indeed, many people we know suffer from mild depression (see signs and symptoms of mild depression). They may find that boosting their brain's serotonin levels with use of this natural agent is beneficial to their condition.

"The use of 5-HTP to elevate serotonin levels can produce astounding results," says Michael Murray, N.D., author of 5-HTP: *The Natural way to Overcome Depression, Obesity, and Insomnia* (Bantam Books 1998).

"Since I first became aware of 5-HTP's benefits in the early 1990s, I have used it to treat hundreds of depressed patients."[266]

Early clinical studies were conducted at the Osaka University Medical School.[267] In one of the first studies, 107 patients received 5-HTP at doses from 50 to 400 milligrams (mg) daily. Within four weeks, 74 of the 107 patients reported significant improvements in their mood. There were no significant complications or side effects. A review of subsequent studies indicates depressed people respond quite quickly to 5-HTP therapy.

In a 1991 study, published in *Psychopathology*, results were observed within three to five days.[268] In fact, 5-HTP even outperformed the medical anti-depressant fluvoxamine (Luvox) whose efficacy is on par with fluoxetine (Prozac). Patients using the medical drug required four to seven days to begin seeing results.

In a head-to-head study with the tricyclic antidepressant drug, imipramine, researchers found that the efficacy between 5-HTP and the drug was equivalent but that the natural agent had far fewer and less severe side effects.[269]

Clearly, based on these and other studies, 5-HTP is able to aid people with mild depression to return to a more normal state.

So, how doees 5-HTP perform its biochemical magic? The body can convert the amino acid tryptophan into 5-hydroxytryptophan (5-HTP), then serotonin. But in many persons, this conversion process malfunctions and, instead of 5-HTP, a molecule called kynurenine is produced. (Stress causes overproduction of kynurenine.) Thus, the body may be unable to adequately synthesize 5-HTP. When this happens, severe health problems often result, including depression, insomnia, fibromyalgia, and weight gain. Thus, persons with chronic depression, insomnia, weight problems, and fibromyalgia may have chronically low levels of serotonin.

Unfortunately, pure serotonin cannot be directly ingested or injected. The brain must manufacture its own serotonin from within the body. Because it is a

sleek, lipid soluble molecule, 5-HTP can pass through the blood-brain barrier fairly easily where, in a series of straightforward enzymatic reactions, it is converted to serotonin. The results of dietary supplementation can be profound. In fact, we now know that some 70 percent of orally ingested 5-HTP is carried in the bloodstream to be delivered to the brain.[270]

Dysthmia Signs and Symptoms

One of the criteria to diagnose mild depression is that a person is depressed most of the time for two years (one year for children and teens). Other signs and symptoms include:

❖ Poor self-esteem and lack of self-confidence

❖ Despair and hopelessness

❖ Loss of interest in ordinary activities and pleasures of daily living

❖ Withdrawal from social events and activities

❖ Fatigue and lethargy

❖ Harboring on past events

❖ Chronic guilt

❖ Bouts of anger and irritability

❖ Loss of productivity

❖ Inability to concentrate or make decisions

If you regularly experience at least three of the above signs and symptoms, you may be suffering from mild depression.

When properly selected, 5-HTP is an extremely beneficial and completely safe dietary supplement. However, on August 31, 1998 Food and Drug Administration scientists confirmed the presence of impurities in some currently marketed 5-HTP products. These results confirmed earlier findings by Mayo Clinic researchers who also found impurities in some products. One of these impurities is known as Peak X. Impurities similar to Peak X were found in L-tryptophan that was associated with a 1989 epidemic of eosinophilia-myalgia syndrome (EMS), a condition characterized by elevations of certain white blood cells and severe muscle pain. The Centers for Disease Control and Prevention identified more than 1,500 cases of EMS, including at least 38 deaths, associated with use of contaminated L-tryptophan. While there are questions whether Peak X findings identified in 5-HTP formulas are the same as found in L-tryptophan, it is clear that smart consumers can, and should, avoid this situation altogether by selecting products whose test procedures guarantee them to be free from Peak X. Not all products today offer this guarantee.

You should only select products whose manufacturers can provide Peak X-free certification. Several such companies now produce Peak X-free formulas. Your health food store, natural product supermarket or pharmacy should carry several such brands.

Persons who are using antidepressants, weight-control drugs, drugs that influence the body's circulating serotonin levels or that are known to impair liver function, should not use 5-HTP until they have consulted a qualified health professional. Persons with scleroderma have sometimes been shown to be hypersensitive to 5-HTP and should first consult a qualified health professional before using this dietary supplement. This same precaution also applies to pregnant and breast-feeding women.

More Herbal Stress Reducers

Plants are uniquely adapted to handling stress. In the plant kingdom, they face stress from insects, poor soil, sudden weather changes, drought, fungi, bacteria, and competition from other plants. The scientific world has identified chemicals in these plants that help to adapt to stress. When they are extracted and combined in formulas, their anti-stress properties can be passed on safely to consumers. The science of the best herbal formulas is in skillful blending of scientifically validated, herbal stress protectors. Among the key ingredients in stress formulas:

Valerian (standardized root extract). Valerian root is the herb that in a large dose put Juliet into temporarily deep sleep in Shakespeare's *Romeo and Juliet*. Its principles include volatile oils, choline, flavonoids, sterols, and alkaloids such as vaerlianine, valerine, chatinine.[271] In small doses, valerian is a muscle relaxant and recommended for supporting healthy blood pressure. If you're suffering muscle tension and stiffness or blood pressure problems, valerian root will help to turn on the body's healing powers.

Valerian root, in small, tonic doses, is a nerve stabilizer. If you're extremely fatigued, valerian can pick you up. If agitated, it calms. Valerian has other beneficial attributes, especially during stressful periods when we are more susceptible to environmental influences. Valerian supports healthy cell division and healthy bacteria levels in the body. It is important to realize valerian the herb is not related to Valium the drug.

Motherwort (whole herb). Motherwort's chemicals have impressive credentials for supporting health even under the most trying of circumstances, and especially heart and circulatory health (wort is old English for plant). Its high glycoside content makes it extremely important to heart health. Motherwort has found its way into every corner of the earth where natural healing is prac-

ticed and is known as heart wort, heart gold, heart heal or heart herb, says herbal expert Daniel Mowrey, Ph.D. Motherwort lowers blood pressure, relaxes the palpitating heart muscle and increases circulation through the tissues.[272] Motherwort also calms the spirit.

Skullcap (whole herb). Back in 1861, Dr. J.D. Gunn wrote in the *New Domestic Physician or Home Book of Health,* "Scull-cap is a valuable tonic nervine and...especially useful in neuralgia, convulsions, delirium tremens...nervous excitability, restlessness, and inability to sleep, and indeed in all nervous affections." Skullcap has been extensively studied by Russian scientists. In their experiments, skullcap proved to be a tonic, sedative, relaxant, and blood pressure lowering agent.

Hops (flower standardized for rutoside content). Hops flower relaxes the central nervous system and is an excellent remedy for tension, stress, and anxiety. Many people seeking deep and relaxing sleep continue to enjoy hops pillows which contain the flowers.

Passionflower (standardized to isovitexin content). Passionflower, with small quantities of tranquilizing alkaloids, relieves nerve pain and acts as an anti-spasmodic.[273] Passionflower's active ingredients were shown to be effective in inducing a relaxed state experimentally.

Chamomile (flower standardized to apigenine content). Chamomile flower is an excellent calming herb long used by traditional healers worldwide.

Kava. According to Dr. Cass, kava calms without sedating, and enhances awareness, concentration, and clarity of focus, all without serious side effects, lethal effects, or addictive potential. In higher doses, kava produces restful, restorative sleep. "If we are looking for analogies with conventional drugs, and consider St. John's wort to be 'Nature's Prozac,' then kava is 'Nature's Valium,'" notes Dr. Cass. "But unlike users of Valium and other anti-anxiety drugs, the mind of the kava user remains clear, with many even reporting a sharpening of physical coordination and mental clarity. Research bears out these findings, as does clinical experience."

Some six double-blind studies of kava in patients with anxiety have shown significant reductions in stress and anxiety as rated by both patient and physician. Some have also shown emotional and muscular relaxation while simultaneously stimulating the thinking process and activity. In the several studies in which kava has been compared to benzodiazepines, these show that kava, as opposed to benzodiazepines, does not sedate and, yet, is equally adept at countering anxiety. Moreover, rather than impairing mental sharpness, it actually improves it.

MORE HELP FOR DEPRESSION

Depression has always been counted among the most common psychological disorders. Some experts say there is no cure for depression but time and, perhaps, adaptation or psychological readjustment. Others note that depression may reflect various bodily chemical imbalances. Most common therapies, including antidepressant drugs, mask symptoms or modulate chemical balances in the body. For more than three millennia, plant-based remedies have been used in the treatment of depression. These too can help to accomplish the same goals as medical drugs but, clearly, have a far superior tolerance and safety profile.

By the third millennium BC, the opium poppy (*Papaver somniferum*) was known to enhance well-being and called "Plant of Joy" by the Sumerians. In Greek Minoan culture, opium, the exudation from unripe poppy capsules, was commonly used and, during the Bronze Age in the third and second millennia BC, widely traded. The *Assyrian Herbal* makes mention of *Atropa belladonna*, taken from the deadly nightshade, for its calming effects and stabilizing effect on the autonomic nervous system when used in small doses. The compendium of remedies gathered by the Pythagorean physicians including Alcmaeon of Croton (around 570 to 500 BC) and Hippocrates (460-377 BC) included some 250 remedies for depression. In the late Hippocratic schools, the euphoric effect of hypericum oil was recognized.

In the era of the great healer Paracelsus (1493-1541), St. John's wort was recognized as "arnica for the nerves." Today, St. John's wort (*Hypericum perforatum*, also referred interchangeably to as hypericum) is perhaps the most well-studied and safest natural medicine for the treatment of depression.

Since 1979, many controlled clinical trials have been carried out with St. John's wort extracts which have confirmed the antidepressant efficacy of the medicine compared to placebo and to other standard medical antidepressant drugs.

If you are suffering mild to moderate depression and are using typically prescribed antidepressants but are concerned about both acute and chronic complications from their use, I suggest you consider the St. John's wort alternative.

Pioneers Widespread Medical Acceptance

It takes a lot for a natural medicine to impress the editorial board of a major medical journal. But that's precisely what happened when a series of medical reports on hypericum were published in a special issue of the *Journal of Geriatric Psychiatry and Neurology* in October 1994.

"Until 3 months ago, I had never heard of hypericum, but in reviewing these papers and other literature, I have been impressed with the potential of this compound as a therapeutic agent in the treatment of mild-to-moderate depressive illnesses, the kind of depressions that predominate in outpatient medical practice," noted supplement editor Michael A. Jenike, M.D., in the lead editorial for the special supplement. "While the precise mechanism of action remains to be determined, the results of the

continued on next page

many studies outlined in this Supplement form an impressive body of evidence indicating that hypericum may well be a potentially useful agent to treat mild-to-moderate depressions."

Examples of Clinical Validation

Versus Placebo

Drs. H. Sommer and G. Harrer studied the natural medicine with 105 mildly depressed patients.[1] They received either St. John's wort or placebo. Therapy lasted four weeks. Efficacy was judged according to a standard depression rating scale. Both groups had similar starting symptom ratings. By the end of the second week, both groups showed a reduction in symptoms. However, after this point, only the group receiving the natural medicine continued to improve. **Symptoms were cut in half within four weeks, according to scale results, a much larger reduction than in the placebo group. More than twice as many patients responded to treatment in the active group than in the placebo group.**

Depression is often manifested as physical complaints. The cardinal somatic symptoms seen with depression are often a feeling of ill-health and various physical complaints, including fatigue, disturbed sleep, heart palpitations. Such persons often turn to their family doctor first and expect to be relieved or cured of their physical complaints but are not aware that their real problem is depression.

With this in mind, researchers utilized St. John's wort extract in a randomized, placebo-controlled, double-blind study with 39 patients suffering from somatic depression.[2] Therapy lasted four weeks. Dosage was 300 mg three times daily.

The patients receiving St. John's wort showed a "significant improvement… as compared to placebo. Seventy percent of the patients treated with LI 160 [a proprietary name used for St. John's wort] were free of symptoms after 4 weeks."

Most responsive were patients who complained of tiredness, fatigue, and disturbed sleep. Additional symptoms that responded well to the natural medicine were heart palpitations, exhaustion, headache, and muscle pain.

The efficacy of St. John's wort was once again confirmed in a multi-center double-blind study conducted at eleven physicians' practices with a wide range of patients participating. Although we generally think of hypericum as a natural remedy for mild to moderate episodes of depression, in this study patients were suffering major depression.[3]

Once again, a statistical evaluation "revealed a significant improvement in… the active group as compared to the placebo. After switching the placebo group to active treatment (5th to 6th week of therapy), significant improvements were found in the original placebo group."

continued on next page

Versus Medical Drugs

How would St. John's wort do against the medical antidepressant imipramine? This question was answered by Dr. E.U. Vorbach and co-investigators in a double-blind study with 135 outpatients treated at 20 centers.[4] Treatment lasted for six weeks. In this study, the Hamilton Depression score improved by 56 percent among persons using the natural medicine and by 45 percent among patients on 75 mg of imipramine. There were far fewer side effects among users of the natural medicine. Thus, the study demonstrated St. John's wort works as effectively as this standard medical antidepressant drug and with far better safety and tolerance profile.

Like imipramine, maprotiline has become a standard medical drug for evaluating antidepressants. In this study, the efficacy of St. John's wort was compared to maprotiline among a group of 102 patients with depression at six specialty centers.[5] Over four weeks, patients received identical pills, either the natural plant medicine in the standard dosage of 300 mg three times daily or 25 mg of maprotiline three times daily. The natural plant medicine demonstrated "roughly equal efficacy" with the drug; however, in terms of patients who were "very much improved" or "no longer ill," the plant medicine was superior. This is probably due to the favorable tolerance profile. In particular, some 22 percent of patients using the drug complained of tiredness, compared to only four percent using the plant medicine.

In Seasonal Affective Disorder

Mankind has always regarded the sun as the source of life-giving energy. However, the significance of sunlight for healing illnesses was not realized until the advent of the industrial age. Seasonal affective disorder represents a subgroup of major depression with a regular occurrence of symptoms in autumn and winter and full remission in spring and summer. Light therapy has become standard treatment, although antidepressants are also used with some success.

The aim of this study was to determine if St. John's wort could be beneficial and whether, combined with light therapy, even better results could be obtained.[6] The results demonstrated that St. John's wort has antidepressive actions in SAD patients; what's more, there was some evidence that the antidepressant effect of St. John's wort might be potentiated by additional application of light therapy.

Improved Sleep

Very often depressed persons experience sleep difficulties, including fitful sleep and early waking. In particular, non-selective MAO inhibitors and tricyclic antidepressants decrease both REM and slow-wave sleep. It is thought that a deficit in slow-wave sleep is a significant indicator in affective disorders. It has also been reported that patients with depression with a high proportion of slow-wave deep sleep have a considerably more favorable prognosis than patients with low values. St. John's wort was studied for its impact on sleep quality in older persons.[7] It was shown St. John's wort has a differ-

continued on next page

ent effect on sleep than medical antidepressants. *There was no decrease in REM sleep and a marked increase in slow-wave sleep in the deep stages.*

Selection Criteria Critical

I am extremely concerned that my patients and readers utilize quality natural medicines. Although many consumers believe the major active compound in St. John's wort formulas is **hypericin**—recent research demonstrates that **hyperforin**, a secondary metabolite, is responsible for much of the natural medicine's antidepressant qualities.

Unfortunately, St. John's wort is so popular, demand has exceeded supply. As a result, some growers are using high-nitrogen fertilizers to enhance crop yield at the expense of these secondary metabolites. This lack of efficacy was suggested in a recent testing carried out by the *Los Angeles Times* and *Boston Globe*.[8, 9]

In biological assays, only two of five St. John's wort products passed the novel "BioFIT" test for their ability to block the reuptake of both serotonin and dopamine, two neurotransmitters involved in depression. Abnormalities in the reuptake, or absorption, of serotonin and other neurotransmitters are believed to be a major cause of depression; many prescription antidepressants work by blocking the reuptake of serotonin into brain cells, thus leaving more in the synapse, or gap, between cells. Although St. John's wort may have other modes of action, about which little is known, the BioFIT testing suggests less potent St. John's wort may have been used in the products. These products may have had less secondary metabolites such as hyperforin.

In a study, published in *Life Sciences*, researchers note that hyperforin is not only absorbed within the fatty tissues of the brain but that it is a potent uptake inhibitor of serotonin, thereby allowing for more of this feel-good chemical to remain active (which is also how many chemical antidepressants work).[10] Furthermore, say the researchers, the potency of various St. John's wort extracts as measured by their effects on depressive symptoms "closely correlate with their hyperforin contents." The doctors add, "In addition, most known neuropharmacological properties of the clinically used hypericum extracts can also be demonstrated with pure hyperforin. It appears, therefore, that this non-nitrogenous constituent is a possible major active principle responsible for the observed clinical efficacies of the extract as an antidepressant...."

This all suggests that savvy consumers who demand quality formulas should seek formulas utilizing plant materials rich in both hypericin and hyperforin, as well as other less well-characterized secondary metabolites.

In the United States, **Enzymatic Therapy**, **Solgar**, **Sunsource** and **Hypericum Buyer's Club** exclusively utilize materials in their St. John's wort-based formulas that provide adequate amounts of hyperforin. Preference for these brands will ensure consumers their very best opportunity for obtaining promised therapeutic results.

References

1 Sommer, H. & Harrer, G. "Placebo-controlled double-blind study examining the effectiveness of an hypericum preparation in 105 mildly depressed patients." *Journal of Geriatric Psychiatry and Neurology*, 1994; 7(supplement 1): S9-S11.

continued on next page

2 Hübner, W.-D. & Podzuweit, H. "Hypericum treatment of mild depressions with somatic symptoms." *Journal of Geriatric Psychiatry and Neurology,* 1994; 7(supplement 1): S12-S14.
3 Hänsgen, K.-D., et al. "Multicenter double-blind study examining the antidepressant effectiveness of the hypericum extract LI 160." Journal of Geriatric Psychiatry and Neurology, 1994; 7(supplement 1): S15-S18.
4 Vorbach, E.-U., et al. "Effectiveness and tolerance of the hypericum extract LI 160 in comparison with imipramine: randomized double-blind study with 135 outpatients." *Journal of Geriatric Psychiatry and Neurology,* 1994; 7(supplement 1): S19-S23.
5 Harrer, G., et al. "Effectiveness and tolerance of the hypericum extract LI 160 compared to maprotiline: a multicenter double-blind study." *Journal of Geriatric Psychiatry and Neurology,* 1994; 7(supplement 1): S24-S28.
6 Martiznes, B., et al. "Hypericum in the treatment of seasonal affective disorders." *Journal of Geriatric Psychiatry and Neurology,* 1994; 7(supplement 1): S29-S33.
7 Schulz, H. & Jobert, M. "Effects of hypericum extract on the sleep EEG in older volunteers." *Journal of Geriatric Psychiatry and Neurology,* 1994; 7(supplement 1): S39-S43.
8 Monmaney, T. "Remedy's U.S. sales zoom, but quality control lags." Los Angeles Times, August 31, 1998: A1.
9 Foreman, J. "St. John's wort: less than meets the eye." *Boston Globe,* January 10, 2000: S4.
10 Chatterjee, S.S., et al. "Hyperforin as a possible antidepressant component of hypericum extracts." *Life Sci,* 1998; 63(6):499-510.

More Thoughts on Stress

It is important to keep in mind that some stress is good, but when stress turns to distress, you do not accomplish as much as you do when you are living in a more relaxed state. Stress is often a very real symbol of our loss of connectedness with our spiritual quest, that our lives are out of balance, or that we are not living our lives in accordance with out deepest needs and values. You can overcome stress by making decisions and sticking with them. Decide right now to determine your needs and make sure you do things daily to fulfill these needs. Discard your sense of time urgency. Put yourself in enjoyable, productive situations.

Now is the time to make decisions that enable the very best you to emerge.

Dr. McBarron's Prescription for
5-Point Emotional Health Action Plan

❖ Identify stress triggers. Learn why you react to them and how not to react to them any more.

❖ Lose your sense of time urgency. Do something that is purely self-enhancing for at least one hour every day.

❖ Determine what your deeply-seated needs are, and live a life in tune with these needs.

❖ Eat a healthy diet low in saturated fat and rich in fruits, vegetables, whole grains, and organic low or nonfat dairy.

❖ Use the daily formulas, nutrients or herbs detailed in this chapter whenever possible rather than resorting to prescription drugs.

CHAPTER TWELVE

Diet for a Beautiful Woman

Make sure you put foods into your body that will promote both inner and outer health. That means consuming the right fats, such as those from flax, seafood, olive oil, and walnuts, and eating plenty of fresh fruits and vegetables. These are the foods that will help to give you beautiful skin, hair and nails, and healthy eyes and bones.

Beauty is more than skin deep. A great diet can help you to fulfill all of your potential to be beautiful and vibrant forever. It nourishes your skin, bones, hair, and nails and helps to maintain healthy veins and avoid cellulite. A great diet can help to protect you from breast cancer, heart disease, diabetes, and other age-related conditions.

Most skin, hair and nail problems are diet-related. By consuming foods rich in nourishing vitamins, minerals, co-factors, and other beauty stimulants, skin, hair and nails reflect good nourishment. Foods have an almost immediate effect on the body. If you eat foods that are good for your hair, skin, and nails, you will start feeling better after your first meal! Guaranteed!

THE GOOD FOODS

Let's look more closely at those foods that you should include in your daily diet.

Whole grains (breads, cereals), pasta, brown rice
 Whole grains should be important parts of your diet. Grains contain important connective tissue nutrients such as inositol and pantothenic acid (vitamin B_5), other members of the B vitamin complex family, as well as minerals such

as magnesium, boron, selenium, silica and copper. Recent biochemical litera-
ture notes that the skin of persons with exceptional hair growth is higher in sili-
cic acid. Some studies have found that, occasionally, high amounts of certain B
vitamins, such as PABA, can return color to graying hair.

Whole grains are rich in selenium, which helps the body resist infections and
stimulates production of antioxidants such as glutathione and glutathione per-
oxidase that help reduce premature skin aging. This mineral's protective effects
against cancer may be important, especially among women whose diets are
selenium-deficient.[274, 275, 276] In 1993, "a preventive effect [against breast cancer] was
found with increasing plasma selenium levels" among postmenopausal women
using supplementary selenium.[277] Additional reports have shown that selenium
prevents breast cancer in mice infected with a carcinogenic virus.[278] Dr. Gerhard
Schrauzer, an international selenium authority, emphasizes, "If every woman in
America started taking selenium supplements or had a high-selenium diet, then
within a few years the breast cancer rate in this country would drastically decline."

Fruit

A diet rich in vitamin C and flavonoids helps remedy spider veins, especial-
ly when you consume flavonoid-rich, deeply colored berries (e.g., blueberries
or blackberries). When my patients increase their overall intake of vitamin C,
both through foods and dietary supplements, these unsightly reminders of the
aging process gradually disappear.

Fresh fruits provide generous amounts of vitamin C. Vitamin C is vital to
building healthy collagen tissues. In nature, vitamin C-rich foods are also rich
in flavonoids, many of which act as antioxidants, and help the body optimize
its use of vitamin C. Both flavonoids and vitamin C are excellent for your skin.

Mandarin orange, papaya, and pineapple are rich in flavonoids and enzymes
that are important to healthy skin in that they help support connective tissues
and fight inflammation.

Vegetables

Fresh greens, especially leafy greens, provide detoxifying chemicals such as
glutathione and high amounts of folic acid and other B vitamins necessary to
proper skin and nail formation. Frequent salad bars. But watch out for fatty,
calorie-loaded salad dressings.

Low-fat protein

Eating low-fat protein like seafood is a great way to feed your body amino acids, which it converts into the protein threads that hold together and build up muscles and skin. Seafood such as salmon and tuna are rich in omega-3 fatty acids. These fats are very good for skin because they reduce inflammation. Omega-3 fatty acids gently lower the body's overall levels of inflammation. Eating omega-3 fatty acid-rich seafood also protects against breast cancer and its spread.

Legumes (beans)

Beans are an excellent, low-fat protein source. Many, such as soy, are a rich source of plant estrogens (phytoestrogens), which boost or balance women's estrogen levels and prevent estrogen imbalances. Remember, by boosting levels of safe plant estrogens in your body, your skin will be softer, more youthful and less wrinkled. Eating tofu helps to fight bloating and water retention, as well as cravings for sweets, because of its high amounts of magnesium and plant estrogens. And beans are great for maintaining healthy cholesterol and regularity.

Organic dairy

Be sure your dairy is organic. My favorite dairy product is nonfat yogurt, which is a great source of calcium and magnesium, two important minerals for skin and bone health, as well as the amino acid cystine. Reintroducing pure, absorbable cystine back into the body helps keep the basic hair protein, keratin, strong. Thinning hair is often low in cystine; thick healthy hair is high in this important amino acid. What's more, one cup of organic non- or low-fat yogurt a day with specific Lactobacillus cultures can help to fight candida overgrowth and yeast infections by restoring a healthy balance of bacteria to the body. This, in turn, helps clear the complexion and reduce inflammation. When you consume dairy products, prefer those products that are organically labeled to avoid factory-farming methods that are cruel to animals and antibiotic drug residues that cause allergic skin reactions in some women. By eating organic dairy products, you also cut down your exposure to pesticides that build up in fat tissue and harm your body's processes in many subtle ways.

Fats and oils

There's good fat and bad fat. Some fats, the ones you fry or bake and burn, cause inflammation and weight gain. Any oil that is heated to too high a temperature produces toxic chemicals such as free radicals. Free radicals age the

skin quickly. It's wise to limit your intake of saturated fats, which are found in animal foods such as beef, lamb, chicken, and dairy. Hydrogenated vegetable oils, which contain trans-fatty acids, are also harmful to your skin. These fats cause the skin to be inflamed, if consumed regularly.

The best oils are flax, walnut, and olive. Our bodies desperately require fats—the proper fats—for ultimate skin beauty, especially as we age. But too many women have cut out *all* fats—and that's dangerous. Up to 70 percent of the population suffers from skin conditions such as eczema, characterized by chronic itchy, inflamed skin that is very dry, red, and scaly. Another two to four percent of people suffer from psoriasis, which is characterized by sharply bordered reddened rashes or plaques covered with overlapping silvery scales.

Using flaxseed in your daily baking can really help. Flaxseed was once a staple food source used by the ancient Greeks, Romans and Egyptians, supplying ample amounts of valuable essential fatty acids, amino acids, protein, dietary fiber and cancer preventing phytonutrients. Unfortunately, within the last 100 years, our use of flax has been replaced by modern methods of food processing, combined with preferences for wheat and other less nutritious enriched grain products.

Nutrition research on flaxseed has confirmed its potential as a new (actually ancient) ingredient for breads, buns, and other bakery products. Ground flaxseed (flaxseed flour) can be added to almost any baked product and adds a nutty flavor to bread, waffles, pancakes, and other products.

Filtered water

Most women will benefit from drinking filtered or bottled water. The low quality of municipal water leaves us vulnerable to infectious organisms, toxic metals, and petrochemicals, which manifest themselves as boils on the skin and other eruptions. The better quality brands of bottled water list their source of water on the label. Be wary of brands that fail to list their source. Also, do your homework if considering a water filtration system for your home. Remember to drink 64 ounces of water every day, more if you exercise.

Green Tea

Green tea is another nutrient known to reduce risk of breast and skin cancer. In the Shizuoka Prefect of Japan, where green tea is a staple of the diet, the incidence of breast cancer is significantly reduced.[279] Its phytochemical constituents also have been shown to help protect against breast cancer when tested in the animals.[280] Green tea's potent phytochemicals, especially its catechins, have

been shown to be highly effective protectors against skin cancer, according to a 1994 report in the *Journal of Investigative Dermatology*.[281] Green tea is widely consumed throughout Asia. If you don't drink green tea daily, taking a nutritional supplement containing green tea is beneficial.

AVOID THESE FOODS

Red meat and fat-laden dairy

Saturated fat and pesticides, synthetic hormones, and antibiotics make red meat a poor choice. If you eat red meat, choose organically raised meats that are produced without hormones, antibiotics, and steroids. Organic meat is less disruptive to women's endocrine systems. Ditto for non-organic butter or ice cream.

Deli foods

Foods such as luncheon meats, corned beef and pastrami cause inflammation and contain allergenic substances called nitrites. Beef liver can contain residues of veterinary drugs used to medicate animals.

Sugar and salt

These foods interfere with the body's proper use of vitamins and minerals. Sugar and salt are often found in foods with the lowest nutritional value and highest fat content, such as soft drinks and potato chips.

Rancid foods

Foods that have been pan- or deep-fried contain inflammatory fats that make your skin red and puffy. Avoid rancid foods, and be sure to check expiration dates of packaged foods containing fat.

Excess caffeine in coffee, black tea, cocoa, soda, and chocolate

Excess caffeine causes dehydration. It can also cause minerals to be leached from the body and damage the health of the hair and nails.

Dr. McBarron's Diet Prescription

Entire books have been written on diet. But it's really quite simple. Most of us know good foods from bad foods—and, in reality, there are no bad foods; more important is how much and how often we consume them. I have a 20/80 rule. I eat good foods 80 percent of the time and allow myself to let loose and splurge about 20 percent of the time. The foods that are good for you include low-fat protein such as salmon, tuna and other types of baked, broiled or poached seafood (non-fried, please); plenty of fruits and vegetables; whole grains; organic nonfat dairy; and oils such as flax, olive, and walnut. Stay away from too much saturated fat-rich dairy and beef, candy, baked goods, and creamy dressings.

PART FOUR

Specialized Health Issues

It is critical to discuss health issues that may not affect all women
but nevertheless seem to afflict a fair share of women—particularly women
who are in their thirties, or older. Among these issues are candidiasis
(yeast syndrome), sluggish thyroid, and joint health. I'll not burden you with
long treatises on each condition but rather will try to get you going on
a solid natural healing foundation. For more information, pick up
a copy of *Encyclopedia of Natural Medicine* by Michael Murray, N.D. and
Joseph Pizzorno, N.D. (Prima Publishing 1998). This book is an
extremely valuable resource.

Paps and Premenstrual Syndrome

Although uncomfortable and potentially embarrassing, a pap smear is and can be a lifesaver to many women. A pap smear is critical to detection of early cervical and reproductive cancer. As a doctor, if I could figure out how to do my own pap smear, I would. However, given this is impossible, I must motivate myself to go for my annual pap smear. As a doctor, I know this is right. As a woman, I wish I had other options and procrastinate this exam as much as possible. However, my message to you ladies is as it is to myself: get your pap smear as often as your gynecologist recommends. It's an important step towards good health and longevity.

Having gone to medical school at Hahenmann University in Philadelphia, I learned that PMS stood for premenstrual syndrome. Upon moving to Atlanta, Georgia, to complete my Fellowship in medicine, I learned that PMS was replaced by FTS, otherwise known as "fixing to start." Kidding aside, all women, even post-hysterectomy, will experience changes in their body secondary to hormonal fluctuations. These fluctuations are normal and we should embrace these changes in our body, not fight them nor feel they are a disease that should be treated. Through proper diet, exercise and supplements, PMS can be a part of our life and not simply something that is dreaded or requires drug intervention. I like to joke with my patients and friends that we go from puberty to PMS to menopause with little or no break in between. These are normal phases in a woman's reproductive life that should be accepted and dealt with as normal just as once a month there is a full moon. In other words, it is not something to be feared or hated, but quite simply "a fact of life."

Doctors are usually good at reminding you to have your Pap smears, but they're not so good at helping women to take care of their PMS problems. Premenstrual syndrome has been a familiar medical condition since at least 1931, although use of the actual term was first coined in 1953.[282, 283] Premenstrual syndrome, or PMS as it is commonly called, encompasses a wide variety of emotional and physical symptoms that occur from several days to weeks before the onset of menstrual flow. Although many women experience some discomfort, these premenstrual changes do not disrupt their daily lives. In some women, however, they are overcome by debilitating mood and behavioral changes in the week preceding menstruation that interfere with their normal daily functioning.

BIG BUSINESS

Menstrual disorders—especially premenstrual syndrome or PMS—are big business. They are becoming ever more so.

Although once doctors were likely to treat such conditions with hormones such as synthetic progesterone (progestins), they are now also likely to prescribe antidepressants such as Prozac or Paxil. Such use of antidepressants has opened up entirely novel and profitable markets for the manufacturers of these drugs.

Recently, a Food and Drug Administration advisory committee unanimously approved fluoxetine (Prozac) as the first drug for treatment of severe premenstrual syndrome, known technically as premenstrual dysphoric disorder (PMDD) and characterized by marked depression, anxiety, moodiness or irritability that interferes with daily activities.

Although Prozac was already being prescribed for PMDD, the drug's manufacturer Eli Lilly renamed the drug Sarafem for this market. Sensing a potentially lucrative market, pharmaceutical giant SmithKline Beecham now markets their antidepressant paroxetine hydrochloride (Paxil) also for PMDD.

Clearly, in cases of severe PMS, the pharmaceutical giants would like to see American women medicating themselves with some very potent—and troubling—drugs.

I question the wisdom of having women take a drug possibly daily which can pose side effects such as anxiety, nausea and loss of sexual desire for a disorder that affects them less than two weeks a month. What's more, the advisory commission's recommendation, which was endorsed by the FDA, was based on a study of only 172 women—none of whom belonged to a racial minority. Plus, women on birth control were excluded—even though such women represent a large segment of menstruating women.

Of further note, Prozac, one of the most over-prescribed drugs in America, was recently shown to promote the growth of breast cancer in rodents following administration of a chemical carcinogen.[284, 285, 286]

My advice in non-life threatening conditions is to use nutritional and herbal intervention first—and to resort to Prozac or Paxil (which has also shown evidence of carcinogenicity) only as a last resort. (What's more, if women must use these drugs, clinical evidence demonstrates intermittent dosing seems to be as effective as daily use for women with PMDD.[287])

Lost in the pharmaceutical community's rush to embrace the latest and greatest medical drug is the steady research into herbal and nutritional remedies.

FOUR TYPES OF PMS & NUTRIENTS THAT HELP

Often, premenstrual difficulties are seen by the practitioner as one single set of symptoms. In fact, professionals involved in the study and treatment of PMS say that this condition has no one single cause. Rather, PMS is intricately bound to women's metabolism and her own individual hormonal milieu. It is important to take a wholistic approach, recognizing that many factors such as diet, endogenous hormone production, environmental stress and woman's general health, play a role in the severity of PMS. In addition, a woman's state of mind may also play a role.

Fortunately, medical research indicates that when health practitioners and their patients look at the PMS symptoms as part of smaller subgroups of symptoms, specific nutritional support programs can be tailored to minimize such discomforts.

Thus, a better, possibly more useful approach is to divide PMS symptoms into four discreet subgroups, as advocated by Dr. Guy Abraham.[288] In working with patients, their symptoms are not likely to fit any one group, and it may appear that patients' symptoms are a combination of two or more of the subgroups. However, the preponderance and severity of symptoms should be used to match your PMS with one of the four subgroups.

Group One (PMS-A [A = Anxiety])

Think of anxiety as the key symptom in group one. The most common constellation of symptoms consists of premenstrual anxiety, irritability and nervous tension, as well as depression, which may be expressed in behavior patterns that are detrimental to self, family, and possibly even society.

It is key to note that medical researchers have observed women with such symptoms generally have *elevated* blood estrogen and *low* progesterone. This is generally the most common hormonal disturbance seen among PMS patients.

Patients in this subgroup also tend to consume excess amounts of dairy products and refined sugar. For this reason, patients should be counseled to instead increase their intake of vitamin B_6-rich foods including bananas, walnuts, salmon, dried beans, dark leafy greens, and wheat germ.

In the first pattern, particularly during the menopausal years, women experience nervous tension with irritability. The cause seems to be "elevated" estrogen levels. Adequate vitamin B_6 levels can help to support healthy estrogen balance, according to Dr. Abraham.

In my own practice, I've found that vitamin B_6 (about 50 mg daily) is a key nutrient. Its anti-depressant effects were first noted in the treatment of depression caused by birth control pills. Some half-dozen clinical studies have generally demonstrated good results for the use of this vitamin in treating PMS-related depression. However, its effectiveness may be further enhanced with additional vitamin B_2 and magnesium, so it is probably a good idea to take a broad-spectrum B complex dietary supplement, together with extra magnesium.

Group Two (PMS-H [H = Hyperhydration])

The second most common subgroup is associated with symptoms of water and salt retention, abdominal bloating, breast pain, and weight gain. This group may have elevated serum levels of the adrenal hormone aldosterone, which causes fluid retention by preventing the excretion of salt from the body. Again, excess estrogen production may cause abnormally elevated increases in aldosterone.

In the second pattern, women experience water and salt retention, bloating, and weight gain. They have elevated levels of aldosterone. Vitamin B_6 and vitamin E help.

Group Three (PMS-C [C = Carbohydrate Craving])

Women experience an increased appetite, particularly craving refined sugars, consumption of which is followed by heart palpitation, fatigue, fainting spells, headache, nervousness, and sometimes shakes. These patients have increased carbohydrate tolerance and low-red-cell magnesium.

In one study, researchers sought to evaluate whether certain foods and beverages that are high in sugar content or taste sweet are related to the prevalence and severity of PMS.[289] Specifically, they sought to evaluate whether consumption of junk foods, chocolate, caffeine-free cola, fruit juices or alcoholic beverages might exert an effect on PMS apart from any effects of daily consumption of beverages that are high in caffeine (caffeine-containing coffee, tea and colas).

The study was based on 853 responses to a questionnaire probing menstrual and premenstrual health and certain daily dietary practices; it was mailed to female university students in Oregon. An analysis of the data revealed that the consumption of chocolate, but not of other junk foods, was related to the prevalence of the premenstrual syndrome among women with more severe premenstrual symptoms. Likewise, the consumption of alcoholic beverages (all alcoholic beverages and beer only) was related to the prevalence of the premenstrual syndrome among women with more severe symptoms, as were both fruit juice and caffeine-free soda. None of the associations were substantially altered when the daily consumption of beverages high in caffeine content was controlled for. Taken together, these data suggest that the consumption of foods and beverages that are high in sugar content or taste sweet is associated with prevalence of PMS.

In this third pattern, women suffer low magnesium and folic acid levels. Indeed, oral magnesium "successfully relieves premenstrual mood changes," according to one recent report in *Obstetrics & Gynecology*.[290]

Many women know magnesium is essential to building strong bones, but how many women know that magnesium can help them to maintain a healthy balance of the sex hormones, that it can promote relaxation, and fight stress? Magnesium can even can help to alleviate migraines and other kinds of headaches, according to Dr. Abraham. Magnesium also provides a protective quieting effect to ease stomach upset.

Although whole-grain wheat contains more than 1,500 parts per million (ppm) of magnesium, white flour has less than 300 ppm. Most bakery and grain products today are made with white flour.[291]

According to the U.S. Department of Agriculture's food-consumption survey, only 25 percent of all women meet even the minimal amounts in the RDA for magnesium. Some 39 percent of women consume less than 70 percent of the RDA. The average consumption of magnesium has dropped drastically since 1900 from an average of 475 milligrams per person to 245 mg today.[292]

Magnesium supplementation alleviates premenstrual symptoms of fluid retention. Researchers from Hugh Sinclair Unit of Human Nutrition, Department of Food Science and Technology, University of Reading, UK, investigated the effect of a daily supplement of 200 mg of magnesium (as magnesium oxide) for two menstrual cycles on the severity of premenstrual symptoms in a randomized, double-blind, placebo-controlled, crossover study.[293] Although there was no effect compared with placebo in any category in the first month of supplementation, by the second month there was a greater reduction of symptoms of weight gain, swelling of extremities, breast tenderness, and

abdominal bloating. The researchers concluded that, "A daily supplement of 200 mg of Mg (as MgO) reduced mild premenstrual symptoms of fluid retention in the second cycle of administration."

Many of the features of PMS are similar to the effects produced by the injection of prolactin.[294] Some women with PMS, particularly women in the PMS-H group, have elevated prolactin levels, but, in most, the prolactin concentrations are normal. It is possible that some women are abnormally sensitive to normal amounts of prolactin. There is evidence that prostaglandin E1, derived from dietary essential fatty acids, is able to attenuate the biologic actions of prolactin and that, in the absence of prostaglandin E1, prolactin has exaggerated effects. Attempts were made, therefore, to treat women who had PMS with gamma-linolenic acid, an essential fatty acid precursor of prostaglandin E1. Gamma-linolenic acid is found in human, but not cows', milk and in evening primrose oil, the preparation used in these studies. Three double-blind, placebo-controlled studies, one large open study on women who had failed other kinds of therapy for PMS and one large open study on new patients, all demonstrated that evening primrose oil is a highly effective treatment for depression and irritability, breast pain and tenderness, and the fluid retention associated with PMS.

Additional nutrients known to increase the conversion of essential fatty acids to prostaglandin E1 include magnesium, vitamin B_6, zinc, niacin and ascorbic acid. The clinical success obtained with some of these nutrients may in part relate to their effects on essential fatty acid metabolism.

Finally, do not forget the use of calcium. Previous reports have suggested that disturbances in calcium regulation may underlie the pathophysiologic characteristics of premenstrual syndrome and that calcium supplementation may be an effective therapeutic approach. In one fairly large study involving some 466 women ranging in age from 18 to 45, researchers from St. Luke's-Roosevelt Hospital Center, College of Physicians and Surgeons, Columbia University, New York, concluded: "Calcium supplementation is a simple and effective treatment in premenstrual syndrome..."[295]

Group Four (PMS-D [D = Depression])

The least common but most dangerous subgroup is the fourth. The symptoms are depression, withdrawal, insomnia, forgetfulness, and confusion. These patients have low blood estrogen levels. Elevated adrenal androgens (male hormones) may be found in some patients with excessive facial hair. Complications such as high lead levels may exacerbate this condition; therefore, hair analysis

or blood testing to rule out heavy metal intoxication is helpful. I recommend additional phytoestrogen supplements together with vitamins B_6, B_5 and folic acid for this group for fighting depression. Balanced amino acids, with an emphasis on lysine and tyrosine, can be helpful.

To evaluate the efficacy of vitamin B_6 in the treatment of premenstrual syndrome depression, a systematic review of published and unpublished randomized placebo-controlled trials of the effectiveness of vitamin B_6 in the management of PMS was undertaken.[296] Women with depressive symptoms were 169 percent more likely to show an improvement in their depressive symptoms, based on four trials representing 541 patients. These results suggest that doses of vitamin B_6 up to 100 milligrams per day (mg/day) are likely to be of benefit in treating PMS symptoms, including depression. However, because of the danger of nerve toxicity at doses above 150 mg/day, limit your daily intake to around 50 to 100 mg/day whenever possible.

Two other natural medicines that may be helpful to women with depressive symptoms are standardized potent extracts of kava combined with St. John's wort. Kava is a powerful natural anti-anxiety medicine that also relieves pain and whose effects are immediate. St. John's wort, on the other hand, is a highly effective anti-depressant with mild pain-relieving properties. It also has diuretic, anti-inflammatory and astringent properties to help reduce bloating and swollen breasts, ankles, and hands. The anti-depressant action of St. John's wort may require several weeks to become apparent.

AND DON'T FORGET...

Dong quai

Dong quai, a major part of Chinese medicine, is extremely important to all women for hormonal balance and is strongly recommended by health experts worldwide.[297, 298] "This herb is high in natural plant estrogens," advises Sandra Cabot, M.D., author of *Smart Medicine for Menopause*.[299] When translated, dong quai means "state of return" or "proper order."[300] In eastern medicine, dong quai is often prescribed for abnormal menstruation, suppressed menstrual flow, painful or difficult menstruation, anemia, and uterine bleeding.[301] It is the Chinese medicine of choice and can help to normalize hormonal balance for women suffering either PMS or menopausal symptoms.

Vitex agnus-castus (Chaste berry)

Chasteberry (*Vitex agnus-castus*), a native of the Mediterranean whose berries have long been considered a traditional women's herb, is particularly well-documented when dealing with premenstrual syndrome symptoms including nervousness, irritability, depression, bloating, breast tenderness, weight gain, and skin and digestive problems.

Scientific investigation has shown chasteberry has profound effects in supporting normal hormone levels in the body. Specifically, it has been shown to increase the secretion of luteinizing hormone by the pituitary while reducing the secretion of follicle-stimulating hormone. As a result, the ovaries put out more progesterone, a goal in cases of premenstrual syndrome and many menstrual disorders. Clinical studies have shown a good effect on premenstrual acne flare-ups and water retention. Chasteberry has also been used to promote and prolong breast feeding.

Chasteberry is also important due to its profound normalizing effect on pituitary function and for stimulating the body's progesterone secretions. More than 1,500 women have participated in the studies utilizing chasteberry.[302, 303] The studies are impressive, as is this natural medicine's impact on women's hormonal balance.

In the most recent study, a team of German investigators designed a controlled, double-blind study to evaluate the efficacy and safety of a standardized chasteberry extract (Agnolyt® from Madaus AG) in comparison with pyridoxine (vitamin B_6, also used in treatment of PMS) in 175 women suffering from PMS.[304]

The women were randomized to receive daily treatment with either chasteberry or 200 mg of pyridoxine. Treatment lasted three menstrual cycles. Therapeutic responses were measured with various standardized PMS scales and assessed by both patients and physicians.

Compared to pyridoxine, chasteberry users experienced "a considerably more marked alleviation of typical [PMS] complaints, such as breast tenderness, edema, inner tension, headache, constipation, and depression."

Some 77.1 percent of women who took chasteberry improved compared to about 60.6 percent of women using the vitamin. Among their doctors, 80 percent rated both the vitamin and herb as providing "adequate" benefits. In contrast, 24.5 percent of doctors evaluated chasteberry therapy as "excellent," compared to about half that percentage (12.1 percent) who felt the vitamin provided equivalent benefits.

Complications were minimal and included headache, gastrointestinal and lower abdominal complaints, and skin problems. No serious adverse events

were reported. Bolstering the reputation chasteberry has for improved fertility, five women who used the herb became pregnant during the study.

Chasteberry profoundly influences the hypothalamus and normalizes pituitary secretion of gonadotropin–releasing hormone (GnRH) and follicle-stimulating-hormone- releasing hormone (FSH-RH). Michael Murray, N.D., notes, "It appears that chasteberry extract has profound effects on the hypothalamus and on pituitary function. As a result, it is able to normalize the secretion of other hormones; for example, it reduces the secretion of prolactin and lowers the estrogen-to-progesterone ratio."[305]

Chasteberry may be particularly useful in cases of corpus luteum insufficiency or prolactin excess.[306] Benefits may require up to three months. The usual recommended dosage in tablet or capsule form is 175 to 225 mg per day of an extract standardized to contain 0.5 percent agnuside. If using a liquid tincture, typical dosage is about two milliliters per day.

Alternative Therapies

A study published in the 1993 December issue of the Journal of Obstetrics and Gynecology found that women who received ear, hand and foot reflexology (pressure applied to reflex points on the body that correspond to specific body areas or functions) 30 minutes once a week for eight weeks experienced a significant decrease in PMS symptoms. Acupuncture, which uses needles instead of manual pressure to stimulate particular points, is also thought to be helpful for women suffering from PMS.

Here's additional help for specific conditions:

Primary Dysmenorrhea

Characterized by painful menstruation, primary dysmenorrhea typically begins a few hours prior to or coincident with the onset of menstruation and may last from a few hours to several days. Although the pattern of pain is variable, a sharp colicky, pain above the pubic area often accompanies it, with radiation to the lower back and thighs, nausea, vomiting, diarrhea, irritability or headaches.

In one study published in 1998 in *Obstetrics & Gynecology Today*, 40 patients were selected who were suffering dysmenorrhea and marked premenstrual symptoms for at least three consecutive months.[307] The women's menstrual cycles were evaluated monthly for a period of three months following treatment with MenstriCare™ from Himalaya USA.

Among the 26 patients suffering dysmenorrhea, patients reported a reduction in lower abdominal and back pain after one month of therapy and all were

totally symptom-free after two to three months. In 14 patients, who experienced PMS, there was a marked decrease in symptoms such as fullness in the breast, lower abdomen, face and feet. Eleven of the fourteen women reported that they were free from premenstrual headache and gastrointestinal upsets they experienced prior to treatment.

Abnormal Uterine Bleeding

Abnormal uterine bleeding is commonly encountered during a woman's reproductive phase; about 20 percent of complaints to gynecologists center on such bleeding. About half of all patients who experience these problems are over 40 years of age, while about 20 percent are teenagers.

A clinical trial was conducted among 35 women patients who were between 19 and 45 years of age.[308] Each had a history of profuse abnormal uterine bleeding with clots for 12 to 14 days for at least six months. Although after one month of treatment with MenstriCare, patients reported only a slight decline in bleeding, by the end of three months all of the women noticed a significant decrease in bleeding and the duration of flow had been reduced to six to eight days.

Oligomenorrhea & Fertility

Infrequent and scanty menstruation (oligomenorrhea) is a common problem in women of reproductive age. In a 1998 study published in *The Antiseptic*, 20 women patients were selected who had regular periods occurring between 40 to 180 days.[309] Several of the patients were suffering from ovarian cysts and considered to be infertile. These women were given the MenstriCare formula for three months.

Among patients who had regular periods but only with spotting or minimal flow, a good response was observed, and the flow increased to three to four days. For five patients with periods occurring between 40 to 60 days with spotting, the amount of flow increased, although the duration of bleeding did not change significantly. One patient conceived in her month of use of MenstriCare. Among seven patients with periods occurring between 40 to 60 days and with a flow of two to three days, two patients reported a decrease in the interval between periods.

By the way, there is limited evidence that MenstriCare may have a favorable influence on ovarian cysts and infertility. Among its ingredients are **Saraca indica**, proven effective in dysmenorrhea and possessing estrogen-like activity that helps in healing the inflamed endometrium during menstruation; **Symplocos racemosa**, reported to be useful in treating uterine dis-

orders; **Boerhaavia diffusa** with potent anti-inflammatory activity; **Asparagus racemosus**, which contains saponins that hinder the oxytocic activity of the uterine musculature, thereby maintaining spontaneous uterine motility and relieving spasms; **Aloe vera** to improve fertility; **Acacia arabica**, a known uterine stimulant; **Cyperus rotundus**, which is effective in the treatment of anemia and general weakness; **Hemidesmus indicus**, with a healing effect on the uterus and helps in uterine involution; and **Tinospor cordifolia**, a well-established immunomodulator that boosts immune status and impairs a feeling of well-being. The therapeutic dosage is two tablets, twice daily; the maintenance dosage is one tablet, twice daily. MenstriCare (also known as Menstrim) is available nationwide from natural health retailers. (See Resources.)

Dr. McBarron's Prescription for HEALING PMS

Be sure to identify your type of PMS and tailor your diet and nutritional supplement choices to match your symptoms.

CHAPTER FOURTEEN

Getting Rid of Candida

If you're feeling "sick all over" and if you've been regularly using antibiotics, you could be suffering from complications of yeast syndrome or candidiasis.

A lot of my women patients suffer from yeast syndrome when they first come to see me. An overgrowth in the gastrointestinal tract of the usually benign yeast (or fungus), *Candida albicans* is now becoming recognized as a complex medical syndrome known as *chronic candidiasis* or the *yeast syndrome*. Many women have yeast syndrome but don't even know it is the reason they feel "sick all over." Yet even women who know they suffer from yeast syndrome often live with this debilitating condition for years because their doctors are unable to provide them with an effective and safe healing program.

The typical patient with the yeast syndrome is female; women are eight times more likely to experience the yeast syndrome than men, due to the effects of estrogen, birth-control pills, and the higher number of prescriptions for antibiotics. Indeed, prolonged antibiotic use is believed to be the most important factor in the development of chronic candidiasis. Antibiotics suppress the immune system and the normal intestinal bacteria that prevent yeast overgrowth, strongly promoting the proliferation of candida.

CANDIDA SYMPTOMS

Major candida symptoms include fatigue or lethargy, feeling "drained"; poor memory; feeling "spacey" or "unreal"; depression; numbness, burning, or tingling; muscle aches and weakness; pain or swelling in the joints; abdominal bloating; constipation or diarrhea; persistent vaginal itch or burning;

endometriosis; cramps and other menstrual irregularities including premenstrual tension; erratic vision including spots in front of eyes; allergies; immune system malfunction; chemical sensitivities; and digestive disturbances.

DIAGNOSIS AND CONVENTIONAL TREATMENT OF YEAST SYNDROME

The best method for diagnosing chronic candidiasis is clinical evaluation by a physician knowledgeable about yeast-related illness. The manner in which the doctor will diagnose the yeast syndrome will probably be based on clinical judgment from a detailed medical history and patient questionnaire. The doctor may also employ laboratory techniques, such as stool cultures for candida and measurement of antibody levels to candida or candida antigens in the blood. Once diagnosed, most physicians prescribe drugs such as Nystatin, Ketoconazole, or Diflucan. These antifungal drugs can provide temporary relief but rarely produce significant long-term results because they fail to address the underlying factors that promote candida overgrowth.

COMPREHENSIVE, SAFE, NATURAL HEALING

In treating chronic candidiasis, a comprehensive approach is more effective than simply trying to kill the candida with an antifungal drug. For example, most physicians fail to recognize that a number of dietary factors appear to promote the overgrowth of candida. It's important to treat patients wholistically for candidiasis, treating the whole person to increase digestive secretions, enhance immunity, and promote detoxification and elimination. I use a comprehensive nutritional supplement program, including the use of natural anti-yeast herbal extracts.

Here's my basic program for treating candidiasis:

Limit sugar
Sugar is the chief nutrient for *Candida albicans*. Restriction of sugar intake is an absolute necessity in the treatment of chronic candidiasis. Most women do well by simply avoiding refined sugar, honey, maple syrup, and fruit juice.

Limit milk and dairy products
There are several reasons to restrict or eliminate the intake of milk in chronic candidiasis. Milk's high lactose content promotes the overgrowth of candida. Milk is a

common food allergen and milk may contain trace levels of antibiotics, which can further disrupt the gastrointestinal bacterial flora and promote candida overgrowth.

Avoid mold- and yeast-containing foods

It is generally recommended that individuals with chronic candidiasis avoid foods with a high content of yeast or mold, including all alcoholic beverages, cheeses, dried fruits, and peanuts.

Increase digestive secretions

In many cases, an important step in treating chronic candidiasis is improving digestive secretions. Gastric hydrochloric acid, pancreatic enzymes, and bile all inhibit the overgrowth of candida and prevent its penetration into the absorptive surfaces of the small intestine. Decreased production of any of these important digestive components can lead to candida overgrowth in the gastrointestinal tract. Restoration of normal digestive secretions through the use of supplemental hydrochloric acid, pancreatic enzymes, and substances that promote bile flow is critical.

Restore immune function

Restoring proper immune function is one of the key goals in the treatment of chronic candidiasis. The thymus is the master gland of immunity, located in our chest at birth. As we age, it shrinks and stops working. Prevention of thymic involution (shrinkage) by ensuring adequate dietary intake of antioxidant nutrients such as carotenes, vitamin C, vitamin E, zinc, and selenium, as well as concentrates of thymus extract is extremely important.

Promote detoxification

Candida patients usually exhibit multiple chemical sensitivities and allergies, an indication that detoxification reactions are stressed. Therefore, the liver function of the candida patient needs to be supported. In fact, improving the health of the liver and promoting detoxification may be a critical factor in the successful treatment of candidiasis.

Damage to the liver is often an underlying factor in chronic candidiasis as well as chronic fatigue. When the liver is even slightly damaged, by chemicals or injury, immune function is severely compromised. The nutrients choline, betaine, and methionine are often beneficial in enhancing liver function and detoxification. These nutrients are referred to as *lipotropic* agents because they promote the flow of fat and bile to and from the liver. In essence, they produce

a decongestant effect on the liver and promote improved liver function and fat metabolism. There is a long list of plants that exert beneficial effects on liver function. The most impressive research has been done on a special extract of milk thistle known as silymarin, which has shown impressive results in improving liver function and detoxification processes in double-blind studies. I also recommend artichoke extract.

Eat more fiber

In addition to directly supporting liver function, detoxification involves proper elimination. A diet that focuses on high-fiber plant foods should be sufficient to promote proper elimination by supplying an ample amount of dietary fiber. If additional support is needed, fiber formulas can be taken. These formulas are composed of natural plant fibers derived from psyllium seed, kelp, agar, pectin, and plant gums such as karaya and guar.

Take probiotics and prebiotics

The gastrointestinal tract is inhabited by both beneficial and harmful bacteria. The intestinal flora play a major role in a person's health and nutritional status. Unfortunately, antibiotics destroy both friendly and unfriendly bacteria That means that the gastrointestinal tract of candida sufferers often must be recultivated with healthy bacteria. Products containing healthy bacteria are called *probiotics*. I also recommend a *prebiotic*, which acts much like a "salt lick" or nourishing food for the body's beneficial bacteria (instead of actually supplying the healthy bacteria). In this way, prebiotics help to nurture the beneficial bacteria that have already adapted to living in your gastrointestinal tract and increase their population. Look for Inuflora™, a natural prebiotic supplement that can aid in restoring such populations.

Use natural anti-yeast compounds

Use appropriate anti-yeast therapy. There are a number of natural agents with proven activity against *Candida albicans*. Among natural agents recommended to treat *Candida albicans* are berberine-containing plants, garlic, and enteric coated volatile oil preparations.

Berberine, an alkaloid, has been extensively studied in both experimental and clinical settings. Berberine exhibits a broad spectrum of antibiotic activity, including activity against bacteria, protozoa, and fungi, particularly *Candida albicans*. Berberine's action in inhibiting both *Candida* and disease-causing bacteria prevents the overgrowth of yeast that is a common side effect

of antibiotic use. Berberine-containing plants include goldenseal, barberry, and Oregon grape. Enzymatic Therapy and PhytoPharmica both offer great lines of berberine-containing supplements.

Garlic has demonstrated significant antifungal activity. In fact, its inhibition of *Candida albicans* in both animal and test tube studies has shown it to be more potent than nystatin, gentian violet, and six other reputed antifungal agents. The active component is allicin, which gives garlic its pungent, distinctive smell.

The newest natural anti-candida formulas are enteric-coated volatile oil preparations. Oils of oregano, thyme, peppermint, and rosemary are all effective antifungal agents. A recent study that compared the anti-candida effect of oregano oil to that of caprylic acid found that oregano oil is over 100 times more potent than caprylic acid against candida. Since volatile oils are quickly absorbed and associated with inducing heartburn, enteric coating is recommended to ensure delivery to the small and large intestines. Such natural anti-yeast supplements are available without a prescription at your local health food store.

Dr. McBarron's Prescription for
NATURALLY HEALING YEAST SYNDROME

* Avoid unnecessary use of antibiotics, steroids, immune-suppressing drugs, and birth control pills. Eliminate refined and simple sugars; milk and other dairy products; foods with a high content of yeast or mold, including alcoholic beverages, cheeses, dried fruits, melons and peanuts.
* Increase digestive secretions with a multiple enzyme formula that provides an extremely high potency pancreatic and digestive enzyme complex.
* Take three to five grams of water-soluble fiber such as guar gum, psyllium seed, or pectin at night before retiring for bed. Your health food store carries many appropriate brands.
* Consider taking lipotropic factors to enhance liver function. These provide a balanced combination of nutrients for liver function, including betaine, choline, and methionine.
* Also consider a milk thistle supplement with silymarin or artichoke extract to facilitate good liver health.
* It is extremely important to take a probiotic/prebiotic formula. These balance your system with friendly bacteria to help stop yeast overgrowths. Anyone on antibiotics also needs a probiotic/prebiotic supplement concurrently to maintain the health of the gastrointestinal tract.

Healthy Thyroid Function

Are You Suffering from Sluggish Thyroid?

Questionnaire

- ❖ Have you recently suffered moderate weight gain combined with cold intolerance?
- ❖ Do you suffer bloating or swelling?
- ❖ Are your cholesterol and triglyceride levels elevated, despite using drugs to lower them?
- ❖ Do you suffer from dry, rough skin covered with fine superficial scales?
- ❖ Is your hair coarse, dry, and brittle?
- ❖ Have you suffered hair loss?
- ❖ Are your nails thin and brittle?
- ❖ Are you depressed, weak, or tired and have difficulty concentrating?
- ❖ Are you extremely forgetful?
- ❖ Do you have muscle weakness and joint stiffness?
- ❖ Do you suffer with constipation?
- ❖ Do you experiencing prolonged and heavy menstrual bleeding?
- ❖ Are you infertile?
- ❖ Have your pregnancies resulted in miscarriages, premature deliveries, or stillbirths?

If you answered yes to five or more of these questions, you may have a sluggish thyroid. Unfortunately, sluggish thyroid (hypothyroidism or underactive thyroid) is not a condition that will necessarily show up on your doctor's usual tests.

You see, scientists now know the blood tests used to measure thyroid function are not sensitive enough to diagnose milder forms of underactive thyroid.

Because mild hypothyroidism is the most common form of hypothyroidism, the majority of people with hypothyroidism are undiagnosed!

About one to four percent of the adult population suffers from moderate to severe hypothyroidism. But, according to experts, another 10 to 12 percent have mild hypothyroidism, while other experts put the rate of mild hypothyroidism in the general adult population at 25 to 40 percent. And these are the folks who are least likely to receive an accurate diagnosis from their doctor. Incidence increases with age.

This is so important. I don't know how many women patients of mine have been going through difficult times because of an undiagnosed, sluggish thyroid. The thyroid gland regulates metabolism in every cell of the body. A deficiency of thyroid hormones, which often goes undiagnosed, can impact virtually all aspects of health. In addition, you won't get full benefit from other nutritional therapies. For example, although vitamin A, zinc, and essential fatty acids can usually relieve dry, scaly skin, they won't improve your skin condition if your thyroid is underactive.

Almost all treatment of sluggish thyroid requires use of desiccated (dried) animal thyroid tissue or synthetic thyroid hormone. Most naturopathic physicians prefer to prescribe desiccated natural thyroid, which is complete with all thyroid hormones. Although the Food and Drug Administration requires thyroid extracts sold in health food stores to theoretically be hormone-free, as a matter of practicality, it is impossible to remove all of the hormone from the gland, so health-food store thyroid preparations could be considered milder forms of prescription strength natural thyroid. In cases of mild hypothyroidism, these preparations may provide enough support to help you with your thyroid problem. But work with your doctor.

How to Tell if You Have a Tired Thyroid

❖ Your basal body temperature is the most sensitive functional test of thyroid function. Body temperature reflects metabolic rate, which is largely determined by hormones secreted by the thyroid gland. All you need is a thermometer. Although men and postmenopausal women can perform the test at any time, menstruating women should perform the test, on second, third, and fourth days of menstruation.

❖ At night, before retiring, shake the thermometer until it registers below 95 degrees Fahrenheit and place it by your bed.

❖ When you awake, place the thermometer in your armpit for a full 10 minutes. Lie as still as possible. (Lying down with your eyes closed is best.) *continued on next page*

❖ After 10 minutes, read and record the temperature and date.

❖ Record the temperature for at least five mornings, preferably at the same time each day.

❖ Give the results to your doctor to interpret. Eliminate the highest and lowest value and average the other three. Your basal body temperature should be between 97.6 and 98.2 degrees Fahrenheit. Low basal body temperatures are very common and could reflect hypothyroidism. Less common is a high basal body temperature, which may be evidence of hyperthyroidism (with signs and symptoms such as bulging eye-balls, fast pulse, hyperactivity, inability to gain weight, insomnia, irritability, menstrual problems, and nervousness).

Dr. McBarron's Natural Prescription for A HEALTHY THYROID

Thyroid hormones are made from iodine and the amino acid tyrosine, so a thyroid supplement should definitely provide both of these nutrients (Often, natural iodine is provided in the form of a kelp-based supplement, since this sea vegetable is a rich source of natural iodine). Vitamins function together in many body processes, including manufacture of thyroid hormone—vitamin C and the B complex vitamins riboflavin (B_2), niacin (B_3), pyridoxine (B_6), iodine, and selenium are necessary for normal thyroid hormone manufacture.

Be sure to reduce excess consumption of foods that can prevent the utilization of iodine. These foods, termed "goitrogens," include turnips, cabbage, broccoli, cauliflower and brussel sprouts. However, cooking usually inactivates goitrogens.

Eating small portions three to five times a day is better than one to two large meals a day.

Exercise is critical to stimulate thyroid gland secretions and increase tissue sensitivity to thyroid hormone. Many health benefits from exercise may, in fact, be the result of improved thyroid function. Exercise is especially important for overweight people with underactive thyroid glands. In addition, it's more beneficial to exercise consistently rather than intensely. For example, I recommend shorter intervals of brisk walking six days a week rather than one super-long walk once a week.

Help for Vaginitis

I worry about my women patients who are diagnosed with vaginitis and then prescribed some very powerful, heavy-duty drugs to get rid of their infection. Vaginitis is often caused by a tiny, one-celled organism called trichomonas. Another cause may be elevated populations of pathogenic organisms called gardnerella. Other organisms may also be involved. Symptoms include itching and irritation of the vagina and swelling and redness of the vulva.

Vaginal infections, known medically as vaginitis, are the most frequent reason American women see their doctors. They account for more than 10 million office visits each year. Yet, a recent Gallup survey found that very few women have a thorough understanding of these common afflictions. While 95 percent of women surveyed had heard about yeast infections, only 36 percent had ever heard of the more common vaginal infection called bacterial vaginosis (BV), which can lead to serious medical complications. Bacteria rather than yeast cause this condition.

VAGINAL INFECTIONS BACKGROUND

Vaginitis isn't one disease. Various organisms cause it; some are transmitted during sex; many cause itchy, smelly, or irritating discharges. Most cases require a laboratory test to determine exactly which organism is to blame, and most are treated with prescription drugs. If sexually transmitted, both partners may need to be treated.

As I mentioned, trichomonas causes one of the commonest types of vaginitis. The outward signs of trichomoniasis are a yellow-gray-green, frothy vaginal

discharge that may have a foul or fishy odor. Burning, itching, soreness and redness of the vagina may also occur. In addition, urination and intercourse may be painful, and the symptoms may worsen during menstruation. On the other hand, many women with this infection may not have any symptoms.

While many physicians once believed vaginal infections were largely harmless, mounting evidence indicates that certain types of vaginitis may lead to complications if left untreated. Bacterial vaginosis is the most common vaginal infection. The disease has been found in 12 to 25 percent of women in routine clinic populations and 32 to 64 percent of women in clinics for sexually transmitted diseases (STDs).

Most importantly, BV has been associated with pelvic inflammatory disease, which can result in infertility, as well as increased risk of endometritis, cervicitis (possibly cervical cancer), pregnancy complications, post-operative infections and other health problems.

Experience has taught me that natural remedies may be preferable to a course of metronidazole (Flagyl), which may kill both trichomonas and gardnerella. My colleague Michael Loes, M.D., M.D.(H.), notes, "Metronidazole is known by doctors and pharmacists alike as the ultimate 'bowel sweeper,' taking everything—including friendly bacteria—with it."

But there's more. Flagyl, made by G.D. Searle, is one of the most widely prescribed antibiotics. It was the first effective drug against vaginal infections (trichomonas), for which it is still widely used. (By the mid-1970s, it was prescribed more than two million times annually.[310])

"Noteworthy" rates of breast cancer in rats have been found with metronidazole. In one report, the drug was said to have "considerable carcinogenic potential."[311]

More experimental studies have also reported "significant" excesses of breast cancer.[312] Although several short-term human studies found no excesses of breast cancer, I believe the animal evidence raises a clear warning—and I want my women patients to try these natural pathways before resorting to a drug like this with its suspect safety record.[313, 314]

Before resorting to some of these very heavy duty and potentially toxic antibiotics, I'd rather have my women patients try boosting their body populations of friendly bacteria. By having healthy populations of friendly bacteria in their gastrointestinal tract, they are likely to experience long-term protection against vaginitis. Not only is its occurrence and recurrence reduced, women can avoid having to repeatedly rely on potentially dangerous medical drugs commonly used to treat this condition.

In contrast to conventional therapy, use of probiotics and prebiotics can help to protect against reinfection.[315]

We know that a decrease in women's lactobacillus populations is associated with increased risk for vaginitis. The studies support what I'm saying:

* In a study of 12 women with non-specific chronic vaginitis, it was found that women were most likely to be symptom-free when their populations of beneficial lactobacilli were highest.[316] As the lactobacilli populations decreased, bacterial pathogens were commonly isolated, indicating a disturbed vaginal ecology.

* In another study, samples of vaginal fluid from 60 women indicated that as the population of lactobacillus decreased, the population of bacterial pathogens increased.[317]

* These findings were reconfirmed in another observational study when vaginal fluid from 53 women with nonspecific vaginitis and without the condition was analyzed and the populations of pathogenic bacteria were found to be elevated among afflicted women.[318]

A probiotic is a dietary supplement containing colonies of beneficial bacteria. A prebiotic is used to feed the beneficial bacteria already in your gastrointestinal tract. I think my patients should use both. With probiotics and the prebiotic Inuflora, we have a safe alternative or complement to antibiotic use. Boosting the body's own healing response by restoring its population of friendly bacteria protects against reinfection and has a decided advantage over antibiotic therapy alone.

* In one study of 94 patients with non-specific vaginitis, treatment with a supplement to increase the body's populations of beneficial lactobacillus resulted in a decrease of pathogens and increase in the population of normal lactobacilli.[319] Vaginal purity and vaginal pH also returned to normal. A cure or at least marked improvement in symptoms was documented in 80 percent of patients.

* In a second study, 444 women with *trichomoniasis vaginalis* were treated with a supplement to raise populations of friendly bacteria.[320] One year later, 427 (96.2 percent) were followed up, and 92.5 percent of them were found to be cured of clinical symptoms, while the remaining 7.5 percent had either a positive slide or culture.

* In another clinical report, 20 patients reported that they cured their candida vulvovaginitis with preparations designed to enhance their populations of friendly bacteria.[321]

Dr. McBarron's Natural Prescription for
VAGINITIS

Before you use metronidazole or other prescription antibiotics, discuss with your doctor the possibility of using natural dietary supplements for boosting your body's populations of beneficial bacteria. These may work as well. There are many quality probiotic formulations available at your natural health retailer, but be sure the ones you purchase are found in the refrigerator section, which will insure that they are more likely to deliver viable cultures of friendly bacteria. See Resources for a source for Inuflora.

Nutritional Help for Pesky Urinary Tract Infections (UTIs)

Despite ever-improving antibiotic therapy, about 10 percent of us are affected by infections of the urinary tract, most often afflicting the bladder as well. Also known as cystitis or UTIs, these irritating infections usually involve an infectious inflammation of the bladder lining (mucosa). As in all urinary tract infections, the characteristic quartet of bacterial pathogens which appear again and again is also encountered here: *E. coli, Enterococci, Proteus bacteria* and *Staphylococcus aureus,* in a mono or polyinfection.

As common as they may be, we want to take care of UTIs and get a complete cure. If only incompletely treated, infections can travel via the urethra or kidneys, spreading systemically. Due to their short urethra, women are more liable to be afflicted with types of ascending infections.

The commonest contributory factors for UTIs are colds, urinary retention, hormonal factors and, of course, sexual intercourse. Less often, usually in more specialized cases, we see cases of allergic cystitis, radiation cystitis or toxic cystitis (effects of chemical substances).

In addition to measures such as bed rest, fluid intake and analgesics, the causative agents respond to specific chemotherapy. But the problem is that UTIs tend to become chronic, especially if the mucosa was damaged previously. Chronic UTIs often come and go intermittently, but with chronic cases, the deeper layers of the bladder wall are usually also involved in the inflammatory process.

Many readers, no doubt, are familiar with use of cranberry juice, which may prove beneficial in such conditions, due to its ability to prevent adherence of pathogenic bacteria to the mucous membranes of the urinary tract. Other persons may rely on colloidal silver—it also has proven benefits in this area of health.

I strongly urge women with any type of UTI to ingest cranberry juice, which truly can be helpful, because of its ability to prevent the bacterial pathogens from attaching themselves to the bladder wall.

But there are some other efficacious avenues of healing wherein we can help ourselves—sometimes by combining natural medicine with your doctor's prescribed antibiotic regimen.

SYSTEMIC ORAL ENZYMES

These little critters—systemic oral enzymes—are great for any kind of infectious inflammation. Enzymes interrupt the causative pathogenic sequence of chronic inflammation. They cause inflammatory edema (water retention) to dissipate and they counteract the inflammation cascade by breaking up immune complexes and aiding in their elimination. Aside from relieving pain, enzymes stimulate the microcirculation and inhibit the further development and chronification of UTIs.[322, 323]

Now here's where it gets really interesting. In an European study, researchers treated 56 women patients with UTIs by giving them a combination of Wobenzym N and antibiotics. This was a very sophisticated study that included laboratory measurements for levels of the therapeutic agents in the bloodstream, as well as urinalysis and bacteriological examination.

What they found was amazing: Wobenzym N increased the serum concentration of all antibiotics and chemotherapeutic drugs. Overall, the researchers concluded that the combination of Wobenzym N and antibiotics was good medicine against infective agents that cause UTIs. In their study, a complete cure without recurrence was achieved only by this combination therapy.[324]

The usual dosage for this application of Wobenzym N is five tablets three times daily, in-between meals. (Never take systemic oral enzymes with meals or they will be used for digestion rather than being systemically absorbed.)

HIMALAYAN HERBOMINERAL FORMULA

The beauty of modern Himalayan remedies is that they often are "the alternative to the alternative." We Americans think of the Himalaya region of India as highly exotic. But once we get beyond the cultural and geographic differences, there are some good medicines that come from this area of the world. The Himalaya region, specifically Bangalore, is home to the Himalaya Drug Company, which is one of the world's leading producers of natural medicines (and the originator of

the use of rauwolfia for high blood pressure). They've produced a good plant-based formula for women with frequent urinary tract infections.

Known as UriCare, this herbomineral remedy possesses proven stone-dissolving, anti-infective, diuretic, antiseptic and antispasmodic properties. Indeed, this clinically proven combination of nine different herbal and mineral extracts may be the preferred treatment for clearing gravel and stones from the urinary system.

FYI: Reduce Urinary Tract Infections to Reduce Risk of Stones

There may be somewhat of a relationship between urinary stones and urinary tract infections.[325] Sometimes doctors find that infection by urea-splitting organisms (e.g., Klebsiella aerogenes, Proteus vulgaris, Pseudomonas aeruginosa, *and* Staphylococcus aureus) *may contribute to urinary stone formation by splitting urea and ammonia, which, in turn, alkalinize the urine. At such high pH values, phosphate precipitates with calcium, magnesium and ammonium. Thus, clearing urinary tract infections may also be key to reducing risk of urinary tract stones.*

Let's look at the studies that support its use:

❖ In a 1980 report in *Probe*, 100 patients with various urinary tract infections were divided into three groups.[326] Group I patients were treated with UriCare, together with multivitamins and alkalizers. Group II patients were treated with UriCare and antibiotics. Group III received antibiotics only. The results demonstrated that the combination of UriCare and antibiotics produced excellent results, surpassing those of either UriCare or antibiotics alone.

❖ In 1991, UriCare was studied in a comparative trial among 227 patients complaining principally of burning and frequent micturition (urination).[327] The aim of the study was to assess UriCare's use as an adjuvant or additive treatment in combination with usual treatment such as alkalizers and specific antibiotics. Clearly, the combination of UriCare with the usual treatment produced much better results and relief from symptoms than with alkalizers and antibiotics alone. The incidence of recurrence of infection and side-effects was much less with the addition of the natural remedy to the usual regimen. Among patients with burning and frequent micturition but no infections, UriCare was able to completely relieve symptoms—without the need of antibiotics or alkalizers.

❖ In 1992, a controlled trial of 80 patients was undertaken to test the ability of UriCare to clear the urinary tract of infectious organisms.[328] Urine cultures of the patients revealed that *E. coli* was most commonly found, followed by *Klebsiella aerogenes, Proteus vulgaris, Pseudomonas aeruginosa,* and *Staphylococcus aureus*. While antibiotics were given to both groups, persons in the active group

also received a dosage of two UriCare tablets, three times daily, for six weeks to three months. After six weeks of therapy with antibiotics and UriCare, only two of sixteen persons who had tested positive for infectious organisms remained positive. Among persons not receiving UriCare, four of fifteen initially positive patients remained infected. None of the UriCare-treated persons had pus cells in their urine, while eight of the fifteen patients in the control group did.

❖ Many more studies support use of UriCare in cases of burning micturition; non-specific urethritis syndrome; urinary tract infections during pregnancy; in cases of urge incontinence; and by persons with kidney disorders.[329, 330, 331, 332, 333, 334, 335, 336]

UriCare is an economical and safe anti-infective remedy for urinary tract infections. Whenever there is frequent urination accompanied by burning, UriCare may be especially useful. It may be used, in all cases, in combination together with your doctor's prescribed antibiotic regimen and should act as a synergist to produce a greater effect than if the antibiotics or natural remedy were used alone.

The phytochemicals pendicinin and pedicellin present in Shilapushpa (*Didymocarpus pedicellata*) have bacteriostatic action, especially against gram-negative organisms, thus contributing to the formula's anti-infective properties.

The dosage during the acute phase of urinary tract infections is two tablets, two to three times daily, until the infection is clear. For recurrent urinary tract infection, take one tablet, twice daily, for six to twelve weeks. It can be used safely for urinary tract infections during pregnancy, since certain antibiotics are contraindicated during pregnancy. By the way, UriCare is available at health food stores and natural product supermarkets as well as in pharmacies where it is known as Cystone (see Resources for Himalaya USA).

Dr. McBarron's Prescription for UTIs

If your doctor says to use antibiotics for your infection, it may be important to do so. But talk with your doctor about combining your treatment with one or a combination of the formulas I've detailed. The studies I've looked at indicate that a combination of antibiotics and natural medicines probably works better than antibiotics or natural medicine alone. In all cases, use a quality prebiotic or probiotic formula to help counter loss of beneficial bacteria whose populations may be harmed by use of antibiotics (especially tetracycline).

Special note: In Chapters 18-21, I'm going to talk a little more about enzyme therapy and how it can be applied to specific and often troubling women's health problems. The natural medicine product I'm going to recommend is the second leading over-the-counter preparation (behind only aspirin) and the ninth leading "drug" of all kinds prescribed in Germany.

J.M.

Relieving the Pain of Pelvic Inflammatory Disease

Pelvic inflammatory disease (PID) primarily afflicts women of child-bearing age. Usually with pelvic inflammatory disease, anti-inflammatory therapy is frequently prescribed—including occasionally use of corticosteroids. Nevertheless, the long-term use of non-steroidal anti-inflammatory drugs (NSAIDs) may also result in adverse effects which, in spite of therapeutic success, are not justified.

This is a case where I think systemic oral enzymes can be particularly beneficial. Dr. F.-W. Dittmar first used systemic oral enzymes in his practice with PID patients and observed good outcomes. This led to his randomized, double-blind study on 100 patients with PID.[337] The group given the systemic oral enzyme preparation received five coated tablets of Wobenzym N three times daily whereas the control group received NSAIDs at the usual dosages. Dr. Dittmar additionally prescribed an antibiotic for patients with subacute or acute PID. The average time of treatment was 16 or 17 days.

Dr. Dittmar performed examinations at the start of therapy and on the 7th and 14th days, including palpation, white blood cell counts, red blood cell sedimentation rate, bacteriological examination and pelviscopy. Systemic oral enzyme therapy led to an improvement in laboratory data and palpatory gynecological findings within a short time. Most of the patients using the enzymes were already free of complaints after only 14 days of therapy. In fact, nearly 57 percent of patients using enzymes were without complaints after therapy, whereas only about 6 percent using the NSAIDs were. In total, 100 percent of patients given the systemic oral enzymes reported their condition as "substantially improved" or were "without complaints" compared to only 73.5 percent of patients using NSAIDs.

Dr. McBarron's Prescription for
HEALING PID

Use the same dosage of Wobenzym N as for urinary tract infections (five tablets, three times daily, on an empty stomach).

Healing Fibrocystic Breast Disease Naturally

Diseases of the female breast play a predominant role in women's health care. Although these diseases are often benign, they may nonetheless be uncomfortable. Often, fibrocystic breast disease occurs in relation to menstruation in younger women and is accompanied by varying pain severity.

In one study, 124 women with fibrocystic breast disease received ten coated tablets of Wobenzym N twice daily while another 123 women received Wobenzym N together with 1,000 mg of vitamin E. The therapeutic success of the regimen was based on sensation of breast pain and tenseness and via use of advanced non-radiation imaging techniques.[338, 339]

After six weeks of treatment, 80 of the patients (65 percent) in the Wobenzym N group were free of complaints. The proportion of patients free of complaints increased to 85 percent under the combined regimen of Wobenzym N and vitamin E. Subjective freedom from complaints also was noted significantly earlier.

Although some cases recurred after one to six months, these responded promptly to renewed therapy. Due to the tendency of recurrence, it is recommended that both preparations be used as maintenance therapy.

In another study, the benefits of Wobenzym N were examined in a six-week randomized, placebo-controlled, double-blind multisite study. Ninety-six patients with breast disease including cysts, verified by mammography, took part.[340] Both groups of 48 patients each received ten coated tablets of Wobenzym N or a placebo twice daily. Prior to treatment, complaints such as pressure, tension and swelling had persisted for an average of 17.5 days in the Wobenzym N group and an average of 16.2 days in the placebo group.

Following treatment, whereas only insignificant changes were found in the placebo group, a significant reduction in the diameter of cysts took place in the group receiving the Wobenzym N preparation. Intensity of complaints was also reduced substantially.

In the Wobenzym N group, 19 patients complained of unpleasant symptoms in the gastrointestinal tract. Only three patients discontinued the therapy for this reason. Nine of the patients in the placebo group complained of adverse effects and two of them discontinued therapy. Three patients of the placebo group discontinued therapy due to its inefficacy.

Dr. McBarron's Prescription for
HEALING FIBROCYSTIC BREAST DISEASE

Again, use a dosage of five tablets of Wobenzym N, three times daily, in-between meals. Due to the recurring nature of fibrocystic breast disease, a maintenance dosage of two to three tablets, two to three times daily, in-between meals, may be required—with higher dosages if the condition returns.

Getting Rid of Chlamydia

Chlamydiae are a type of microscopic organism that are not bacteria, viruses, or fungi. Chlamydiae cause one of the most common sexually transmitted diseases (STDs), nongonococcal urethritis, a urinary tract inflammation whose symptoms in both sexes include pain when urinating and a watery, mucous discharge. This STD may result in pelvic inflammatory disease and cause inflammation and infection of the uterus, fallopian tubes, ovaries and surrounding tissues, causing infertility even in asymptomatic carriers.

At the present time, chlamydial infections are one of the most common causes of inflammation in the genitourinary system in both men and women. Although antibiotics are effective, there are no optimal methods for managing these infections.

The recommended regimens provide clinical results, but, still, in 30 to 50 percent of cases there is no etiological cure (elimination of the causative agent). The use of conventional antibacterial drugs frequently only transforms an infection into a latent chronic form and increases the likelihood of selection of drug-resistant strains. However, systemic oral enzymes may be just the answer people with this STD have been seeking—at least according to the latest research presented at the Second Russian Symposium on Oral Enzyme Therapy, held in St. Petersburg, Russia. In this case, I want to report on results for both men and women, since such infections can be transferred back and forth unless both partners are treated.

SYSTEMIC ENZYMES ENHANCE ANTIBIOTICS

Recently, a clinical trial was undertaken to study the effect of systemic oral enzymes and its ability to wipe out any traces of this virulent microorganism.

The researchers also examined this preparation's effect on the interferon system in patients with inflammatory diseases of the genital tract.

The study participants consisted of 68 women and 91 men attending the Scientific Center for Obstetrics, Gynecology and Perinatology of the Russian Academy of Medical Science because of inflammatory diseases of the genitourinary system and/or infertility.[341]

Some 93 percent of the women were suffering vaginal discharge and pain in the lower part of the abdomen; 77 percent joint pain; 91 percent itching (pruritus); 72 percent difficult or painful urination (dysuria); 28 percent inflammation of the cervix (cervicitis); and 41 percent inflammation of the mucous membrane that covers the exposed portion of the eyeball and lines the inner surface of the eyelids (i.e., conjunctivitis, a symptom of a form of the chlaymidial-related disease called trachoma). Some 57 percent of the women had been diagnosed with infertility of unknown cause and 35 percent had suffered chronic miscarriages. They were in dire need of help in ridding themselves of their infectious state.

The main disorders in the men were pruritus, urethral pain, abnormally large amounts of blood in portions of the body (hyperemia); minor urethral discharges; and pain in the perineum, anus and lumbar areas.

In some cases there were sexual problems such as erectile dysfunction and reduced duration of intromission. Although 83.5 percent of men did not report problems with the genitourinary system, nevertheless, a reduction in quality of ejaculate was observed in the majority of men (about 80.9 percent) in the form of various combinations of low sperm counts (oligospermia); weak sperm (asthenozoospermia); deformed sperm (teratozoospermia) and pus mixed with sperm (pyospermia); with a predominance of asthenozoospermia.

In the first group, 29 women and 20 men received two 10-day courses, one week apart, of conventional antibiotics.

In the second group, 25 women and 37 men were given the same treatment with intramuscular injection of one bottle a day of chymotrypsin.

In the third group, 14 women and 34 men received antibiotics and Wobenzym N at a dose of 5 tablets three times a day.

The conventional course of antibiotics produced clinical recovery only in 17.2 percent of the women with chlamydial infections. Indeed, chlamydia remained in the smears of 72.4 percent of patients after treatment.

The antibiotic treatment was greatly increased if proteolytic enzymes were used, either intramuscularly or orally, in combination with antibiotics. The injected enzymes however were both physically painful and produced allergic reactions.

For practical purposes, it is the orally administered formula with which typical medical consumers should be concerned. In the case of Wobenzym N, its use resulted in 62.5 percent to 66.7 percent of women showing complete clinical recovery with clean smears. All women experienced good results.

The therapeutic effect of the Wobenzym N treatment of male genitourinary inflammatory diseases also enhanced antibiotic treatment. Complete recovery was obtained far more frequently with additional use of orally administered enzymes.

In fact, 89.5 percent of men experienced complete elimination of the causative agent.

The study shows systemic oral enzymes given in multi-drug therapy with antibiotics greatly increased efficacy against inflammatory disease of the genital tract caused by chlamydial infections. Recovery is accompanied not only by an improvement in the clinical situation, but also by more effective elimination of the causative agent.

How Enzymes Help Recovery from Chlamydia

The mode of action in using Wobenzym N seems to be a change in interferon status. Interferons are proteins produced by virus-infected cells. They inhibit reproduction of invading viruses and induce resistance to further infection. Enzyme therapy appears to normalize serum interferon concentrations.

Before treatment, most patients with chronic infections had a reduced capacity for production of both white blood cells and interferons. In 58 percent of patients taking Wobenzym N the capacity of lymphocytes for synthesis of interferons was restored within 24 hours. Two days after starting treatment with Wobenzym N, lymphocyte capacity to produce interferons was restored in 73 percent of patients. None of the patients taking oral enzymes experienced any allergic or adverse reactions.

Dr. McBarron's Prescription for
HEALING CHLAMYDIA INFECTIONS

If you or a loved one suffer from chlamydia, it is important to consult with your health professional. If your health professional prescribes antibiotics, be sure to take five Wobenzym N tablets three times daily 30 to 45 minutes before meals.

Dealing with Painful Joints

Health is mobility. If you don't have mobility, you don't have health. It's as simple as that. Far too many women, however, simply don't know how to properly care for their joints—especially after around age 30 or 35. We're talking about arthritis—in most cases, osteoarthritis.

Another name for osteoarthritis, *arthrosis*, literally means "degenerative joint disease." This certainly characterizes osteoarthritis. Whereas inflammation accompanies rheumatoid and other forms of arthritis, the most common osteoarthritis symptom is pain, especially in the weight-bearing joints, such as the ankles, hips, knees, and neck.

Morning stiffness is another common symptom of osteoarthritis. Pain after prolonged use of a certain joint is another early sign, especially if the pain becomes worse with prolonged activity and better with rest. Pain and stiffness lead to loss of flexibility and range of motion. Many doctors believe osteoarthritis is inevitable, given the daily wear and tear on the body's joints. However, we can certainly minimize joint destruction with diet, lifestyle, and nutritional supplements.

AN AMAZING UNION

Your joints are truly amazing. The biomechanical union of two bones in the body, a smoothly moving, healthy joint's mobility far exceeds mechanical engineering's greatest feats. Human joints rotate and move forward, backward, even side to side. Think about your knees' freedom of movement, or that of your fingers, especially your thumb. Every movement you make is the result of your

joints' mobility. Running, jumping, hopping, dancing, hiking, sewing, knitting, even painting are all possible thanks to your body's joints. Your joints help to make you physically, fully dimensional.

Such natural smoothness depends on properly nourished joint surfaces. Your joints consist of a synovial membrane, synovial fluids, ligaments, tendons, and muscles, all bathed in nutrient-rich liquid within a watery capsule. These living, permeable (porous) tissues rely on your body's movements, your inner tides, for their nourishment and health.

A CLOSER LOOK AT YOUR JOINTS

Cartilage is the firm, white connective tissue at the end of bones. Have you ever looked at the ends of a chicken bone? The blue-white, shiny stuff—that's cartilage. Cartilage is the body's shock absorber, and it works extremely well, even though we probably start to lose some of our body's abundant reserves in our teens. Healthy cartilage is slick and slippery and contains up to 80 percent water. Because it does not have blood vessels, it must be nourished through fluid exchange. Articular cartilage, found at the ends of bones, is a specialized form of connective tissue. This is the type of cartilage usually involved in osteoarthritis and rheumatoid arthritis. It is extremely slippery—perhaps eight times more slippery than ice.

When cartilage is healthy, the articular cartilage is white, smooth and firm to the touch. Microscopically, it shows strong color variations (metachromasia) due to the high proteoglycan (special proteins) content. Beneath the abundant proteoglycans, cartilage appears threaded, due to the interwoven collagen, which relieves the traction forces caused by body movements.

In the first stages of osteoarthritis, the cartilage appears faded and the beautiful metachromasia of health is yielding. Inside your body, the cartilage releases proteoglycans into the synovial fluid and gradually loses its metachromatic appearance. Over time, the cartilage slowly cracks, turning rough and pitted, like drought-blighted earth. Flecks and bits of cartilage break off and can end up in the joint fluid and irritate the synovial membrane, causing pain.

If left untreated, arthritis worsens into joint degeneration. The cartilage wears down and synovial fluid leaks out. The fluid brings with it toxic, cartilage cell-destroying enzymes (collagenase) into the cartilage. Gradually, cartilage-damaging enzymes outnumber joint protectors, causing further joint deterioration. If the body's healing mechanism is overwhelmed, cartilage will

eventually wear through and leave the bone exposed. The body tries to compensate and emergency blood vessels grow into an area that once had none. The area is now stressed. If repair processes are poor, the new cartilage is supported with inferior "mortar" that enjoys only a short lifetime. The new surface, fibrocartilage, is also inferior. It is the last layer, and small bits of bone may be poking through. Mineralized osteophytes grow at the ends of the affected bone. These cause scraping and may even break off and irritate synovial membranes even further. Gradually this cartilage becomes thinner and roughened. When the bone underneath the cartilage eventually erodes, bone surfaces rub directly against one another, causing severe discomfort. The term "bone rubbing on bone" means the insides of the bones are inflamed. Movement can be difficult, if not impossible.

Sounds pretty terrible. But we don't need to allow our joints to fall victim to this process. Here are some of my favorite arthritis remedies.

GLUCOSAMINE SULFATE

Glucosamine sulfate inhibits cartilage degrading enzymes. In an *in vitro* study performed with human osteoarthritis cartilage, glucosamine sulfate inhibited collagenase, the key enzyme in osteoarthritis cartilage destruction, and cellular phospholipase A2, an activator of collagenase, resulting in a complete suppression of collagenase activity.[342]

Glucosamine is a member of the glycosaminoglycan family.[343] Glycosaminoglycans are found in high concentration in seashells, from which glucosamine is harvested. A simple, very small molecule, glucosamine sulfate is composed of glucose, glutamine, and sulfur and is highly soluble in water. Early on, researchers discovered that healthy joint cartilage has high concentrations of glucosamine sulfate. Glucosamine is now known to be used by the body to manufacture proteoglycans.

The early work on glucosamine sulfate was done mostly in the test tube. By the 1950s, researchers were employing a variety of culture media, incubation times, and types of fibroblasts or cartilage samples from different sources, using different determination methods to evaluate the effects of glucosamine on tissues.[344]

They began by actually growing cartilage tissue in the test tube. Then they put NSAIDs (drugs like ibuprofen and aspirin) with cartilage cells in one dish and glucosamine sulfate with cartilage cells in another dish. What they found was amazing. The NSAIDs damaged the cartilage cells while the glucosamine

sulfate actually stimulated more healthy cartilage regrowth. This was very important because it was evidence that showed glucosamine sulfate could actually modify the disease. True, it was in a test tube, but it gave hope where before there was none. Subsequent studies, however, proved that glucosamine can penetrate intact articular (joint) cartilage. After intravenous and oral administration, glucosamine sulfate has now been shown to be enriched in cartilage tissues.[345, 346, 347]

Researchers also examined the primary components of glucosamine sulfate: glucose, glutamine, and sulfate, as these each have important roles in the metabolism of the body's joints. In 1951, researchers, using radioactive tagging, discovered that the sulfate portion was actually taken up by the joints, and converted into glycosaminoglycans.[348] In 1974, research demonstrated increasing concentrations of radioactively tagged glucosamine, when added to cultured chick embryo cartilage, stimulated an increase in glycosaminoglycan production.[349] These findings were confirmed in 1978, when glucosamine was conclusively shown to stimulate glycosaminoglycan production in cultured mouse tissues.[350]

Glucosamine actually feeds the joints and stimulates stability (at the cellular level) of the materials that comprise cartilage. The healing miracle of glucosamine sulfate is that taking it in supplement form stimulates the body's chondrocytes (cartilage cells) which, in turn, cause the body to produce better quality glycosaminoglycans, which make up proteoglycans and, therefore, help to produce better quality collagen, returning strength to cartilage. Glucosamine favorably turns the tide, re-stimulating normal production of glycosaminoglycans.[351] Glucosamine is the first-ever totally safe joint stabilizing agent to be available to the public without a prescription.

One team of researchers notes, "Indeed, altered glucosamine metabolism would appear to be part of the background of arthrosis and, according to recent biochemical and pharmacological findings, the administration of glucosamine tends to normalize cartilage metabolism, so as to inhibit the degradation and stimulate the synthesis of proteoglycans and, finally, to restore, at least partially, the articular function. Animal studies have shown that orally administered glucosamine is taken up selectively by cartilage."[352]

That is why glucosamine is the body's healing food.

Glucosamine Works in the These Ways...

❖ As joint food (the actual building-block of cartilage).

❖ Prevents cartilage breakdown.

❖ Rebuilds cartilage.

❖ Provides long-lasting pain relief.

❖ Appears to reduce the side effects of osteoarthritis medications.

The human scientific studies that validate modern glucosamine sulfate therapy have been performed in the U.S., Germany, Italy, Thailand, Portugal, and other nations on more than 6,000 people suffering many forms of osteoarthritis.[353] Some of the clinical trials are classic double-blind, placebo-controlled tests. Others have compared glucosamine sulfate to familiar pain killing drugs such as ibuprofen. Many studies are on-going. This is definitely one nutrient you want to position on your side. Consider taking it to prevent damage from occurring in the first place.

CHONDROITIN SULFATE

Made up of chains of sugars with negative electrical polarities, chondroitin sulfates are found in cartilage where they create tiny reservoirs to attract and hold water in the proteoglycan mortar. They help to bring water, shape, and cushioning to cartilage.

Chondroitin sulfates inhibit destructive enzymes that breakdown cartilage and prevent the carrying of nutrients into the cartilage; they stimulate synthesis of proteoglycans, glycosaminoglycans, and collagen, which make up healthy cartilage. They are manufactured from healthy cartilage.

Chondroitin sulfate is an extremely large molecule and is not well absorbed in the body when taken orally.[354] Nevertheless, there is growing evidence supporting its benefits for persons with arthritis.

❖ In 1986, a French study, using oral chondroitin sulfates, found that it helped in the healing of arthritic cartilage better than pain medication.[355]

❖ A 1992 study focusing on oral chondroitin sulfates found improvement.[356]

❖ A 1996 study from the *Journal of Rheumatology* assessed the clinical efficacy of chondroitin sulfate in comparison with diclofenac.[357] Patients treated with the NSAID showed prompt and plain reduction of clinical symptoms, which, however, reappeared after the end of treatment; in the chondroitin group, the therapeutic response appeared later in time but lasted for up to three months after the end of treatment.

Most recently, the W.B. Saunders Company published *Osteoarthritis and Cartilage* which presents new findings on chondroitin sulfate and arthritis. Among these are the following study abstracts:

❖ In one recently published study, doctors from Hungary's National Institute of Rheumatology and Semmelweis Medical School looked at chondroitin sulfates among patients suffering osteoarthritis of the knee.[358] All were given either 800 mg of oral chondroitin sulfates or a placebo and could also take pain killers such as paracetamol. Six months later, the chondroitin sulfate group experienced significant improvement and required less pain medicine.

❖ European researchers compared chondroitin sulfate with a placebo in a three-month, double-blind multi-center study of 127 patients suffering osteoarthritis of the knees.[359] Patients taking 1,200 mg of the chondroitin sulfates either all at once or three times daily in divided doses enjoyed significant pain relief and improved mobility compared with the placebo group.

❖ In a year-long double-blind, placebo-controlled study, patients were given chondroitin sulfate or a placebo.[360] The patients receiving chondroitin experienced significantly improved mobility and less swelling, instability and effusions. Six of the patients using chondroitin showed significantly smoother, thicker cartilage, a sign of improved health. The chondroitin group used less pain killer medication. "Chondroitin is a symptomatic slow acting drug for the treatment of knee osteoarthritis with a good clinical outcome," concluded the researchers.

❖ American and French researchers used x-ray analysis to determine whether chondroitin sulfate could halt progression of osteoarthritis joint degradation.[361] In this study, 42 men and women, ranging in age from 35 to 78, were given either 800 mg of oral chondroitin sulfate or placebo. After a year of supplementation, thickness of the femoro-tibial joint of the knee decreased significantly among patients using the placebo, but not among patients taking chondroitin sulfate.

Vitalogic Joint Formula is certainly one of the best remedies for both adults and children with arthritis. Check with your health food store or natural pharmacy for other quality formulas from companies like Enzymatic Therapy, PhytoPharmica, Solaray, Schiff, and Solgar.

SYSTEMIC ORAL ENZYMES

Although rheumatoid arthritis is truly an immune and inflammatory disease, few conventional treatments address the underlying systemic condition. Most treat-

ments reduce the inflammation and pain but do nothing to start the healing process. In this sense, systemic oral enzymes may be superior. Their influence on the immune system is profound and stimulates once again healthy production of messenger immune cells (cytokines) that quench inflammation, and revs up immunity to produce a cleansing effect, helping to cleave or break up circulating immune complexes (CICs) at the center of the body's immune/inflammation firestorm.

Systemic Oral Enzymes and Rheumatoid Arthritis

Excellent early results using the patented enzyme formula Wobenzym® N were noted by researchers writing in 1985 in *Zeitschr. f. Rheumatologie*. In this study, patients took eight Wobenzym N tablets four times daily. Sixty-two percent of patients significantly improved.[362]

A 1988 report in *Natur- und Ganzheitsmedizin* showed that the same formula can prevent further flare-ups, and helps to lower levels of inflammatory-related circulating immune complexes in rheumatoid arthritis patients.[363]

Another study, also published in *Natur- und Ganzheitsmedizin*, noted that Wobenzym N has demonstrated similar benefits to gold therapy but without the toxic side effects.[364]

Wobenzym N will also be helpful with non-inflammatory active osteoarthritis, as has been shown for more than 20 years now. In one study among 80 patients, Wobenzym N was pitted against the NSAID diclofenac.[365] Patients received either seven coated Wobenzym N tablets four times daily and two capsules of placebo, or seven coated tablets of placebo four times daily and two 50 mg capsules of diclofenac. The groups were similar with respect to symptoms. An evaluation of all principal criteria examined revealed equivalent therapeutic results in both groups after four weeks. This means that even in cases of osteoarthritis, Wobenzym N can be considered equivalent treatment.

Most recently, researchers from the Ukrainian Rheumatology Centre, in Kiev, tested Wobenzym N on 78 patients with severe, crippling rheumatoid arthritis, and who were using other prime treatment drugs.[366] Half the patients had chronic fevers, some 23 percent had rheumatic nodules, and more than half were suffering from low hemoglobin/red blood cell counts. Many of these people had tried gold salts, methotrexate, and other non-steroidal anti-inflammatory drugs but to no avail, and some were even using canes and wheelchairs.

All of the patients experienced a decrease in CIC concentrations, averaging between 28 and 42 percent, and decreases in rheumatoid factors. Twenty percent of patients reduced their NSAID doses by 50 to 75 percent. One patient

stopped taking methotrexate and experienced a clinical remission of the disease. Morning stiffness scores improved. More than half the patients rated their treatment with Wobenzym N as good, compared to only about a third of the patients using only medical drugs.

"The study results therefore confirm that Wobenzym is a new and quite effective antirheumatic agent, which also presents the properties of a second-line agent," said the Russian researchers at the Second Russian Symposium on Oral Enzyme Therapy in St. Petersburg, Russia, 1996.*

PHYTODOLOR®

Phytodolor®, an herbal tincture from Germany with extensive scientific validation for rheumatoid arthritis patients, is another important natural medicine now available in the United States.

Medical Validation

In total, 1,151 patients have now been studied in some 30 open and controlled studies. Phytodolor proved to be clearly superior to placebo, and, in comparison with analgesics, an equally good effect could be demonstrated.

In one 1989 study, the efficacy and tolerance of Phytodolor was tested in a 12-week trial on 20 arthritis patients with pain, inflammation, swelling and functional impairment.[367] Three-quarters of patients experienced significant improvement in their symptoms. Some 11 patients felt completely (or almost completely) free of symptoms after the full three months of treatment. The researchers concluded that Phytodolor provided a very well tolerated alternative to synthetic anti-rheumatic agents in the treatment of slight to moderately severe stages of chronic polyarthritis. They also noted that Phytodolor could be combined with other pain medications in cases with more marked clinical symptoms.

In a 1991 study, Phytodolor was tested against a placebo and the pain medication piroxicam on 108 patients.[368] Duration of treatment was four weeks. There was marked pain on movement in virtually all patients, with many suffering degenerative vertebral column diseases. Patients given Phytodolor expe-

At this same conference, researchers presented findings on Wobenzym N and juvenile arthritis. In the study, among 10 children from the Pediatric Clinic of the Institute of Rheumatology of the Russian Academy of Medical Science, 10 children with JCA were given five tablets three times a day. They could also receive treatment with one NSAID in addition to Wobenzym N. In the children, the number of actively inflamed joints was reduced from 44 to 15, especially in the second month. One youthful patient with psoriatic arthritis experienced a significant reduction in dermal signs of the disease. The natural agent proved effective generally after four to five months of treatment.

rienced a statistically significant reduction in pain compared to placebo. These same patients experienced improvement in overall result that were comparable to the piroxicam. Better yet, no complications were associated with its use, while 20 percent of patients receiving piroxicam suffered complications.

Phytodolor, only recently arrived from Germany to the United States, was identified through a thorough literature search to be "the remedy for which more randomized clinical trials have been conducted than any other herbal preparation," reports E. Ernst, M.D., Ph.D., of the Department of Complementary Medicine, School of Postgraduate Medicine and Health Sciences, University of Exeter, UK.[369]

Dr. Ernst further notes that seven clinical trials "conducted against active treatments [such as diclofenac] demonstrate that it is as effective as synthetic drugs." What's more, Phytodolor has much better tolerance and, therefore, patient compliance.

The action of Phytodolor extends from non-inflammatory musculoskeletal pain to inflammatory rheumatic conditions. Indeed, this is very good news for persons with rheumatoid arthritis and other forms of rheumatism. Studies have repeatedly shown that red blood cell sedimentation rate is normalized through therapy with Phytodolor.

How Phytodolor Works

The formula's anti-inflammatory properties are due in part to the salicylate content of aspen. The golden rod portion provides antispasmodic and diuretic effects. Common ash, rich in coumarins, offers a variety of pharmacological properties, including immune modulation and inhibition of the pro-inflammatory arachidonic acid cascade. The authors of one Phytodolor study note, "Various *in vitro* and especially *in vivo* studies proved its anti-inflammatory and antirheumatic properties, often comparable to non-steroidal anti-inflammatories, but with little or no side effects."[370]

The formula also has strong antioxidant powers.[371] Since free radical processes are also involved in inflammatory processes, the beneficial activities of the complete formula may at least in part be due to the reported antioxidative functions.

Tell Me More...

Phytodolor is a specially formulated tincture with extracts of common ash (*Fraxinus excelsior*), aspen (*Populus tremula*) and golden rod (*Solidago virgaurea*). Phytodolor fulfills the growing need of Americans for safe and effective natural medicines for rheumatoid arthritis. It is clinically validated and will soon find

its place in front-line therapy for use either alone in mild to moderate inflammatory arthritis or, for persons with more marked clinical symptoms, combined with typically prescribed medications.

How to Obtain Phytodolor®
Phytodolor is now available in the United States, imported from Germany by Enzymatic Therapy and PhytoPharmica. (See Resources for information on how to obtain this formula.)

How to Use Phytodolor®
Take 20 to 30 drops of the Phytodolor tincture three to four times daily mixed with your favorite juice or water. In cases of severe pain, take 40 drops three to four times daily. Allergic reactions can occur in cases of known salicylate allergy; in rare cases, gastric and intestinal complaints may occur. There are no known drug or nutrient interactions.

METHYLSULFONYLMETHANE (MSM)

Methylsulfonylmethane (MSM) is a sulfur compound that is naturally found throughout the body and that is now available in supplement form. It is a natural source of organic sulfur, which is vital to several of the body's connective tissues including hair, joints, muscles and skin, as well as to specific enzymatic and detoxification processes. Thus, MSM is thought to have wide-ranging benefits to human health.

Advertisements for its use have proliferated in recent months, and consumer interest in this compound is extremely high. There may be good reason, in that sulfur is an often overlooked healing compound in modern medicine.

As the authors of *The Miracle of MSM*, the definitive book on MSM note, "Sulfur also has a long history of healing but it has been overlooked in our current fascination with vitamins and minerals. When asked to think of minerals important for health, most people know that calcium is good for their bones, that iron is important for their blood, that zinc is needed by the prostate. But rarely does anyone mention sulfur."[372]

A metabolite of dimethylsulfoxide (DMSO) but without its annoying odor, MSM is valued for its ability to support healthy cells by supplying readily bioavailable sulfur. However, it is not possible to directly compare DMSO and its derivative, MSM, although both belong to the same chemical family. MSM is a dietary factor found abundantly in dairy; DMSO is not. Still, each contributes

to our well-being but in differing ways, and it was out of research on DMSO that we have come to know MSM as a potential healing agent.

In fact, MSM's rising popularity stems from the fact that studies of its parent compound DMSO have not progressed as projected some 20 to 30 years ago, largely due to the rejection of most of its uses in medicine by the Food and Drug Administration and the fact that the cost of the drug approval process is prohibitive.[373] As noted in the *Annals of the New York Academy of Sciences*, "One product of DMSO appears to have a bright scientific and commercial future: the stable metabolite methylsulfonylmethane (MSM)."

Interestingly, quite apart from a recent book by one of the principle MSM investigators Stanley W. Jacob, M.D., there is actually very little published data on MSM. Almost all of what we know is from anecdotal clinical reports. Its first use commenced about twenty years ago after an article was published on its use in an equine journal. At that time Dr. Jacob, a physician at the DMSO Clinical at Oregon Health Sciences University in Portland, began using it with patients.

Sulfur Deficiency Not Uncommon

Although MSM occurs naturally in the body and some foods, unless our diet is almost solely milk, it appears that our bodies have a critical deficiency, notes Dr. Jacob. Research suggests that a minimum concentration in the body may be critical to both normal function and structure. Also, limited studies suggest that the concentration of MSM drops in mammals with increasing age.

Other important areas of use are for inhibition of pain impulses along nerve fibers; lessening of inflammation; increasing of blood supply; reduction of muscle spasm; and softening of scar tissue. Thus, people suffering from a wide range of chronic pain conditions could find MSM extremely useful.

According to Jacob and co-authors, "Many people experience rapid relief after starting MSM. We have often heard the statement, 'Within a few days my pain was gone.'" The authors go on to note, "MSM is a surprising supplement. When you start taking it, you may notice a number of good things happening in your life in addition to pain and allergy relief: more energy; cosmetic benefits such as softer skin, thicker hair, stronger nails; decreased scar tissue; and relief of constipation."

Research continues on the action of MSM in other medical problems as well. One fascinating aspect of this work is that MSM appears to be pharmacologically inactive in normal situations. Only when abnormality is present does MSM influence a return towards normalcy, defined as being within the measurable parameters of good health.

Dr. McBarron's Prescription for
TAKING CARE OF YOUR JOINTS

In my work with hundreds of arthritis patients, I have implemented eight simple, powerful natural healing strategies for alleviating pain and joint damage.

1. **Practice good nutrition.** A semi-vegetarian diet emphasizing more seafood and less fatty beef, lamb, and dairy is helpful for keeping the weight off. Some evidence suggests vegetarians have less problems with osteoarthritis. Keeping off extra pounds keeps further stress off joints.

2. **Take supplements.** Vitamins and minerals are important additions to the diet. Glucosamine sulfate, chondroitin sulfate and systemic oral enzymes, used individually or together, can help to rebuild cartilage and/or reduce pain and inflammation. You may also try the additional nutrients and herbs I have detailed in this chapter.

3. **Exercise and stretch regularly.** Exercise and stretching are two powerful tools. If you suffer from osteoarthritis, activities such as walking, stretching, and swimming can help strengthen muscles and bones to compensate for weakened joints. Stretching can also help you regain youthful flexibility.

4. **Avoid repetitive, awkward motions.** Don't work straight through if your job or other activities involve repetitive motion. Take breaks. This is very important for jobs involving frequent lifting. Be sure your chair provides your shoulders and neck with the proper support.

5. **Use biomechanics and ergonomics.** Be aware of how you walk and sit. Don't hunch your shoulders or slouch. Protect your joints when lifting or pulling by using carts or other devices equipped with wheels.

6. **Alleviate stress.** It's part of life, but we can all learn to cope. A positive support group of family and friends with whom you can have open, non-defensive communication is helpful. Take half an hour to walk in a natural, serene setting daily.

7. **Pamper yourself.** Set aside time each day for the things that you enjoy. It'll help you to maintain a positive outlook.

8. **Keep the right attitude.** Take time every day to visualize your life when your physical and mental health are at their best.

Epilogue: Enjoy Fantastic Health

Well, there's so much more I want to tell you. I guess I'll just have to do another book that takes up where we've left off. This is an exciting time to be a physician, with many new possibilities for healing. The success of herbs is leading to a renewed recognition and acceptance of herbal and natural medicine. It is bringing this entire field to the attention of the general population, those who are willing to look beyond conventional medicine for solutions to health problems. Our dependence on technological medicine, including the use of pharmaceuticals, has not yielded increased freedom from disease.

I believe most doctors are motivated to find the best, least-harmful approaches to helping their patients. Many of my colleagues, previously skeptical of my interest in and practice of complementary medicine, now ask me for information on how to use a more natural approach. This field is growing so quickly it is difficult to keep up. Fortunately, patients who seek complementary care tend to be those most likely to take responsibility for their own healing, and least likely to expect the doctor to do everything or to know it all.

Many women really don't need HRT or many other drugs that today are dispensed all too frequently and unnecessarily. Today, nature's pharmacy makes it possible to enjoy a safe and vital passage into your new life. In this book, I've given you some of the tools to help you build a solid foundation for the most important home of your life: *your body*. You've learned how to use both foods and dietary supplements to reduce or eliminate uncomfortable menopausal symptoms without requiring estrogen drugs. You've learned about how to reduce your risk of osteoporosis. I have also provided solid information on naturally reducing your risk of heart disease, as well as eliminating unsightly cel-

lulite, varicose veins, and wrinkles. I've also discussed coping with many other troubling women's health problems, even how to get rid of graying hair without using commercial hair dyes that contain potentially cancer-causing ingredients.

For now, emphasize vitamin- and mineral-rich—preferably organic—foods, especially whole grains, fruit and vegetables. Be sure to exercise, eliminate health-damaging dietary/lifestyle habits, and use these powerful, new, scientifically validated dietary supplements. These will put you on the road to a healthy body and help you maintain your total health and beauty for a long time.

There is no cure for death. However, we want to remain as healthy and productive and feel good as long as possible and when death knocks we want a minimum amount of suffering. Take care of yourself by monitoring what you eat, your exercise, and your mental and spiritual awareness. It's all up to you. You are ultimately responsible and have more control over your health than you probably even realize. Your doctor is your consultant but you are the ultimate decision maker. Health and wellness can be yours—naturally.

I love all of you and look forward to seeing you and hearing from you in my many personal appearances and, of course, with my husband Duke on our nationally syndicated radio show *Duke & The Doctor*.

Best of health and happiness,

Dan McBerron, M.D.

Resources

I cannot emphasize strongly enough that the success you achieve with the suggestions in *Being a Woman—Naturally* will depend on the quality of the natural remedies and other products you choose to use. The formulas reported on may be purchased at health food stores, natural product supermarkets—or from pharmacies and health professionals.

As a completely independent publication devoted to informing consumers about which brands conform to the highest standards of natural medicine, I investigated all natural medicines. I have recommended the formulas in the book because of their quality and due to the fact that they are widely available.

Natural Solutions for Graying Hair
Paul Penders Color Me Naturally,
Light Mountain® Natural Hair Color and Conditioner and **Color the Gray**
Lotus Brands, Inc.
P.O. Box 325, Twin Lakes, WI 53181
(800) 824-6396/(262) 889-8561
Email: lotusbrands@lotuspress.com
Website: www.lotusbrands.com

Wobenzym N & Inuflora™
Naturally Vitamins
4404 East Elwood Street, Phoenix, AZ 85040
(800) 899-4499
Website: www.naturallyvitamins.com

Vitalogic Dietary Supplement Formulas
Institute for Healthy Living
2920 Macon Road, Columbus, Georgia 31906
(800) 225-6855
Website: www.dukeandthedoctor.com

Formula 50
Marlyn Nutraceuticals
4404 East Elwood Street, Phoenix, AZ 85040
(800) 462-7591
Website: www.naturallyvitamins.com

Enzymatic Therapy / PhytoPharmica
825 Challenger Drive, Green Bay, WI 54311
Enzymatic Therapy: (800) 783-2286
Website: www.enzy.com
PhytoPharmica: (800) 553-2370
Website: www.phytopharmica.com

Himalaya USA
6950 Portwest Drive, Suite 170 , Houston, TX 77024
(800) 869-4640
Website: www.himalayausa.com

Aubrey Organics
4419 North Manhattan Avenue, Tampa, FL 33614
(800) 282-7394
Email: info@aubrey-organics.com
Website: www.aubrey-organics.com

Other Works by **Jan McBarron, M.D.**

The Columbus Nutrition Program - $14.95

- Easy to follow program to help you lose weight and keep it off
- Choice of 3 food plans
- Learn how a heavy versus thin person thinks
- Guaranteed weight loss
- This is how Dr. McBarron lost 70 pounds

Flavor Without Fat - $15.95

- Over 100 easy to prepare and delicious recipes
- Learn how to convert your own recipes to low fat and keep the flavor
- Charts for ideal weight, cholesterol, fat & fiber intake
- **BONUS** chapters include: *Ideal Nutrition, Salt, Fiber, Vitamins, A Low Fat Kitchen* and *Low Fat Cooking!*

Duke and The Doctor Learning Series - $9.95 each

- 14 easy to understand health topics and natural solutions
- Each 45 uninterrupted minutes
- On CD or cassette
- Topics include: Thyroid, Heart, Ear, Eye, Digestion (GERD, Spastic Colitis, IBS, Crohn's, Diverticulitis), Liver, Cholesterol, Gallbladder, Pancreas, Asthma & Emphysema, Kidney & Bladder, Immune System
- Hosted by Duke Liberatore and Jan McBarron, M.D.

SPECIAL OFFER!

- *PURCHASE BOTH BOOKS, GET 1 LEARNING SERIES ($9.95 VALUE) FREE !*
- *PURCHASE ALL 14 LEARNING SERIES ($139.30 VALUE) ONLY $69.95 !*

To Order Call: 1•800•225•6855
or On-Line: dukeandthedoctor.com

References

1 Brody, J.E. "Personal health: a new television series helps to explode the many damaging myths about menopause." *The New York Times*, December 1, 1993: B9.
2 Sheehy, G. *Silent Passage*. New York: Pocket Books, 1998.
3 Steingraber, S. Patton, K. "When a little xenophobia is a good thing: xenoestrogens and women's health." *Sojourner: The Women's Forum*, March 1994: 3H, 5H.
4 Wilson, R.A. *Feminine Forever*. New York: M. Evans, 1966.
5 Braunstein, G.D. "Opinion: pro. The benefits of estrogen to the menopausal woman outweigh the risks of developing endometrial cancer." *CA-A Cancer Journal for Clinicians*, 1984; 34(4): 220-231.
6 Seiler, J.C.: "Estrogens for the menopause: maximizing benefits, minimizing risks." *Postgrad Med.*, 1977; 62: 73-79.
7 Wallis, C. "The estrogen dilemma." *Time*, June 26, 1995.
8 Ibid.
9 McNeil, C. "ERT for breast cancer survivors: 'a hot debate' runs on little data." *Journal of the National Cancer Institute*; 1995; 87(14): 1047-1050.
10 Gittleman, A.L. *The Living Beauty Detox Program*. New York: HarperCollins Publishers, 2000.
11 Nacht, D.I. & Cook, H.M. *J. Amer. Assn.*, 1932; 21: 324.
12 V. Gizycki, H. *Z. Ges. Exp. Med.*, 1944; 113; 635-644.
13 Tyler, V. "The bright side of black cohosh." *Prevention*, April 1997: 76-78.
14 Ibid.
15 Kupperman, H.J., et al. Journal of the American Medical Association, 1959; 171: 1627-1637.
16 Hamilton, M. *British Journal of Psychiatry*, Spec. Pub., 1969; 3: 76-79.
17 Stolze, H. *Gyne*, 1982; 1: 14-16.
18 Daiber, W. Ärztl. *Praxis*, 1983; 35: 1946-1947.
19 Vorberg, G. ZFA, 1984; 60: 626-629.
20 Warnecke, G. *Med. Welt*, 1985; 36: 871-874.
21 Stoll, W. *Therapeutikon*, 1987; 1: 23-31.
22 Colditz, G.A., et al. "The use of estrogens and progestins and the risk of breast cancer in post-menopausal women." *The New England Journal of Medicine*, 1995; 332(24): 1589-1593.
23 Berrino, F., et al. "Serum sex hormone levels after menopause and subsequent breast cancer." *Journal of the National Cancer Institute*, 1996; 88(5): 291-296.
24 Zeleniuch-Jacquotte, A., et al. "Relation of serum levels of testosterone and dehydroepiandros-terone sulfate to risk of breast cancer in postmenopausal women." *Am J Epidemiol*, 1997; 145(11):1030-8.
25 Pethö, A. Ärztl. *Praxis*, 1987; 47: 1551-1553.
26 Lehmann-Willenbrock, E. & Riedel, H.H. Zent. Bl. Gynäkol. 1988; 110: 611-618.
27 Düker, E.-M., et al. *Planta Medica*, 1991; 57: 420-424.

28 Liske, E., et al. "Phytocombination alleviates psychovegetative disorders." *TW Gynakologic*, 1997; 10: 172-175.

29 Monographie Cimicifuga, Banz Jg. 41, p. 1070, No. 43 from 3/2/89.

30 Schrage, R. (ed.) *Therapie des klimakterischen Syndroms*, Edition Medizin, VCH-Verlagsgesellschaft Weinheim, 1985; 172.

31 Mowrey, D. *The Scientific Validation of Herbal Medicine*. New Canaan, CT: Keats Publishing, 1986.

32 Albert-Puleo, M. "Fennel and anise as estrogenic agents." *Journal of Ethnopharmacology*, 1980; 2: 337-344.

33 Costellos, C.H. & Lynn, E.V. "Estrogenic substances from plants: I. Glycyrrhiza." *Journal of the American Pharmaceutical Association* (no date; approximately 1949).

34 Albert-Puleo, M., op. cit., pp. 337-344.

35 Costellos, C.H. & Lynn, E.V., op.cit.

36 Albert-Puleo, 1980.

37 Adlercreutz, H., et al. "Determination of urinary lignans and phytoestrogen metabolites, potential antiestrogens and anticarcinogens, in urine of women on various habitual diets." *J. Steroid Biochem.*, 1986; 25(5B): 791-797.

38 Ibid.

39 Harada, M. "Effect of Japanese angelic root and peony root on uterine contraction in the rabbit in situ." *J. Pharm. Dyn.*, 1984; 7: 304-311.

40 Hikino, H. "Recent research on oriental medicinal plants." *Economic Medical Plant Research*, 1985; 1: 53-85.

41 Yoshiro, K. "The physiological actions of tang-kuei and cnidium." *Bull. Oriental Healing Inst.*, USA, 1985: 10: 269-278.

42 Fugiwara, S., et al. "Metabolism of gamma-oryzanol in rabbit." Yakugaku Zasshi (*Journal of the Pharamceutical Society of Japan*, 1980; 100(10): 1011.

43 Fukushi, T. "Studies on edible rice bran oils, part 3. Antioxidant effects of oryzanol." *Rep. Hokaido Inst. Public Health*, 1966; 16: 111.

44 Murase, Y., et al. "Clinically cured cases by per os gamma-oryzanol of menopausal disturbances or menopausal-like disturbances." *Sanfujnka no Jissai*, 1963; 12(2): 147.

45 Ishihara, M. "Effect of gamma-oryzanol on serum lipid peroxide level and clinical symptoms of patients with climacteric disturbances." *Asia-Oceanic J. Obstet. Gynaecol.*, 1984; 10(3): 317.

46 Murase, Y., et al., op. cit., p. 147.

47 Ishihara, M., op. cit., p. 317.

48 Christy, C.J. "Vitamin E in menopause. Preliminary report of experimental and clinical study." *American Journal of Obstetrics and Gynecology*, Additional source information not available.

49 Kavinoky, N.R. "Vitamin E and the control of climacteric symptoms. Report of results in one hundred seventy-one women." *Annals of Western Medicine and Surgery*, January 1950; 4(1): 27-32.

50 Nielsen, F.H. "Boron—an overlooked element of potential nutritional importance." *Nutrition Today*, January/February 1988: 4-7.

51 Nielsen, F.H., et al. "Effect of dietary boron on mineral, estrogen, and testosterone metabolism in postmenopausal women." *FASEB Journal*, 1987; 1: 394-397.

52 Ibid.

53 Neilsen, F.H., op. cit., 1988.

54 *Taking Hormones and Women's Health: Choices, Risks, Benefits*. Washington, D.C.: National Women's Health Network (NWHN), 1989.

55 Edwards, L. & Fraser, M. "How do we increase awareness of osteoporosis?" *Baillieres Clin Rheumatol*, 1997; 11(3):631-644.

56 McDougall, J. "Hormone Replacement Therapy (HRT). Is this for you?" *Your Good Health*. May/June 1994.

57 U.S. Department of Health and Human Services. *The Surgeon General's Report on Nutrition and Health*. U.S. Department of Health and Human Services. Washington, D.C.: U.S. Government Printing Office, 1988 017-001-00465-1: 312-313.

58 Felson, D.T., et al. "The effect of postmenopausal estrogen therapy on bone density in elderly women." *The New England Journal of Medicine*, October 14, 1993; 329(16): 1141-1146.

59 U.S. Department of Health and Human Services, op. cit., p. 313.

60 Ibid.

61 Ellis, F., et al. "Incidence of osteoporosis in vegetarian omnivores." *American Journal of Clinical Nutrition*, 1972; 25: 555-558.

62 Spencer, H., et al. "Further studies of the effect of a high protein diet as meat on calcium metabolism." *American Journal of Clinical Nutrition*, 1983; 37: 924-929.

63 Sanchez, I.V., et al. "Bone mineral mass in elderly vegetarian females." *American Journal of Roentgenology*, 1978; 131(3): 539-553.Check

64 Marsh, A., et al. "Bone mineral mass in adult lacto-ovo-vegetarian and omnivorous adults." *American Journal of Clinical Nutrition*, 1983; 37: 453-456.

65 McDougall, J.A. *McDougall's Medicine: A Challenging Second Opinion*. Clinton, NJ: New Win Publishing, 1985, p. 73.

66 Recker, R.R. & Heaney, R.P. "The effect of milk supplements on calcium metabolism, bone metabolism and calcium balance." *American Journal of Clinical Nutrition*, February 1985; 41: 254-263.

67 Demarco, C. *Take Charge of Your Body*. The Well Woman Press, May 1997, p. 206.

68 Ibid., p. 207.

69 United States Department of Health and Human Services, op. cit., p. 315.

70 Carper, J. *Total Nutrition Guide*. New York, NY: Bantam Books, 1989, p. 139.

71 Teegarden, D. & Weaver, C.M. "Calcium supplementation increases bone density in adolescent girls." *Nutrition Reviews*, not dated; 52(5): 171-173.

72 Lore, F., et al. "VItamin D metabolites in postmenopausal osteoporosis." *Horm. Metabol. Res.*, 1984; 16: 58.

73 Gallagher, J., et al. "Intestinal calcium absorption and serum vitamin D metabolites in normal subjects and osteoporotic patients: effect of age and dietary calcium." *J. Clin. Invest.*, 1979; 64: 729-736.

74 Lips, P., et al. "Vitamin D supplementation and fracture incidence in elderly persons: a randomized, placebo-controlled clinical trial." *Annals of Internal Medicine*, 1996: 124: 400-406.

75 Mulrow, C.D. "Vitamin D and fractures." *Journal Watch*, 1996; 56(7): 56.

76 Dawson-Hughes, B., et al. "Effect of calcium and vitamin D supplementation on bone density in men and women 65 years of age or older." *N Engl J Med*, 1997; 337(10):670-676.

77 Francis, R.M. & Beaumont, D.M. Letters to the editor. "Involutional osteoporosis.:" *New England Journal of Medicine*, 1987; 316: 216.

78 Anonymous. "Magnesium found to deter postmenopausal bone loss." *Medical World News*, August 1993: 13.

79 Carper, J. *Total Nutrition Guide*. New York, NY: Bantam Books, August 1989, p. 202.

80 Ibid.

81 Ibid.

82 Cohen, L. & Litzes, R. "Infrared spectroscopy and magnesium content of bone mineral in osteoporotic women." *Isr. J. Med. Sci.*, 1981; 17: 1123-1125.

83 Rude, R.K., et al. "Low serum concentration of 1,25-dihydroxyvitamin D in human magnesium deficiency." *J. Clin. Endo. Metabol.*, 1985; 61: 933-940.

84 Carper, J, op. cit., p. 207.

85 Adapted from Carper, J., op. cit., pp. 208-209.

86 U.S. Department of Health and Human Services, op. cit., p. 332.

87 Leveille, S.G., et al. "Dietary vitamin C and bone mineral density in postmenopausal women in Washington State, USA." *J Epidemiol Community Health*, 1997; 51(5):479-85.

88 Birchall, J.D. & Espie, A.W. "Biological implications of the interaction of silicon with metal ions." Ciba Foundation Symposium, 1986; 121: 140.

89 Carlisle, E.M. "Silicon as an essential trace element in animal nutrition." Ciba Foundation Symposium, 1986; 121: 123.

90 Moshfegh, A.J., et al. "Presence of inulin and oligofructose in the diets of Americans." *Journal of Nutrition*, 1999; 129(7 Suppl): 1407S-1411S.

91 Nondigestible carbohydrates and mineral bioavailability." *Journal of Nutrition*, 1999;129:1434S-1435S.

92 Morohashi, T., et al. "True calcium absorption in the intestine is enhanced by fructooligosaccharide feeding in rats." *Journal of Nutrition*, 1998;128:1815-1818.

93 Abrams, S.A. & Griffin, I.J. "Calcium absorption is increased in adolescent girls receiving enriched inulin." World Congress of Pediatric Gastroenterology, Hepatology & Nutrition. Abstract, August 5-9, 2000, Boston, Massachusetts.

94 Kruger, M.C. & Horrobin, D.F. "Calcium metabolism, osteoporosis and essential fatty acids: a review." *Prog Lipid Res*, 1997;36(2-3):131-151.
95 Bankova, V.S., et al. *J Chromatogr*, 1982; 242: 135-43.
96 Albanese, C.V., et al. "Ipriflavone Directly Inhibits Osteoclastic Activity." *Biochem Biophys Res Commun.* 1994; 199(2):930-936.
97 Cecchini, M.G., et al. *Calcif Tissue Int*, 1997; 61(Suppl. 1): S9-11.
98 Agnusdei, D. et al. "A double blind, placebo-controlled trial of ipriflavone for prevention of postmenopausal spinal bone loss." *Calcification Tissue International*, 1997; 61(2):142-147.
99 Gennari, C., et al. "Effect of chronic treatment with ipriflavone in postmenopausal women with low bone mass." *Calcif Tissue Int.* 1997; 61:Sl9-S22.
100 Gennari C. "Effect of Ipriflavone—a Synthetic Derivative of Natural Isoflavones—on Bone Mass Loss in the Early Years After Menopause. *Menopause: The Journal of the North American Menopause Society*," 1998; 5(1): 9-15.
101 Valente, M., et al. "Effects of 1-year Treatment with Ipriflavone on Bone in Postmenopausal Women with Low Bone Mass." *Calcif Tissue Int.* 1994; 54(5):377-380.
102 Agnusdei, D. & Bufalino, L. "Efficacy of Ipriflavone in Established Osteoporosis and Long-Term Safety." *Calcif Tissue Int.*, 1997; 61:S23-S27.
103 Gambacciani, M., et al. "Effects of Combined Low Dose of the Isoflavone Derivative Ipriflavone and Estrogen Replacement on Bone Mineral Density and Metabolism in Postmenopausal Women." *Maturitas.* 1997; 28(1):75-81.
104 Agnusdei, D., et al. "Prevention of Early Postmenopausal Bone Loss using Low Doses of Conjugated Estrogens and the Non-hormonal, Bone-active Drug Ipriflavone." *Osteoporosis Int.* 1995; 5(6):462-466.
105 Monostory, K. & Vereczkey, L. *Eur J Drug Metab Pharmacokinet*, 1996; 21: 61-66.
106 Monostory, K. & Vereczkey, L. "Interaction of theophylline and ipriflavone at the cytochrome P450 level." *Eur J Drug Metab Pharmacokinet*, 1995; 20(1):43-7.
107 Young, S. "Healthy bones at 20, 30, 40, 50." *Glamour*, January 1993: 38.
108 Chestnut, C. cited in Young, S. "Healthy bones at 20, 30, 40, 50." *Glamour*, January 1993: 38.
109 Reuter. "Study links smoking to brittle bones in women." February 9, 1994.
110 Gavaler, J.S. & Van Thiel, D.H. "The association between moderate alcoholic beverage consumption and serum estradiol and testosterone levels in normal postmenopausal women: relationship to literature." *Clinical and Experimental Research,* January/February 1992; 16(1): 87-92.
111 Davis, B.J., et al. "Total and free estrogens and androgens in postmenopausal women with no fractures." *J Clin Endocrinol Metab.*, 1982; 54: 115-120.
112 Felson, D.T., et al. "Alcohol consumption and hip fractures: the Framingham study." *American Journal of Epidemiology*, 1988; 128(5): 1102-1110.
113 Hemenway, D., et al. "Fracture and lifestyle: effect of cigarette smoking, alcohol intake and relative weight on the risk of hip and forearm fractures in middle-aged women." *American Journal of Public Health*, 1988; 78: 1554-1558.
114 Carper, J. *Total Nutrition Guide.* New York, NY: Bantam Books, August 1989, p. 147.
115 Murray, M. *Natural Alternatives to Over-the-Counter and Prescription Drugs.* New York, NY: William Morrow & Company, 1994.
116 Murray, M. & Pizzorno, J. *Encyclopedia of Natural Medicine*, Rocklin, CA: Prima Publishing, 1991: 518-524.
117 Carper, J., op. cit., p. 147.
118 Ibid., p. 150.
119 Garrison, R.H., Jr. & Somer, E. *The Nutrition Desk Reference.* New Canaan, CT: Keats Publishing, Inc., p. 60.
120 Carper, J., op. cit., pp. 207-208.
121 Carper, J., op. cit., p. 210.
122 Garrison, R.H., Jr. & Somer, E., op. cit., p. 63.
123 Carper, J., op. cit., p. 211.
124 Garrison, R.H., Jr. & Somer, E., op. cit., p. 64.
125 Cichoke, A.J. "Silica: nature's health-giving mighty mite." *Townsend Letter for Doctors*, April 1995: 19-22.
126 Garrison, R.H., Jr. & Somer, E., op. cit., p. 82.
127 Cichoke, A.J., op. cit., pp. 19-22.
128 Carper, J. op. cit., p. 199.

129 Ibid., p. 144.
130 Brattstrom, L.E., et al. "Folic acid responsive postmenopausal homocysteinemia." *Metabolism*, 1985; 34: 1073-1077.
131 Carper, J. op. cit., p. 144.
132 Gura, T. "Estrogen: key player in heart disease among women." *Science*, 1995; 269: 771-773.
133 Marx, J.L. "Estrogen use linked to breast cancer." *Science*, August 11, 1989; 245: 593.
134 Goldman, L. & Tosteson, A.N.A. "Uncertainty about postmenopausal estrogen." *The New England Journal of Medicine*, September 12, 1991; 325(11): 800-802.
135 Ibid.
136 Stampfer, M.J. & Colditz, G.A. "Estrogen replacement therapy and coronary heart disease: a quantitative assessment of the epidemiologic evidence." *Prev. Med*, 1991; 20: 47-63.
137 Gura, T., op. cit., pp. 771-772.
138 Associated Press. "Study finds estrogen hormone helps postmenopausal women." *The New York Times*, January 1, 1996: 8Y.
139 Ibid.
140 Colditz, G.A., et al., op. cit., pp. 1589-1593.
141 Goldman, L. & Tosteson, A.N.A. "Uncertainty about postmenopausal estrogen." *The New England Journal of Medicine*, September 12, 1991; 325(11): 800-802.
142 Medical Research Council's General Practice Framework. "Randomized comparison of oestrogen versus oestrogen plus progestogen hormone replacement therapy in women with hysterectomy." *British Medical Journal*, 1996; 312: 473-478.
143 Goldman, L. & Tosteson, A.N.A., op. cit., pp. 800-802.
144 Ibid.
145 Riemersma, R.A., et al. "Risk of angina pectoris and plasma concentrations of vitamins A, C, and E and carotene." *Lancet*, January 5, 1991: 1, v337, n8732.
146 Buring cited in Long, P. "Vitamin E: Should you believe in it? Here's all you need to know." *Hippocrates*, November/December 1994: 46, 48, 50, 53.
147 Goldstein, M.R. "Mediterranean diet in coronary heart disease." *The Lancet*, July 23, 1994: 344: 276.
148 Ibid.
149 United States Department of Health and Human Services, op. cit., p. 86.
150 American Heart Association. "Search for best 'antioxidants' to protect LDL points to vitamin E, new study suggests." News release. April 12, 1993. Dallas, Texas.
151 United States Department of Health and Human Services, op. cit., pp. 83, 87.
152 Stampfer, M.J., et al. "Vitamin E consumption and the risk of coronary disease in women." *The New England Journal of Medicine*, 1993: 328: 1444-1449.
153 American Heart Association. "New studies suggest vitamin E reduces heart disease risk in men and women." November 17, 1992. News Release. Dallas, Texas.
154 Knekt, P., et al. "Antioxidant vitamin intake and coronary mortality in a longitudinal population study." *American Journal of Epidemiology*, 1994; 139: 1180-1189.
155 Hoffman, R.M. & Garewal, H.S. "Antioxidants and the prevention of coronary heart disease." *Archives of Internal Medicine*, February 13, 1995; 155: 241-246.
156 American Heart Association. "Antioxidants may reduce risk of stroke, 3 teams of scientists report." News release. March 18, 1993. Dallas, Texas.
157 Vitamin E Research & Information Service. *Vitamin E Fact Book*. LaGrange, IL: Vitamin E Research & Information Service, 1994.
158 Ibid.
159 Ibid.
160 Ibid.
161 Ibid.
162 Packer, L. "Vitamin E is nature's master antioxidant." *Scientific American Science & Medicine*, March/April 1994; 1(1): 54-63.
163 Vitamin E Research & Information Service, op. cit.
164 Ibid.
165 Hallfrisch, J., et al. "High plasma vitamin C associated with high plasma HDL-and HDL2 cholesterol." *The American Journal of Clinical Nutrition*, 1994; 60: 100-105.
166 Raloff, J. "Path to heart health is one with a peel." *Science News*;158:327.

167 Bordia, A., et al. "Effect of garlic (Allium sativum) on blood lipids, blood sugar, fibrinogen and fibrinolytic activity in patients with coronary artery disease." N *Prostaglandins Leukot Essent Fatty Acids*, 1998; 58(4):257-63.

168 Kunze, R. Unpublished *in vivo* studies, personal communication, October 14, 1997.

169 Vinzenz, K. "Ödembehandlung bei zahnchirurgischen eingriffen mit hydrolytischen enzymen." *Die Quintessenz*, 1991; 7: 1053.

170 Segers, A.M., et al. "Cellulite." *J Med Cutan Ibero Lat Am*, 1985; 13(6):539-44.

171 Monograph: *Centella asiatica*. Indena S.p.A., Milan, Italy, 1987.

172 Bourguignon, D. "Study of the action of titrated extract of *Centella asiatica*." *Gaz Med Fr*, 1975; 82: 4579-4583.

173 Bonnett, G.F. "Treatment of localized cellulitis with asiaticoside Madecassol." *Prog Med*, 1974: 102: 109-110.

174 Keller, F. & Grosshans, E. "Cellulite: Reality or fraud?" *Med Hyp*, 1983; 41: 1513-1518.

175 Tenailleau, A. "On 80 cases of cellulitis treated with the standard extract of *Centella asiatica*." *Quest Med* 1978; 31: 919-924.

176 Carraro Pereira, I. "Treatment of cellulitis with *Centella asiatica*." *Folha Med*, 1979; 79: 401-404.

177 Monograph: *Escin* (Milan, Italy: Indena S.p.A., 1987).

178 Annoni, F., et al. "Venotonic activity of escin on the human saphenous vein." *Arzneim-Forsch*, 1979; 29: 672-675.

179 Diehm, C., et al. "Comparison of leg compression stocking and oral horse-chestnut seed extract therapy in patients with chronic venous insufficiency." *Lancet*, 1996; 347: 292-294.

180 Pittler, M.H. & Ernst, E. "Horse-chestnut seed extract for chronic venous insufficiency. A criteria-based systematic review." *Arch Dermatol*, 1998; 134(11):1356-60.

181 Pointel, J.P., et al. "Titrated extract of *Centella asiatica* (TECA) in the treatment of venous insufficiency of the lower limbs." *Angiology*, 1987; 38: 46-50.

182 Marcelon, G., et al. "Effect of *Ruscus aculeatus* on isolated canine cutaneous veins." *Gen Pharmacol*, 1983; 14: 103.

183 Ihme, N., et al. "Leg edema protection from buckwheat herb tea in patients with chronic venous insufficiency: a single center, randomized, double-blind, placebo-controlled clinical trial." *Eur J Clin Pharmacol*, 1995; 50: 443-447.

184 "The Physiological Significance of Sea Buckthorn in Health Care" by Sun Zhenhua, Zhang Jike, Lin Meizhen (China Research & Training Center on Sea Buckthorn, Beijing, China and the Department of Biological Science, Shanxi University, Taiyuan, Shaanxi, China).

185 Gao, X., et al. "Changes in antioxidant effects and their relationship to phytonutrients in fruits of sea buckthorn (*Hippophae rhamnoides L.*) during maturation." *J Agric Food Chem*, 2000; 48(5):1485-1490.

186 Li, Y. "[Blocking effect of sea buckthorn juice on the nitrosation of morpholine in vitro]." *Chung Hua Yu Fang I Hsueh Tsa Chih*, 1987;21(4):199-201.

187 Li, Y. & Liu, H. "Prevention of tumour production in rats fed aminopyrine plus nitrite by sea buckthorn juice." *IARC Sci Publ*, 1991;(105):568-570.

188 Kostrikova, E.V. "[Experimental study of wound-healing effect of the preparation 'Aekol (artificial sea buckthorn oil)']." *Ortop Travmatol Protez*, 1989; (1):32-36.

189 Ianev, E., et al. "[The effect of an extract of sea buckthorn (*Hippophae rhamnoides L.*) on the healing of experimental skin wounds in rats]." *Khirurgiia (Sofiia)*, 1995;48(3):30-33.

190 "Development and Utilization of Sea Buckthorn Fruit Cosmetic" by He Xuejiao, Fang Zheng, Liang Zhaorong, Jiang Lisha (Guangdong Provincial Institute of Materia Medica, Guangzhou, China); Zhang Fushun, Gao Jinming, Zhao Enqu (Shaanxi Quinyong Chemical Bioengineering Institute, Yongshou, Shaanxi, China).

191 Pinnel, S.R., Murad, S., Darr, D. "Induction of collagen synthesis by ascorbic acid. A possible mechanism." *Archives of Dermatology*, 1987; 123(12):1684-6.

192 Cheraskin, E. *Vitamin C: Who Needs It?* Birmingham, AL: Arlington Press & Company, 1993, pp. 142-153.

193 Murray, M. *Encyclopedia of Nutritional Supplements*. Rocklin, CA: Prima Publishing, 1996: 249.

194 Horrobin, *J Am Acad Dermatol*, 1989; 20: 1045-1053.

195 Wright, *Br J Dermatol*, 1991; 125: 503-515.

196 Morganti, et al. *J Appl Cosm*, 1985; 3: 211-222.

197 Speiser, K., et al. "Hemp seed oil, the wonder oil for the new millennium." *happi*, June 1999: 106-109.

198 Morris, G.M., et al. "Modulation of the cell kinetics of pig skin by the topical application of evening primrose oil or Lioxasol." *Cell Prolif*, 1997; 30(8-9): 311-323.

199 Moreno Gimenez, J.C. et al. "[Treatment of skin ulcer using oil of mosqueta rose]." *Med Cutan Ibero Lat Am*, 1990; 18(1):63-66.

200 Hochman, L.G., et al. "Brittle nails: response to daily biotin supplementation." Cutis, 1993; 51: 303-307.

201 Markowitz, J.A., et al. "Hair dyes and acute nonlymphocytic leukemia (ANLL)." *American Journal of Epidemiology*, 1985; 122: 523. Abstract.

202 Cantor, K.P., et al. "Hair dye use and risk of leukemia and lymphoma." *American Journal of Public Health*, 1988; 78: 570-571, as cited in Zahm et al. 1992.

203 Zahm, S., et al. "Use of hair coloring products and the risk of lymphoma, multiple myeloma, and chronic lymphocytic leukemia." *American Journal of Public Health*, July 1992; 82(7): 990-997.

204 Brown, L.M., et al. "Hair dye use and multiple myeloma in white men." *American Journal of Public Health*, 1992; 82: 1673-1674.

205 International Agency for Research on Cancer. *IARC Monographs on the Evaluation of Carcinogenic Risks to Humans. Occupational Exposures of Hairdressers and Barbers and Personal Use of Hair Colourants; Some Hair Dyes, Cosmetic Colourants, Industrial Dyestuffs and Aromatic Amines.* Volume 57. Lyon, France, 1993.

206 Thun, M.J., et al. "Hair dye use and risk of fatal cancers in U.S. women." *Journal of the National Cancer Institute*, February 2, 1994; 86(3): 210-215.

207 Brown, L.M., et al., op. cit., pp. 1673-1674.

208 Markowitz, J.A., et al., op. cit., p. 523.

209 Cantor, K.P., et al., op. cit., pp. 570-571.

210 Zahm, S., et al., op. cit., pp. 990-997.

211 Shafer, N. & Shafer, R.W. "Potential of carcinogenic effects of hair dyes." *New York State Journal of Medicine*, 1976; 76: 394-396.

212 Kinlen, L.J., et al. "Use of hair dyes by patients with breast cancer: a case-control study." *British Medical Journal*, 1977; ii: 366-368.

213 Shore, R.E., et al. "A case-control study of hair dye use and breast cancer." *Journal of the National Cancer Institute*, 1979; 62: 277-283.

214 Hennekens, C.H., et al. "Use of permanent hair dyes and cancer among registered nurses." *The Lancet*, June 30, 1979, pp. 1390-1393.

215 Nasca, P.C., et al. "Relationship of hair dye use, benign breast disease, and breast cancer." *Journal of the National Cancer Institute*, 1980; 64: 23-28.

216 Rojanapo, W., et al. "Carcinogenicity of an oxidation product of p-phenylenediamine." *Carcinogenesis*, 1986, 17(12): 1997-2002.

217 IARC 57 1993, p. 105.

218 Lynge, E. & Thygesen, L. "Use of surveillance systems for occupational cancer: data from the Danish national system." *International Journal of Epidemiology*, 1988; 17: 493-500.

219 Silverman , D.T., et al. "Occupational risks of bladder cancer among white women in the United States." *American Journal of Epidemiology*, 1990; 132: 453-461.

220 IARC, op. cit., p. 105.

221 Cantor, K.P. & Lynch, C.F. "Occupational risk among women from a case-control study of 6 cancer sites in Iowa." National Institutes of Health International Conference on Women's Health: Occupation & Cancer, November 1-2, 1993. Abstract.

222 Kuijten, R.R., et al. "Parental occupation and childhood astrocytoma: results of a case-control study." *Cancer Research*, 1992; 52: 782-786.

223 Kramer, S., et al. "Medical and drug risk factors associated with neuroblastoma: a case-control study." *Journal of the National Cancer Institute*, 1987; 78: 797-804.

224 Bunin, G.R., et al. "Gestational risk factors for Wilms' tumor: results of a case-control study." *Cancer Research*, 1987; 47: 2972-2977.

225 Lotus Brands, Inc. Package insert. Twin Lakes, WI.

226 Nader, R. "The regulation of the safety of cosmetics." *Consumer Health and Product Hazards/Cosmetics and Drugs, Pesticides, Food Additives.* [editors] Epstein, S.S. & Grundy, R.D. Cambridge, MA: The MIT Press, 1974, vol. 2, pp. 100-102.

227 Epstein, S.S. *Politics of Cancer.* San Francisco, CA: Sierra Club Books, 1978.

228 "Prevalence of leisure-time physical activity among persons with arthritis and other rheumatic conditions—United States, 1990-1991." *Mmwr. Morbidity and Mortality Weekly Report*, May 9 1997, 46(18):389-93.

229 McIlwain, H.H. & Fulghum Bruce, D. *Stop Osteoarthritis Now!* New York, NY: Simon & Schuster, 1996, p. 86.

230 U.S. Department of Health and Human Services, op. cit., p. 333.

231 Young, S., op. cit., p. 38.

232 United Press International. "Exercise, estrogen benefit older women."

233 Associated Press. "Lower cancer risk found in athletic women." *The New York Times*, January 10, 1986: 7Y.

234 Frisch, R.E., et al. "Lower prevalence of breast cancer and cancers of the reproductive system among former college athletes compared to nonathletes." *British Journal of Cancer*, 1985; 52: 885-891.

235 Frisch, R.E., et al. "Lower lifetime occurrence of breast cancer and cancers of the reproductive system among former college athletes." *American Journal of Clinical Nutrition*, 1987; 45: 328-335.

236 Thompson, H.J., et al. "Inhibition of mammary carcinogenesis by treadmill exercise." *Journal of the National Cancer Institute*, 1995; 87(6): 453-455.

237 Cohen, L.A., et al. "Modulation of N-nitrosomethylurea induced mammary tumorigenesis by dietary fat and voluntary exercise." *In Vivo*, 1991; 5(4): 333-344.

238 Thompson, H.J., et al. "Effect of type and amount of dietary fat on the enhancement of rat mammary tumorigenesis by exercise." *Cancer Research*, 1989; 49: 1904-1908.

239 Thompson, H.J., et al. "Effect of exercise on the induction of mammary carcinogenesis." *Cancer Research*, 1988; 48: 2720-2723.

240 Cohen, L.A., et al., op. cit., pp. 333-344.

241 Thompson, H.J., et al al., op. cit., 1995.

242 Bernstein, L., et al. "Physical exercise and reduced risk of breast cancer in young women." *Journal of the National Cancer Institute*, 1994; 86: 1403-1408.

243 Bernstein cited in Raloff, J. "Exercising reduces breast cancer risk." *Science News*, October 1, 1994: 215.

244 Vena, J.E., et al. "Occupational exercise and risk of cancer." *American Journal of Clinical Nutrition*, 1987; 45: 318-327.

245 Pelletier, K. *Mind as Healer, Mind as Slayer.* New York, NY: Dell Publishing Co., Inc., 1977, p. 6.

246 Peteet, J.R. "Psychological factors in the causation and course of cancer." *Cancer, Stress, and Death*, [ed. Day, S.B.] New York and London: Plenum Medical Book Company, 1989: 63-77.

247 Riley, V. "Psychoneuroendocrine influences on immunocompetence and neoplasia." *Science*, 1981; 212: 1100-1108.

248 Leedham, B. & Meyerowitz, B.E. "The mind and breast cancer risk." In: *Reducing Breast Cancer Risk in Women*, [ed., Stoll, B.A.]. Netherlands: Kluwer Academic Publishers, 1995: 223-229.

249 Greer, S., et al. "Psychological response to breast cancer; effect on outcome." *Lancet*, 1979; ii: 785-787.

250 Levy, S.M., et al. "Immunological and psychosocial predictors of disease recurrence in patients with early-stage breast cancer." *Behav. Med.* 1991; 17: 67-75.

251 *British Medical Journal*, 1995; 311: 1527-1530.

252 Leedham, B. & Meyerowitz, B.E., op. cit., pp. 223-229.

253 Pennington, A. "Women's health. Anxiety disorders." *Prim Care*, 1997;24(1):103-111.

254 Roy-Byrne, P.P. "Generalized anxiety and mixed anxiety-depression: association with disability and health care utilization." *J Clin Psychiatry*, 1996;57;Suppl 7:86-91.

255 Jonas, B.S., et al. "Are symptoms of anxiety and depression risk factors for hypertension? Longitudinal evidence from the National Health and Nutrition Examination Survey I Epidemiologic Follow-up Study." *Arch Fam Med*, 1997;6(1):43-49.

256 Tudge, C. "Does valium promote cancer?" *New Scientist*, January 8, 1981: 80.

257 Mathews, J. "Concern over Prozac-induced tumor growth may dwindle following FDA study." *Journal of the National Cancer Institute*, 87(17): 1285-1287.

258 Burton, T.M. "Lilly sales rise as use of Prozac keeps growing." *The Wall Street Journal*, January 31, 1996; B1, B3.

259 Brandes, L.J. "Stimulation of malignant growth in rodents by antidepressant drugs at clinically relevant doses." *Cancer Research*, July 1, 1992; 52: 3796-3800.

260 Leedham, B. & Meyerowitz, B.E., op. cit., pp. 223-229.

261 Carper, J. *Jean Carper's Total Nutrition Guide*, New York: Bantam Books, 1987, p. 120.

262 Dubey, G.P., et al. "Geriforte in psychosomatic and anxiety disorders." *Asian Med. J.*, 1984;27(11): 723.

263 Boral, G.C., et al. "Geriforte in anxiety neurosis." *Ind. J. Psychiatr.*, 1989;31(3):258.

264 Shah, L.P., et al. "Clinical evaluation of Geriforte in patients with generalized anxiety disorders." *Bom. Hosp. J.*, 1990; 32(3):29.

265 Gopumadhavan, S., et al. "Toxicity studies. Acute toxicity study. Chronic toxicity study. Teratogenicity study." R & D Center, The Himalaya Drug Co., Bangalore, India, unpublished data, 1992.

266 Murray, M. 5-HTP. *The Natural Way to Overcome Depression, Obesity, and Insomnia*. New York: Bantam Books, 1999.

267 Sano, I. "L-5-hydroxytryptophan therapy." *Folia Psychiatrica et Neurologica Japonica*, 1972;26:7-17.

268 Pöldinger, W., et al. "A functional-dimensional approach to depression: serotonin deficiency as a target syndrome in a comparison of 5-HTP and fluvoxamine." *Psychopathology*, 1991;24:53-81.

269 Angst, J., et al. "The treatment of depression with L-5-hydroxytrytophan versus imipramine: results of two open and one double-blind study." *Archiv für Psychiatrie und Nervenkrankheiten*; 1977;224:175-186.

270 Brown, R. "Tryptophan metabolism in humans," in O. Hayaishi, et al. [eds.] *Biochemical and Medical Aspects of Tryptophan Metabolism*, Amsterdam: Elsevier/North Holland Press, 1980:227-236.

271 Murray, M. *The Healing Power of Herbs*, pp. 339-342.

272 Mowrey, D. *The Scientific Validation of Herbal Medicine*. New Canaan, CT: Keats Publishing, 1986, p. 138.

273 Lutomskin, V.J., et al. "Pharmacochemical investigation of the raw materials from Passiflora genus." *Planta Medicine*, 1975; 27: 112-117.

274 Shamberger, R.J., et al. "Antioxidants and cancer. VI: selenium and age-adjusted human cancer mortality." *Archives of Environmental health*, 1976; 31: 231-235.

275 Clark, L.C. "The epidemiology of selenium and cancer." *Federal Proceedings*, 1985; 44: 2584-2589.

276 Schrauzer, G.N., et al. "Cancer mortality correlation studies, III: statistical association with dietary selenium intakes." *Bioinorg. Chem.* 1977; 7: 23-35.

277 Hardell, L., et al. "Levels of selenium in plasma and glutathione peroxidase in erythrocytes and the risk of breast cancer: a case-control study." *Biological Trace Element Research*, 1993; 36: 99-108.

278 Schrauzer, G.N., et al. "Effects of temporary selenium supplementation on the genesis of spontaneous mammary tumors in inbred female C3H/St mice." *Carcinogenesis*, 1980; 1: 199.XXX

279 Oguni, I., et al. "A preliminary study on the protection against cancer risk by green tea drinking." Department of Food and Nutrition, University of Shizuoka Hamamatsu College, Nunohashi, Hamamatus, Shizuoka 432.

280 Nagasawa, H., et al. "Two-way selection of a stock of Swiss albino mice for mammary tumorigenesis: Establishment of two new strains (SHN and SLN). *Journal of the National Cancer Institute*, 1976; 57: 425-430.

281 Mukhtar, H. "Green tea and skin-anticarcinogenic effects." *Journal of Investigative Dermatology*, 1994; 102: 5-7.

282 Frank, R.T. "The hormonal causes of premenstrual tension." *Arch Neurol Psychiatry*, 1931;26:1052.

283 Greene, R. & Daulton, K. "The premenstrual syndrome." *BMJ*, 1953;1:1007.

284 Brandes, L.J. "Stimulation of malignant growth in rodents by antidepressant drugs at clinically relevant doses." *Cancer Research*, July 1, 1992; 52: 3796-3800.

285 Mathews, J., op. cit., pp. 1285-1287.

286 Burton, T.M., op. cit., 1996; B1, B3.

287 Steiner, M., et al "Intermittent fluoxetine dosing in the treatment of women with premenstrual dysphoria." *Psychopharmacol Bull*, 1997; 33(4):771-774.

288 Abraham, G.E. "Nutritional factors in the etiology of the premenstrual tension syndromes." *The Journal of Reproductive Medicine*, 1983; 28(7): 446-462.

289 Rossignol, A.M. & Bonnlander, H. "Prevalence and severity of the premenstrual syndrome. Effects of foods and beverages that are sweet or high in sugar content." *J Reprod Med*, 1991; 36(2): 131-136.

290 Facchinetti, F., et al. "Oral magnesium successfully relieves premenstrual mood changes." *Obstetrics & Gynecology*, 1991; 78(2): 177-181.

291 Carper, J. *Total Nutrition Guide*, New York, NY: Bantam Books, 1987, p. 206.

292 Ibid., p. 202.

293 Walker, A.F., et al. "Magnesium supplementation alleviates premenstrual symptoms of fluid retention." *J Womens Health*, 1998; 7(9):1157-1165.

294 Horrobin, D.F. "The role of essential fatty acids and prostaglandins in the premenstrual syndrome." *J Reprod Med*, 1983; 28(7): 465-468.

295 Thys-Jacobs, S., et al. "Calcium carbonate and the premenstrual syndrome: effects on premenstrual and menstrual symptoms. Premenstrual Syndrome Study Group." *Am J Obstet Gynecol*, 1998; 179(2):444-452.

296 Wyatt, K.M., et al. "Efficacy of vitamin B-6 in the treatment of premenstrual syndrome: systematic review." BMJ, 1999; 318(7195): 1375-1381.

297 Hikino, H. "Recent research on oriental medicinal plants." *Economic Medical Plant Research*, 1985; 1: 53-85.

298 Yoshiro, K., op. cit., pp. 269-278.

299 Cabot, S. *Smart Medicine for Menopause. Hormone Replacement Therapy and its Natural Alternatives.* Garden City Park, NY: Avery Publishing Group, 1995, p. 94.

300 Foster, S. "Chinese herbs for mainstream America." *Energy Times*, February 1997: 34-42.

301 Ibid.

302 Dittmar, F.-W., et al. "Premenstrual syndrome. Treatment with phytopharmaceutical." *Therapiewoche Gynakol*, 1992; 5: 60-68.

303 Peteres-Welte, C. & Albrecht, M. "Menstrual abnormalities and PMS: Vitex agnus-castus." *Therapiewoche Gynakol*, 1994; 7: 49-52.

304 Lauritzen, C., et al. "Treatment of premenstrual tension syndrome with Vitex agnus-castus. Controlled, double-blind study versus pyridoxine." *Phytomedicine*, 1997; 4(3): 183-189.

305 Murray, M. & Pizzorn, J. *Encyclopedia of Natural Medicine*. Rocklin, CA: Prima Publishing, 1998, pp. 750-751.

306 Milewicz, A., et al. "*Vitex Agnus-castus* in the treatment of lueteal phase defects due to hyperprolactinemia." *Arzneim-Forsch*, 1993; 43: 752-756.

307 Swarup, A. & Umadevi, K. "Evaluation of Evecare in the treatment of dysmenorrhoea and premenstrual syndrome." *Obs & Gynae Today*, 1998;III(6):369.

308 Mitra, S.K., et al. "EveCare (U-3107) as a uterine tonic—pilot study." *The Ind Practit*, 1998;51(4):269.

309 Venugopal, S. "Effect of EveCare in oligomenorrhoea." *The Antiseptic*, 1998;95(10):329-330.

310 Mintz, M. "FDA evaluates link between cancer, drug." *The Washington Post*, January 21, 1976.

311 Rustia, M. & Shubik, P. "Experimental induction of hepatomas, mammary tumors, and other tumors with metronidazole in nonbred Sas:MRC(WI)BR rats." *Journal of the National Cancer Institute*, 1979; 63: 863-868.

312 Cavaliere, A., et al. "Induction of mammary tumors with metronidazole in female Sprague-Dawley rats." *Tumori*, 1984; 70: 307-311.

313 Danielson, D.A., et al. "Metronidazole and cancer." *Journal of the American Medical Association*, 1982; 247(18): 2498-2499

314 Beard, C.M., et al. "Lack of evidence for cancer due to use of metronidazole." *The New England Journal of Medicine*, 1979; 301(10): 519-522.

315 "Effect of lactobacillus immunotherapy on genital infections in women (Solco/Gynatren)." *Geburtshilfe Fraunheilkd*, 1984; 44(5): 311-314.

316 Fredricsson, B., et al. "Gardnerella-associated vaginitis and anerobic bacteria." *Gynecol. Obstet. Invest.*, 1984; 17(5): 236-241.

317 Spiegel, C.A., et al. "Diagnosis of bacterial vaginosis by direct gram stain of vaginal fluid." *J. Clin. Microbiol.*, 1983; 18(1): 170-177.

318 Spiegel, C.A., et al. "Anaerobic bacteria in nonspecific vaginitis." *The New England Journal of Medicine*, 1980; 303(11): 601-607.

319 Karkut, G. "[Effect of lactobacillus immunotherapy on genital infections in women (Solco Trichovac/Gynatren)." *Geburtshilfe Fraunheilkd*, 1984; 44(5): 311-314.

320 Litschgi, M.S., et al. "Effectiveness of a lactobacillus vaccine on trichomonas infections in women. Preliminary results." *Fortschr. Med.*, 1980; 98(41): 1624-1627.

321 Will, T.E. "Lactobacillus overgrowth for treatment of moniliary vulvovaginitis." Letter to the editor. *Lancet*, 1979; 2: 482.

322 Barsom, S., Sasse-Rollenhagen, K., Bettermann, A. "Erfolgreiche prostatitisbehandlung mit hydrolytischen enzymen." *Erfahrungsheilkunde*, 1982; 31: 2.

323 Riede, N.U., et al. *Allgemeine und Spezielle Pathologie.* Stuttgart: Thieme Verlag, 1989.

324 Barsom, S., Sasse-Rollenhagen, K., Bettermann, A. "Zur behandlung von zystitiden und zystopyelitiden mit hydrolytischen enzymen." *Acta Medica Empirica*, 1983; 32: 125.

325 Thompson, R.E. & Stamey, T.A. "Bacteriology of infected stones." *Urology*, 1973;2:627.

326 Ghose, A., et al. "Cystone in urinary tract infections." *Probe*, 1980;4:270.

327 Srivastava, R.K., et al. "Role of Cystone in management of urinary tract infections." *Curr Med Pract*; 1991;35(4):89.

328 Suresh Sharma, Merwaha, D.C. & Gupta, R.R. "Role of Cystone in management of urinary tract infections." *Probe*; 1992;XXXII;1:20.

329 Garg, S.K. & Singh, R.C. "Role of Cystone in burning micturition." *Probe*, 1985;XXIV(2):119.

330 Koshore, B. & Agrawal, G.C. "Effect of Cystone in non-specific, persistent, burning micturition syndrome." *Capsule*, 1979;3:55.

331 Tripathi, K., et al. "Non-specific urethritis syndrome—a clinical puzzle." *Probe*, 1984; XXIII;2:87.

332 Sabuj, S. "Cystone in urinary tract complaints during pregnancy." *Med & Surg*, 1987;27(8):7.

333 Mukherjee, M. "Cystone in urgency incontinence of urine." *Probe*, 1979;2:82.

334 Patel, G.T. "Cystone in renal dysfunction." *Antiseptic*, 1974;8:452.

335 Sharma, B.M., et al. "Clinical trial of Cystone in various renal disorders." *Probe*, 1983;2:113.

336 Chandan, R.C.Y., et al. "Competitive exclusion of uropathogens from human uroepithelial cells by Lactobacillus." *Infect Immun*, 1985; 47: 84-89.

337 Dittmar, F.-W. & Weisssenbacher, E.R. "Therapie der adnexitis—unterstützung der antibiotischen basisbehandlung durch hydrolytische enzyme." *International Journal of Experimenta and Clinical Chemotherapy*, 1992; 5: 73-82.

338 Scheef, W. "Gutartige veränderungen der weiblichen brust." *Therapiewoche*, 1985: 5090.

339 Scheef, W. "Neue aspekte in der komplexen behandlung von fortgeschiritenen malignen tumoren." In: *Medizinische Enzym-Forschungsgesellschaft e.V.* (ed.): Systemische Enzymtherapie, 3rd Symposium, Vienna, 1988.

340 Dittmar, F.-W., et al. "Wobenzym® zur behandlung der mastophatie." Publication in preparation.

341 Sukhikh, G.T., et al. "The therapeutic action of Wobenzym® in multidrug therapy of genitourinary, Chlamydial and mycoplasmal infections." *Oral Enzyme Therapy. Compendium of results from Clinical Studies with Oral Enzyme Therapy.* Second Russian Symposium, St. Petersburg, Russia. Stockdort, Germany: Forum-Medizin, 1997: 39-44.

342 (Vignon et al. 1997).

343 Krajickova, J. & Macek, J. "Urinary proteoglycan degradation production excretion in patients with rheumatoid arthritis and osteoarthritis." *Annals of the Rheumatic Diseases*, 1988: 468-471.

344 Vidal y Plana, R.R., et al. "Articular cartilage pharmacology: I. In vitro studies on glucosamine and non-steroidal anti-inflammatory drugs." *Pharmacological Research Communications*, 1978; 10(6): 557-569.

345 Setnikar, R., et al. "Pharmacokinetics of glucosamine in man." *Drug Research*, 1993; 43(II), Nr. 10: 1109-1113.

346 Setnikar, R., et al. "Absorption, distribution and excretion of radioactivity after a single intravenous or oral administration of [14C]-glucosamine to the rat." *Pharmatherapeutica*, 1984; 3: 538-550.

347 Setnikar, R., et al., op. cit., pp. 1109-1113.

348 Dziewiatkoswski, D.D. *J.Biol.Chem.*,1951;189: 187.

349 Kim, J.J., Cornered, H.E.J. *Biol.Chem.*, 1974; 249:3091.

350 Vidal y Plana, R.R., et al., op. cit., pp. 557-569.

351 Bucci, L. *Pain Free*, Lenexa, KS: Wilie International, Inc.

352 Crolle, G. & D'Este, E. "Glucosamine sulfate for the management of arthrosis: a controlled clinical investigation." *Current Medical Research and Opinion*, 1980; 7(2): 104-114.

353 Murray, M. *Encyclopedia of Nutritional Supplements.* Rocklin, CA: Prima Publishing, 1996, p. 262.

354 Baici, A., et al. "Analysis of glycosaminoglycans in human serum after oral administration of chondroitin sulfate." *Rheumatology International*, 1992; 12: 81-88.

355 Pipitone, V.R. "Chondroprotection with chondroitin sulfate." *Drugs in Experimental and Clinical Research*, 1991; 17(1): 3-7.

356 Mazières, B., et al. "Le chondroitin sulfate dayns le traitement de la gonarthrose et de la coxarthrose." *Rev. Rheum. Mal Ostéoartic*, 1992; 59(7-8): 466-472.

357 Morreale P., et al. "Comparison of the anti-inflammatory efficacy of chondroitin sulfate and diclofenac sodium in patients with knee osteoarthritis." *Journal of Rheumatology*, 1996 Aug, 23(8):1385-1391.

358 Busci, L., et al. "Efficacy and tolerability of 2 x 400 mg oral chondroitin sulfate as a single dose in the treatment of knee osteoarthritis." In: *Osteoarthritis and Cartilage*, vol. 5, Supp. A, Philadelphia, PA: W.B. Saunders, 1997.

359 Bourgeois, P., et al. "Efficacy and tolerability of chondroitin sulfate 12—mg/day vs. chondroitin sulfate 3 x 400 mg /day vs. placebo." In: *Osteoarthritis and Cartilage*, vol. 5, Supp. A, Philadelphia, PA: W.B. Saunders, 1997.

360 Fleisch, A.M., et al. "A one-year randomized, double-blind, placebo-controlled study with oral chondroitin sulfate in patients with knee osteoarthritis." In: *Osteoarthritis and Cartilage*, vol. 5, Supp. A, Philadelphia, PA: W.B. Saunders, 1997.

361 Uebelhart, D., et al. "Chondroitin 4 & 6 sulfate. A symptomatic slow-acting drug for osteoarthritis, does also have structural modifying properties." In: *Osteoarthritis and Cartilage*, vol. 5, Supp. A, Philadelphia, PA: W.B. Saunders, 1997.

362 Steffen, C., et al. "Enzymtherapie im vergleich mit immunkomplexbestimmungen bei chronischer polyarthritis." *Zeitschr. f. Rheumatologie*, 1985; 44: 51.

363 Streichhan, P., et al. "Resorption partikulärer und makromolekularer Darminhaltsstoffe." *Nature- und Ganzheitsmedizin*, 1988; 1: 90.

364 Miehlke, K. "Enzymtherapie bei rheumatoider arthritis." *Nature- und Ganzheitsmedizin*, 1988; 1: 108.

365 Singer, F. "Aktivierte arthrosen knorpelschonend behandeln." In': *Medizinische Enzym-Forschungsgesellschaft* e.V. (ed.): Systemische Enzymtherapie, 10th Symposium, Frankfurt, 1990.

366 Mazurov, V.I., et al. "Systemic enzyme therapy in combination therapy for rheumatic disease." *Oral Enzyme Therapy. Compendium of Results from Clinical Studies with Oral Enzyme Therapy.* Second Russian Symposium, St. Petersburg, Russia, 1996.

367 Reiter, W., et al. "What is the effect of an antirheumatic agent with plant-based active substances in the therapy of chronic polyarthritis?" *Therapiewoche*, 1989; 39(46): 3409-3414.

368 Bernhardt, M., et al. "Double-blind, randomized comparative study of Phytodolor® N and placebo, and open comparison with piroxicam on patients with arthroses." Internal Research Report, 1991.

369 Ernst, E. "The efficacy of Phytodolor® for the treatment of musculoskeletal pain—a systemic review of randomized clinical trials." Department of Complementary Medicine, School of Postgraduate Medicine and Health Sciences, University of Exeter, UK.

370 von Kruedener, S., et al. "A combination of *Populus tremula*, *Solidago virgaurea* and *Fraxinus excelsior* as an anti-inflammatory and antirheumatic drug. A short review." *Arzneimittelforschung*, 1995; 45(2): 169-71.

371 Meyer, B., et al. "Antioxidative properties of alcoholic extracts from *Fraxinus excelsior*, *Populus tremula* and *Solidago virgaurea*." *Arzneimittelforschung*, 1995; 45(2)·174-6

372 Jacob, S.W., et al. *The Miracle of MSM*. New York, NY: Putnam, 1999.

373 Jacob, S.W. & Herschler, R. "Biological actions and medical applications of dimethyl sulfoxide." *Ann NY Acad Sci*, 1983; 411: 13-17.

About the Author

Jan McBarron, M.D., is a nationally recognized preventive and nutritional medicine specialist who emphasizes the use of vitamins and herbal supplements. A graduate of Hahnemann University Medical School in Philadelphia, Pennsylvania, Dr. McBarron specializes in preventive medicine and maintains a full-time medical practice in Georgia, where she lives with her husband, Duke Liberatore.

Together, they co-host the number-one rated radio health talk show in the nation—*Duke and the Doctor*. This nationally syndicated two-hour daily broadcast is heard in more than 150 cities nationwide. Each year, *Talkers* magazine selects the top 100 best talk radio programs out of more than 4,300 on the air. *Duke and the Doctor* has made the list every year since 1997. You can listen to her radio broadcast 24 hours a day, seven days a week at www.dukeandthedoctor.com.

Dr. McBarron is a member of the American Medical Association, American Society of Bariatric Physicians, Georgia Medical Association, and Muscogee Medical Society. A regular columnist in two Georgia newspapers and numerous magazines, she has been a featured medical authority in *Sports Illustrated*, *Reader's Digest*, and *Time*. She was also selected as a nutritional consultant for the 1996 Summer Olympic Games.

Dr. McBarron is not asking you to do anything she doesn't practice herself. More than 10 years ago she quit a two-pack-a-day smoking habit and lost 70 pounds after years of yo-yo dieting.

What's her lifestyle? She espouses to her own 20/80 rule—eighty percent of the time she makes healthy food choices and twenty percent of the time she lets loose and splurges. She exercises constantly (six days a week), drinks 64 ounces

or more of water daily, and takes her vitamins and other dietary supplements daily. Spiritually and mentally, she feels balanced. Mammograms and pap smears are scheduled. She remains adamant in her decision that when the time comes she will not take HRT, but will embrace that time in her life—naturally.